Hélène Cixous
Rootprints

Hélène Cixous is undoubtedly one of the most brilliant and innovative contemporary thinkers. Published here in English for the first time, *Hélène Cixous, Rootprints: Memory and Life Writing* traces Cixous's development as a writer and intellectual whose remarkable perspicacity and poetic force are known worldwide. This unique collection speaks with many voices and in different registers, allowing the reader myriad entries into the rich diversity of Cixous's works. At once profound and limpid, *Rootprints* is an ideal introduction to Cixous's theory and fiction, exploring such vital questions as sexual difference, literary theory, feminism, philosophy, self and other, death and life. It weaves together a broad range of documents: extended interview, critical essays, photographs from Cixous's family album, pages from her private notebooks, with a stunning poetico-biographical musing by the author, complete with bio-bibliographical information and a contribution by Jacques Derrida.

This book will provide endless fascination for all those who wish to get to know the author, the professor, the political activist, the dreamer, the mother, the daughter, the analyst, the thinker, the person, named Hélène Cixous.

Hélène Cixous has written nearly thirty books of poetic fiction, innumerable critical essays, and eight plays. Her works have been translated into more than ten languages. She is Professor of Literature at the Université de Paris VIII, an experimental university she helped found in 1968.

Mireille Calle-Gruber is Professor of French Literature at Queen's University, Ontario. She is also a writer and has published widely. Her works include *Les Partitions de Claude Ollier* (Paris: L'Harmatton, 1996), *La division de l'intérieur* (Montréal: L'Hexagone, 1996) and *On the Feminine* (New Jersey: Humanities Press, 1996).

Eric Prenowitz is affiliated with the Centre d'Études Féminines at the Université de Paris VIII.

This work was made possible by
assistance from the
Social Sciences and Humanities Council of Canada (SSHCC)

Hélène Cixous
Rootprints

Memory and Life Writing

Hélène Cixous and Mireille Calle-Gruber

(translated by Eric Prenowitz)

London and New York

First published in French by Editions des femmes, Paris,
France, as *Photos de Racine*, 1994

First published in English 1997
by Routledge
11 New Fetter Lane, London EC4P 4EE

Simultaneously published in the USA and Canada
by Routledge
29 West 35th Street, New York, NY 10001

© 1997 Hélène Cixous and Mireille Calle-Gruber

Typeset by LaserScript, Mitcham, Surrey
Printed and bound in Great Britain by
Biddles Ltd, Guildford and King's Lynn

British Library Cataloguing in Publication Data
A catalogue record for this book is available from the British Library

Library of Congress Cataloging in Publication Data
A catalogue record for this book has been requested

ISBN 0–415–15541–X (hbk)
ISBN 0–415–15542–8 (pbk)

For Marguerite Sandré
who has played a vital role
in Hélène Cixous's seminars
for more than twenty years

Contents

———— ❦ ————

WE ARE ALREADY IN
THE JAWS OF THE BOOK

INTER VIEWS

> *The windows in the text give*
> *onto Hélène Cixous's notebooks*

...
......................... one cannot talk about it without
...
.. attitudes, positions, dispositions
of the body-(and)-of-the-soul or even mechanisms

Mireille Calle-Gruber: One cannot talk about your work if, from the outset, one ignores the thirty or so books of fiction you have written. What is most true, for you, is poetic writing.

Hélène Cixous: What is most true is poetic. What is most true is naked life. I can only attain this mode of seeing with the aid of poetic writing. I apply myself to 'seeing' the world nude, that is, almost to e-nu-merating the world, with the naked, obstinate, defenceless eye of my nearsightedness. And while looking very very closely, I copy. The world written nude is poetic.

How can we see what we no longer see? We can devise 'tricks': my grandmother's room which I looked at through the keyhole; because of the focalization, I had never seen a room that was so much a room. The city of Algiers which I looked at in the bus windows.[1] The person we love made to appear by an aura. Microscopes, telescopes, myopias, magnifying glasses. All this apparatus in us: attention. To think, I knit my brows, I close my eyes, and I look.

> *What happens: events interiors, snatch them from the cradle, from the source.*
> *I want to watch watching arrive.*
> *I want to watch arrivances. I want to find the root of needing to eat. And taste it: work of sweat*
> *sleep.*

What is most true is poetic because it is not stopped-stoppable. All that is stopped, grasped, all that is subjugated, easily transmitted, easily picked up, all that comes under the word concept, which is to say all that is taken, caged, is *less* true. Has lost what is life itself, which is always in the process of seething, of emitting, of transmitting itself. Each object is in reality a small virtual volcano. There is a continuity in the living; whereas theory entails a discontinuity, a cut, which is altogether the opposite of life. I am not anathematizing all theory. It is indispensable, at times, to make progress, but alone it is false. I resign myself to it as to a dangerous aid. It is a prosthesis. All that advances is aerial, detached, uncatchable. So I am worried when I see certain tendencies in reading: they take the spare wheel for the bird.

M.C-G.: By 'theory' you are referring in particular here to a north-American situation of which echoes are returning presently to Europe, and which, under the name of 'feminist theory', has excluded your books of fiction, limiting itself to a few essays or articles: 'The Laugh of the Medusa', 'Sorties', your participation in *The Newly Born Woman*. To carry out this amputation is unjust to your work which is plural; overflowing; which incessantly questions what it draws. The risk, with writing that is attentive to subtleties, is that laziness, deafness, or surprise should lead people to hear only one voice, to stop at a single aspect. That the reading should reduce and reify because this is easier.

One must wonder how this happens. What happens – or does not happen – when one does so little justice to a body of work. Admittedly, there is misunderstanding about the term 'theory': the writing you practise is more like a form of philosophical reflection that you lead through poetry. But the misun-

derstanding comes also from the fact that, in the very course of the work of
fiction, you pursue an effort of lucidity: in the very place of writing's blind-
ness – of which you are conscious. A kind of work that involves turning back
on the sentence, that recycles, that reflects and flexes the flux of writing.
Certain people misunderstand; consider it to be a theoretical treatment
whereas it is a poetic treatment: incessant fictional practice. It's in the same
linguistic dough, from the same pen, that poetry and philosophical reflexion
weave a text. Which does not close itself in conceptualization, even locally.
Hearing you speak of the concept which fixes, I thought of Derrida's sentence
on the cover of *Circumfession:* 'As soon as it is poached by writing, the con-
cept is done (for).'[2] It is clearly more than a simple pun. To the letter: at the
speed of lightning, your text tries to say the 'raw', blood, tears, the body
which is a 'state of meat'. (I am thinking of the self-portrait as a flayed animal
in *FirstDays of the Year* which refers to Rembrandt; and *Déluge:* 'She remains
alone with her terrible meat' p. 93.)

H.C.: I planted those essays *deliberately*, at a very dated, entirely
historical moment, to mark off a field; so that we would not lose
sight of it entirely – to have done something deliberately: that
already tells you what it is! 'The Laugh of the Medusa' and other
texts of this type were a conscious, pedagogic, didactic effort on my
part to class, to organize certain reflections, to emphasize a
minimum of sense. Of common sense.

M.C-G.: You say 'dated, historical moment', that is to say, is it not, a political
moment? *The Newly Born Woman* is a precisely circumstantial text that
served as argumentational evidence at a moment in the struggle.

H.C.: I was inspired to write those texts by the urgency of a
moment in the general discourse concerning 'sexual difference'.
Which appeared to me to be confused and to be producing
repression and loss of life and of sense. I would never have
thought, when I began writing, that one day I would find myself
making strategic and even military gestures: constructing a camp
with lines of defence! It's a gesture which is foreign to me. I did do
it. Because of ideological aggressions, all marked by intolerance –
that were not addressed to me personally – all of a sudden I saw
myself having an obligation to become engaged to defend a
certain number of positions. To do this, I left my own ground.

I do not regret it. To 'defend' is sometimes a necessity. But it is an ambiguous gesture: whoever defends him- or herself forbids [*qui se défend défend*], i.e. interdicts. And I do not like the regions where people lay down the law. In addition, this secondary gesture screens the principal act.

My vocation, I must say, is not political, even if I am quite conscious that all expression is always indirectly political. The ethical question of politics, or of responsibility has always haunted me, as I imagine it haunts all the fireflies irresistibly attracted by the flame of the art-candle. (You will recognize in the candle an image of Kafka.) I am at once always on the alert (this began when I was three years old, in the streets of Oran, I remember clearly), always tormented by the injustices, the violences, the real and symbolic murders – and at the same time very menaced, too menaced in truth by the excesses of reality. I have always known that I could not have been a doctor (the true doctor, the doctor of compassion) without succumbing, like my father, to human pain. That's how it is. And in the same way, I could never have ventured onto the scene of political combat, which nonetheless is decisive for almost the totality of our destiny. This is why I felt a little bit 'saved' – in any case relieved, and greatly spared – when I met Antoinette Fouque, it was already late, in 1975. I had created the *Centre d'Études Féminines* in 1974. And I had forced myself into those armed gestures in '74–'75. Then I discover that there is an entirely exceptional woman, a genius of political thought, in action, whose vocation is to think through the fate of women today and for the future. A woman given over body and soul to the most demanding of causes. Since then I have always said to myself, each time I see the monstrous blades of socio-political reality rise like mountains before me (that is to say almost every day): thank goodness there is Antoinette. I know that she keeps watch, that she acts, that she represents a vast part of humankind also, which she protects. That presence has always appeased a part of my political-cultural worries. You will tell me that I delegate. But one always delegates. The hardship is to be unable to do it. Others delegate to me the responsibility of keeping watch to ensure that a poetic imagination does not fall into dust.

* *I am not page I*
1) *I am the black kid*
2) *I am*
 – *States of shadow*
3) *I am mother Achilles, Achilles the sacred cow.*

M.C-G.: I am always surprised that there is so little space, in the woman's movement, for the right to literary creativity. I am surprised also that people generally name Cixous–Irigaray–Kristeva together, amalgamating works between which I see mostly differences. Particularly: literary difference. Irigaray and Kristeva are theoreticians, they do not produce writer's works. However, it is the writer that I touch on in you. Where I touch down. One must recall that your field of action, indeed your combat, takes place in poetic writing, language, fiction.

H.C.: This happens because the texts of mine that are put into circulation are often texts that can easily be circulated and appropriated. They were made for this, by the way. The others are not read.

M.C-G.: Those other texts do not require the same threshold of readability. Nor the same kind of work.

H.C.: Exactly, but the situation then produces errors in evaluation: because to have an upright position, analogous to that of a theoretician, is not my intention.

M.C-G.: Are we in the process of saying that it is more difficult for a woman to be taken as a writer than as a theoretician?

H.C.: I must give several responses: it is easier for a woman to be accepted as a theoretician, that is to say, as less woman. And then, one cannot generalize your statement without caution because: as a woman, to be accepted as a writer . . . well . . . it depends a lot on the women . . .

M.C-G.: . . . it depends on the writer . . .

H.C.: Of course, it depends on what she offers to the reader. In any case it's determined by the degree to which it can be appropriated. If you give a text that can be appropriated, you are acceptable. When the text runs far ahead of the reader and ahead of the author, or when the text simply runs, and requires the reader to run, and when the reader wishes to remain sitting, then the text is less well received.

M.C-G.: It does not all come from the fact of being a female or male writer, but from the way reading is most often considered in terms of appropriation.

H.C.: Unfortunately. While the reading that makes us happy is on the contrary reading that transports, with which we go off on a voyage, not knowing where. However, in my theoretical texts I use a 'form' of writing; but from time to time I resume. This is what happens in theoretical texts: there are moments when you sit down. And it is these moments, where you can sit down, where you can take, the moments of stopping, that make these texts more visible than others, those which dash off continually without stopping.

M.C-G.: Writing that refuses an assignable position is disturbing. Writing that chooses the interval space, the between, the in-between, the *entre-deux*,[3] and that works in the place of otherness. Of relationship – or of non-relationship. We are here at a crucial point: namely the staging of otherness and alteration that constitutes, for me, one of the essential aspects of your fictional universe. An entire process through which you tear up conventions of writing; you tear up conventional literary images, ways of seeing-and-saying. You tear your reader, who finds himself or herself torn between recieved ideas/feelings that are dismembered by each word.

I asked myself about what provoked my interest as a reader. When I met you in your texts, you had been making your way for a long time, and that road was full of books already, full of points of view, of encounters which, often, were not to be found in my bookcase. I came from elsewhere. Yet when I read your work, it was not a departure, a beginning, it was a bit as if you were giving me a known-unknown, continuous-discontinuous thread. There was a sort of familiarity. You gave me a means of recognition, perhaps. And I suppose that this is what makes it *my* affair too: that endlessly restaged *otherness*; the fact that I am incessantly thwarted (in my habits) by the other. What every reader tends to repress because it is more comfortable being in an illusion of sameness. Such that I (reader) find my bearings where I have no bearings; I find my bearings where I become lost. There is a sort of irremediable, never finished cutting into pieces of I-me. This is what holds me back at first; it is what I would say about your books: they recount *I*-prey-to-the-other. *I* in a bout of otherness – as one would say a bout of fever. This is

> *I know that it's by being unknown to myself, that I live.*

the major accent – it is not a definition, nothing is ever definitive. This, fundamentally, is what makes it concern *me*, and it must concern many readers. And disturb them.

Otherness *(Altérité)*

H.C.: *Otherness*, yes. But are we not *always* prey to otherness? The fever only lets up in appearance. At the exterior floor, 'up above', at the floor of the semblance – of myself – of order. Below, next door, we are always adrift. We respond straight ahead and think sideways. Always in the process of betraying (ourself), of leaving (ourself). We 'take decisions': in a stroke, we come down on one side – we cut out a part of ourself. We are tortuous, impenetrable. We do the thing we just decided not to do. We are the place of a structural unfaithfulness. To write we must be faithful to this unfaithfulness. To write in voltes. In volts.

The word '*entredeux*': it is a word I used recently in *Déluge* to designate a true in-between – between a life which is ending and a life which is beginning. For me, an *entredeux* is: nothing. It *is*, because there is *entredeux*. But it is – I will go through metaphors – a moment in a life where you are not entirely living, where you are almost dead. Where you are not dead. Where you are not yet in the process of reliving. These are the innumerable moments that touch us with bereavements of all sorts. Either there is bereavement between me, violently, from the loss of a being who is a part of me – as if a piece of my body, of my house, were ruined, collapsed. Or, for example, the bereavement that the appearance of a grave illness in oneself must be. Everything that makes the course of life be interrupted. In this case we find ourself in a situation for which we are absolutely not prepared. Human beings are equipped for daily life, with its rites, with its closure, its commodities, its furniture. When an event arrives which evicts us from ourselves, we do not know how to 'live'. But we must. Thus we are launched into a space–time whose coordinates are all different from those we have always been accustomed to. In addition, these violent situations are always new. Always. At no moment can a previous bereavement serve as a model. It is, frightfully, all new: this is one of the most important experiences of our human

histories. At times we are thrown into strangeness. This being abroad at home is what I call an *entredeux*. Wars cause *entredeux* in the histories of countries. But the worst war is the war where the enemy is on the inside; where the enemy is the person I love the most in the world, is myself.

On the other hand, what I work on does not take place in the violent interruption – which opens up, and instead there is a sort of strange material which would be called '*entredeux*' – but always in the *passage*. In the passage *from the one to the other, de l'une à l'autre.*[4] Why do I say '*de l'une à l'autre*'? If I were to remain in the frame of the sober practice of the French language, I would say: '*de l'un à l'autre*'. This established expression has always irritated me. This is also a part of my work: to be irritated, as the skin is irritated, by the stubborn, outdated side of a number of idiomatic locutions which are not questioned and which impose their law on us. With '*de l'un à l'autre*', one expels the feminine – because neither of the two elements of the group carries the incontestable mark of the feminine. So I prefer to say: *de l'une à l'autre* (but I am playing at the same time). I think that when I write, it is because something goes from *l'une à l'autre*, there and back. But also, in play, I wrote: *de lune à l'autre*, from (the) *moon* to the other. It's a game, but a serious one. It is a way of dehierarchizing – everything. Being geocentric, because we are geocentric, we say: from the earth to. And the moon is the other. For a very long time I have felt myself to be in a poetic and fantasmatic relationship to the moon our other . . . to whom I always say – silently looking at her – excuse me for acting as if you were the other, whereas you are *lune*. Let us change points of view. If I write '*de lune à l'autre*', in this case the other would be the earth. And it is a good thing. Each one should get her or his turn. In all ways. Not only because we must play musical chairs with hierarchies; it is also because, by dint of commanding without knowing, that is of being commanded in advance by language, we deprive everyone of everything. We deprive ourselves of otherness – of the otherness of the earth.[5] We ourselves finish by no longer seeing it from another point of view, while it absolutely needs this. The earth seen from the point of view of the moon is revived: it is unknown; to be rediscovered.

> *No sooner I write . . . it is not true.*
> *And yet I write hanging on to Truth.*

This perhaps is one of my motives – I will not say one of the motifs because I prefer it to be more buried, an intention which is not voluntary but is spread throughout me – this tendency to rehabilitate what is forgotten, subordinated. Or else it is an unconscious leitmotiv: when I speak it comes forth exterior to myself and I recognize it. But basically, it is active in me, permanently, like one of the springs, like one of the sources of what I write. I write also with an incessant drive for re-establishing the truth, justice. I want to use this word: justice. We do not think with justice. The world is not just. The world-wide non-justice that we all know politically has spread all the way to our imagination. It goes so far that we are not just with the earth, with the stars, with ground, with blood, with skin. In advance, and without our even being informed, everything is already ordered-classed according to a scale which gives primacy to one element over another. And power to one thing, or to one being over another. All the time. And in an unfounded manner.

So when I write, in the writingness [*écrivance*] itself, in the material, in the course of the writing, I am already in the process of shaking all this up. So that what is at the top stops being at the top by believing itself to be at the top; not so as to make the top fall towards the bottom, but so that the bottom has the same prestige, that it be restored to us with its treasures, with its beauties. And the top also. That the top not be only opposed to the bottom. That it be on an initial, augural level where we would discover, in a new way, all that it can bring us. I am saying the top and the bottom: I could obviously change the terms infinitely.

'Tearing of conventions, of '*received*' ideas, received feelings': you are right. It is what has been received for a long time, and never called into question, and dead for a long time, that I do not accept. It is even the sound of 'received' that alerts me. As if I had a sort of ear for cliché, in all the domains: and also for the cliché of *jouissance*,[6] the cliché in the body. There must be positions of the body and of the sensations that we have lost from the beginning, as our body is itself so much a cliché. More than ideas, it is

a deluge
We would have to annul Time, undo History. Un-recount. Un-know.
Un-arrive
Un a gree
– Begin again at zero, all powerfully

feelings that are more important to me than anything in the world. My working material is what was once called the 'passions'; or, the 'humours' and what they engendered, that is to say the phenomena that appear first in our body, coming from the innumerable turbulences of the soul. In other words: what gives us suffering. Or what gives us joy. And the two touch, they are always in exchange. The most incredible is to notice to what extent we are all ignorant of ourselves. To what extent we are 'stupid', that is to say without imagination. To what extent we are sorts of corks without poetry, tossing about on oceans . . . Yet I am convinced that we all desire not to be corks tossing on an ocean; we desire to be poetic bodies, capable of having a point of view on our own destiny; on . . . humanity. On what makes humanity, its pains and its joys. Which is not the point of view of a cork. Of a cork without a bottle, of course! Which would also be great. I am sure that we are all thirsting after our virtuality of greatness. And it is without limits. It is as great as the universe. And we are deprived of it because we no longer even know how to let ourselves feel, how to allow ourselves to feel what we feel. Nor how to accompany this feeling with the song that echoes it and restores it to us.

We receive what happens to us with 'received feelings'. We do not profit from it in any way. Neither in knowing how to suffer from it, nor in knowing how to enjoy it. We do not know how to suffer, this is perhaps the worst. It is our greatest loss. And we do not know how to enjoy. Suffering and joy have the same root. Knowing how to suffer is knowing how to have joy in suffering. Knowing how to enjoy is knowing how to have such intense joy that it almost becomes suffering. Good suffering.

That is my material. Where do I find it? In me and around me. What sets me writing is that lava, that flesh, that blood, those tears: they are in all of us. I am not the one who invented them. They are worked on in all the great tragic texts; it was their flesh, it was their body. I work on unknown events (because I find myself before them): what life brings me. The arrow that hits me in the face. The car that runs over the person next to me. Fire, prison; these are things which have a very high index of intensity. But in situations that are less acute one can also find material to work on and to rediscover what one has never had.

You are right, I work (on) relations all the time. We look at the garden together: the garden is a place of relations. We could express this place in a thousand ways. Relations of colours together; of different species together; between the vegetable and the human. In relation to all the phenomena of growing, to the question of preservation. Gardening is an act that is absolutely strange, in relation to life and death. And if I only listen to myself gardening, I have a very light sense of suffering in saying to myself: why garden when I know it will die? That, for me, is the other. Between us: death. Together we look at the garden.

M.C-G.: If I understand you correctly, alone, *I* does not exist. *I* is nothing. *I* is only with the other, and it is the other who gives me *I*. Is the other thus innumerable? Are *they* also of all sorts, my others?

H.C.: The other in all his or her forms gives me *I*. It is on the occasion of the other that *I* catch sight of *me*; or that *I* catch *me* at: reacting, choosing, refusing, accepting. It is the other who makes my portrait. Always. And luckily. The other of all sorts, is also of all diverse richness. The more the other is rich, the more I am rich. The other, rich, will make all his or her richness resonate in me and will enrich me. This is what people do not know, in general, and it's too bad. They are scared of those they consider to be stronger or richer or bigger, without realizing that the richer, the bigger, the stronger person enriches us, makes us bigger, stronger.

It's the other who makes my portrait

M.C-G.: That attitude is part of the hierarchizing spirit you spoke of.

H.C.: A spirit that rages between individuals, between people, between parties. All the time. The world is mistaken. It imagines that the other takes something from us whereas the other only brings to us, all the time. The other is complex. He can be our enemy, and our friend.

M.C-G.: He is incalculable also. Which is not inevitably bad.

H.C.: Our enemy is not necessarily bad. Our enemy also teaches us something. He does not necessarily teach us hate. He makes a sort of mysterious map of all our points of vulnerability appear. He does not only teach us to defend ourselves. He teaches us to grow: because there are many possibilities to work with the enemy, when he is not death itself. When it is not the death drive or assassination.

And conversely, you said to be 'thwarted by the other': I think you must have been alluding to limitations?

M.C-G.: Or to displacements, to changes of position that awaken an ankylosis we had not suspected. Habits, mania, a routine. Because of this, the shock of the other is at once painful and salutary. At least it seems to me that we live through it at first in this way: painful because it involves a putting into question of the self-image that allows us to believe we know ourself, to believe we recognize ourself. That allows one to live with oneself. To rest . . . as long as some 'other' does not make this interior cliché vacillate.

So the other can be felt as a breaking, a point of rupture that is more or less painful according to whether one is more or less used to the self-image, whether a sort of defence has been established, an imagination that keeps us on the defensive.

H.C.: Here is difference between us, which is to say that we have been fabricated, moulded, written by millions of elements and authors ending in a different chapter. For you, if I take you literally, there is always breaking and for me, in a certain sense, not. What is it that makes a membrane, a defence, something I do not know, probably be situated in a different place for you than for me?

M.C-G.: Yet, what strikes me in your texts – perhaps the term breaking is too irredeemable – is to be propelled out of myself, of us, of the 'self'. And the question of passages: who am I? Or rather, you do not say: who am I? but: who *I?* Who *you-me?* Who the voices? The voices that sound and resound. It's one of the passages and it's the opposite of identity. And never psychology. Since it's not psychology, there is no risk of identification for the reader – in the novelistic sense. There is not *one* particular voice among all 'your' voices, not *one* that speaks to *me*. On the contrary, the oxymoric writing surprises and calls: the 'suffering-enjoying' you just spoke of. Oppositions, pairs, a practice of the in-between between words that are contrary and that call to each other.

On the one hand there is the practice of the writer who interrogates language. On the other, and together, what you called 'dehierarchizing', and which I would call, with another word that echoes this one: *disarming*. Your writing never stops disarming: disarming the head, disarming the heart, disarming the body: each one by means of the others and all disarming language. Limit situation, untenable situation that the writing tries to maintain.

Dehierarchizing, disarming

In doing this the writing works on our 'faulty condition'. *Déluge*: 'our condition is faulty, but the fault is no one's, it's in the air, in the hour, in the time zones: our letters do not arrive at the hour they leave, nor do our heartbeats'. It is also the faulty condition of our imagination, of the human, of stupidity. In this respect, I find a Pascalian side to your latest works – *Déluge, FirstDays of the Year, L'ange au secret*. This is not a familiar reference for you and you would more willingly designate Shakespeare . . . I hear a Pascalian accent in the way of putting on stage the human being torn between dwarf and giant, tragedy and comedy, between the gigantically insane and the insanely intimate. The 'faulty condition' is the derisory everyday lag, expressed in the image of 'our letters do not arrive at the hour they leave'. Our problem: time. We do not *have* time; we *are* not on time. Always in passage. The problem of time is also that of writing. You spoke of an in-between that is a moment of nothing, of bereavement, of going empty, blanking out. In *Déluge* I also read the in-between of writing: the passing that constitutes it. The condition of writing: such is its place of action. An example towards the end of *Déluge*: 'I speak the truth. I speak: the truth, I speak the word: truth, and just then the earth trembles and tilts violently against my intention, the harmattan rolls me in its enormous winds of apocalypse' (p. 217). After having written 'I speak the truth', by taking back up the first line, you immediately rectify, a nothing, a sign of punctuation (:) that separates, lags, deports.

> 'At least (said Montaigne, my most ancient and necessary third party), our faulty condition ought to make us behave with more moderation and restraint in our changes'. If we were not always busy forgetting to what extent we are faulty [fautières], we would not so commonly be a 'false third party' [faux tiers]'. I am madly in love with my third party and with each of his words equally. Because there is not a single word of him that does not shift five hundred times at once: say 'fautière', you will hear: faut tiers, faux tiers, faute hier, faut hier, faux témoin, vrai témoin, faut faux, faux faute,[7] *false yesterday true tomorrow* . . . This is why we are enchanted with this word.

A nothing that changes everything. The minuscule overturns: a colon, a comma, everything tilts. Different rhythm, different scansion: everything vacillates. It is the force of writing: the interval opened by the punctuation widens, makes us pass from the concept to the word – and this is the 'apocalypse'. You speak of justice and non-justice. Justness or accuracy also: that we do not think just right. What fascinates – and which is not psychologizing identification – is the justice-justness of the writing, the *cardiac* truth that beats in your texts. Beats time. It is breaking in this sense: no doubt beating, breath, syncopation would be better to designate the enormous minuscule passage – that makes all the difference: 'I speak the truth. I speak: the truth.'

H.C.: I did not follow you about the word *breaking*. Here is the end of language; it is a word that does not fit what I feel. Because in breaking I sense: irreparable. But there is *wounding*. The wound is what I sense. The wound is a strange thing: either I die, or a kind of work takes place, mysterious, that will reassemble the edges of the wound. A marvellous thing also: that will nonetheless leave a trace, even if it hurts us. It is here that I sense things taking place. The wound is also an alteration. Breaking, for me, remained in the domain of a less fleshy material. I see a stick being broken . . . of course, one can also break one's bones, but then the sticks of the body repair themselves, and there is no scar . . . I like the scar, the story.

Negative incomprehension
Positive incomprehension

To return to the eventual shock with the other, the violence of the other: there is one that happens daily, that is up to us to manage. We are always in a relation with *negative incomprehension*; not even an incomprehension, but very often a non-comprehension. Simply put: there is no openness. And this spreads out infinitely, in all our relations. But there is also a *positive incomprehension*. It is perhaps what we discover in love; or in friendship-love: the fact that the other is so very much other. Is so very much not-me. The fact that we can say to each other all the time: here, I am not like you. And this always takes place in the exchange, in the system of reflection where it is the other we look at – we never see ourselves; we are always blind; we see of ourselves what comes back to us through

(the difference of) the other. And this is not much. We see much more of the other. Or rather, on the one hand, we see an enormous amount of the other; and on the other hand, at a certain point we do not see. There is a point where the unknown begins. The secret other, the other secret, the other itself. The other that the other does not know. What is beautiful in the relation to the other, what moves us, what overwhelms us the most – that is love – is when we glimpse a part of what is secret to him or her, what is hidden, that the other does not see; as if there were a window by which we see a certain heart beating. And this secret that we take by surprise, we do not speak of it; we keep it. That is to say, we keep it: we do not touch it. We know, for example where the other's vulnerable heart is situated; and we do not touch it; we leave it intact. This is love.

> *I love* dialogue *(this is why I love theatre)* – *work, dance, groping,* rectification, repentirs, *misunderstandings* – *(portrait of dialogues)* – *assault and battery* – *duet*

But there is also a not seeing because we do not have the means to know any further. There are things that we do not understand because we could never reproduce them: behaviours, decisions that seem foreign to us. This also is love. It is to find one has arrived at the point where the immense foreign territory of the other will begin. We sense the immensity, the reach, the richness of it, this attracts us. This does not mean that we ever discover it. I can imagine that this infinite foreignness could be menacing; disturbing. It also can be quite the opposite: exalting, wonderful, and in the end, of the same species as God: we do not know what it is. It is the biggest; it is far off. At the end of the path of attention, of reception, which is not interrupted but which continues into what little by little becomes the opposite of comprehension. Loving not knowing. Loving: not knowing.

> *to believe: to have faith in the other beyond*
> *all proof*
> *movement of faith*
> *to believe the other even if he himself be-lies*
> *to believe (in) God even if he does not exist*
> *There is no proof of the existence of God:*
> *there is faith*
> *Faith:* my *movement. I exist God.*

You said: it is never psychology. Psychology is a bizarre invention, about which I understand nothing, a sort of verbal gadget. First of all we are sentient beings.

First of all we are sentient beings

The most impassioned, the most passionate in us is the quantity, the flood of extremely fine and subtle affects that take our body as a place for manifestation. It begins in this way, and it is only belatedly, and to go quickly, to sum up, that we give general and global names to a whole quantity of particular phenomena. In *My Pushkin*, Tsvetaeva says in passing: it begins with a burning in the chest, and *afterwards* it is called love. Now writing deploys itself *before* 'it is called'. Before . . . This is undoubtedly the cause of my problem with titles: I just finish writing a book, someone asks me what it is called . . . and there is never a title. Never. One must obey the law of the book which is to have a title. For me the book should not have a title. The book wrote itself before the title, without a title.

The dream is that someone who is my alter ego would take the magic decision to name, to give me the name.

M.C-G.: The title is a reduction — as if one could account for two hundred pages in a few words . . .

So deep inside that there had never been a name.
(No names in the stairwell, no names in the kitchen)
It was voices that were seen, seeing.

H.C.: Each (word or) sentence of a text has survived the shipwreck of two hundred pages. The process of writing is to circulate, to caress, to paint all the phenomena before they are precipitated, assembled, crystallized in a word. A practice which is not only my own. So it is not 'psychology', because it begins with this experimental annotation which, what is more, is always taken from life. That is to say always mobile. Which is dated; carries the dates of a certain moment that will not return. Or at times, what writing does well is this meticulous work that one does not have the time to do, one does not take the time to do when one is not

writing. Such that in the end we will not have lived these innumerable intimate events that constitute us because we will not have recognized them. In a book, sometimes, all of a sudden, we see the portrait of a palpitation pass, the portrait of an instant of which we ourselves have been the lead character, without being able to detain it. This is what the book gives: this (re)cognition that had escaped us.

'Oxymoric' writing: perhaps, but it's reality that is oxymoric. When I say take joy in suffering, this is not a trope or a rhetorical effect. This is exactly what waylays us, our chance as human beings. The word suffering has in general a negative connotation, as painful. But it suffices to suffer to know that there is not only pain in the suffering of the soul; that one can suffer without pain. And that for the soul there is sometimes, in suffering, a strange profit. Which is not a joyous profit, but a profit. That suffering cannot do without. Fever, which is unbearable, is a defensive phenomenon. It is a combat. It is the same thing for suffering: in suffering there is a whole manœuvre of the unconscious, of the soul, of the body, that makes us come to bear the unbearable.

Where does the manœuvre lead us? For example to not being expropriated; to not being the victim but rather the subject of the suffering. Of course there are sufferings of which we are the victim, sufferings of the body which nip our mind and from these we die. But human beings try to live through the worst sufferings. To make humanity of them. To distill them, to understand their lesson. This is what the poets did in the concentration camps. And what we do, ourselves, when the pain that strikes us in our personal life makes poets of us.

We can say the same thing of joy. Whoever has not suffered from enjoying, whoever has not suffered from joy, has not known true joy. True joy, when it attains its paroxysm, drives us crazy. Because – luckily, by the way – it goes beyond us, it is bigger than we are. We suffer from our smallness and we make superhuman efforts to be superhuman. To follow joy.

As for what you call, why not, the Pascalian, that is, dwarf giant side, yes, I would more likely say Shakespearean. If Shakespeare has crossed the centuries, it's because he did not make a rupture in the truth of our states. He always made what happens to us in reality appear: that in the most extreme tragedy, in the most

extreme pain, we can feel ridiculous and be ridiculous. This is moreover what we dread. Because we are in the multiple register all the time. The monovocal register does not exist. That is what I recount in *Déluge*: when someone is prey to an atrocious despair, he has a handkerchief problem. All of a sudden, no handkerchief; and you remember that you are not an actor in a tragedy but a human person. To be in the depths of anguish, ready to die and to say to oneself: and what's more, tomorrow I'm going to have puffy eyes, this is us. It's that we do not stop being in the process of living, even when we are in the process of dying. At the edge of the tomb, we live, we blow our nose, a mirror watches us.

Suffering is a nobility of the human being

And then, in the most cruel moments of existence, basically we will be inclined to search out the noble form: perhaps by a sort of need to aid ourselves narcissistically. That is to say, to see ourselves from a point of view that raises us up at the moment we are debased. Perhaps, also, because it *is* noble; because suffering is a nobility of the human being. So we are ill-at-ease because everyday life, which is not at all noble, irrupts onto our high stage: and we do not quite know what costume we are wearing, or with what handkerchief we blow our nose. If it is a kleenex or if we will look for a fine cloth. The dwarf giant is the same thing: these are the two extremities of our being together. We are dwarf giants, or giant dwarfs. That is to say the two at the same time, which is what is beautiful. And this is Shakespeare. The charm of theatre, what makes us be able to love the theatre or makes the theatre have a life is that it plays these two notes at the same time. On the one hand, with its language, it must attain the royal register which is the universal register. Because the vulgar register is an excluding register. As soon as something is vulgar, it excludes, in effect, the majority of humanity. When, on the contrary, something has elevation, when it is poetic, then it is democratic. This is where it is universal. On the other hand, and at the same time, the biggest is communicated to the public by a system of signs which remain modest. As if the prophet, or the queen, or the king – good or bad makes no difference – had to set out a minuscule gangway for the public to join him. As if it were

necessary that there not be any interruption between the present of the performance and the eternity in which the stage of the theatre is always situated, beyond the present. And for this to happen, we go each time through the very small, the smallest detail.

To come back to the dwarf to the giant, to the giant to the dwarf: they can change places. I do not think of a dwarf dwarf or a giant giant. When I say dwarf, I mean someone who feels small – what happens to us all the time. Inside, we probably feel we are a bit or too much of a dwarf before the ogre-world. But in the encounter with the world, we ought to be and we are, certainly, bigger than ourselves: this is the point of view of the self. Now the point of view looking on the other: surely the most moving other is the most admirable being, great by generosity, who at the same time is only a human being dwarf. Deep inside me I have an image that comes from Blake, I think, a vision of a human couple: it is at the edge, on the line that borders the earth, facing the stars. I just saw another vision in Bonn: it was the tiny little characters of Giacometti, they are 1½ cm tall, they were exposed in a very big cube of light. What moved me was not the little characters – if you had put them on a table they would have fallen on the ground like matches – it was the whole. It was the round trip. Their smallness made the immensity. The immensity made them – immense: immensely small.

M.C-G.: A question of relationship. It is the relationship to the big cube of light.

H.C.: And that is what we are. We are tiny-little-bodies-in-a-big-cube-of-light. Now it happens that the junction between this minuscule side and this infinite side produces comic effects almost all the time. Which thrills me. I think that laughter is set off when we are not

> *What we feel shame for: what we feel glory in.*
>
> *the subject was fear*
> *fear of fire*
>
> *– I mean fear of*
> *shame –*
>
> *Of suspended flight*
> *The fear of seeing oneself with bad*
> *eyes.*

afraid. When we see that the immense is not overwhelming; and also, perhaps, when the maternal in us can manifest itself: as the

imaginary possibility of taking a mountain in one's arms. That is to say, knowing that one can always give life, protection, care, even to the biggest. And that the biggest also needs that care. And that we escape or we have escaped death.

I liked very much what you said about how what overturns in my text is a comma. That is our privilege in language. To think that we have at our disposal the biggest thing in the universe, and that it is language. What one can do with language is . . . infinite. What one can do with the smallest sign! . . . This may be why so many people do not write: because it's terrifying. And conversely, it is what makes certain people write: because it's intoxicating. Language is all powerful. You can say everything, do everything, that has not yet been said, not yet been done. What is beautiful is that it is so economic. It suffices to displace a letter, a full stop, a comma, and everything changes. Out to infinity.

M.C-G.: Wound and not break: I agree absolutely. It is the word that says the shock with the other. Wound: what I am touched by in the texts you write. The dichotomizing connotations attached to certain words are left behind. At each moment we notice that we do not *live* there: because we must invent or reinvent the words. There are only positive and negative words: for example 'suffering'. As for the traces that are not quantifiable, or classable, we censure them. You speak of our fear: that we believe we must erase the traces of fear and of suffering. The loss of that memory is impoverishing and the concern of your writing is to reinscribe it. Because only the forge of language can give the truth of our feelings, the sensory knowledge of our affects. Not without this paradox: we do not write because we feel, but we feel because we write – and that much more.

> *If I told you that this book is already . . . almost –*
> *just this very instant.*
> *I only need to provide the time and the paper. That's the hardest part.*

As for love: I have always thought that the person I love is the person with whom I can be vulnerable without being taken advantage of. Love and vulnerability go hand in glove. But we agree that one must mark the difference between psychology which you refuse and the very subtle affects that summon you. In this respect I would like you to explain the function of capital letters in your narratives: Love, Deluge, Story, Weight of the Book, etc. They do not represent entities, do not consist in reducing an infinite range of

palpitations to a few global categories. One must explain how they result from a meticulous work, how they have another goal than to convoke 'grand', 'coarse' generalizing words.

Fever: a kind of defence that lets us be the subject and not the victim. In listening to you I was thinking that we suffer from tepidness and frosty over-cautiousness. This is what your texts say. I like that fever; the paroxysm that is put into play: where all sorts of ties play, including the play of *I*. Admittedly, it is the question of the handkerchief and the human theatre. But if there is fever, there is also work: you are not afraid of detail, of the minuscule labour of writing that makes a toiler of the writer. Toiling to tear 'suffering' from the clichés that literature confers on it – so as to let it be known that words are full of tricks. Which leads to a surprising tension in your books between the writing of the wound and a certain jubilation of writing, that carries one from bereavement to play, play which is joy from working. Another pregnant oxymoron: bereavement-joy. Does being the subject and no longer the victim not mean becoming the subject of *writing*? In the sense of the double genitive.

You construct in this way a singular staging where there is a confrontation between the subject-of-writing and the other, the author and the multiple I-me by which the subject, on the verge of taking hold of some mastery, finds himself in an infinity of passages, becomes innumerable and unassignable (for example you play on the *auteur-elle* [she-author] and the *Je-aile* [I-wing]). What permits you to hold to these stakes of non-mastery is in the first place, I believe, a system of *interchanges* in the text – register interchanges that reflect language by effervescence. You spoke of the dwarf, of the giant, and right away warned: one must again define the dwarf who is not dwarf, the giant not giant.

To make language *alive*, writing puts out gangways between the registers – like highway interchanges. Metaphor has a privileged role here. In all the senses of the term it is transport: ascension or elevation. And incessant displacement; by which a word is-and-is-not the word, it is also its opposite, its neighbour, its phonic double.

The interchanges of the text

The interchanges of the writing constitute a weaving that makes the texts unique; it operates an all-out putting into relation of elements: from the big to the small, from low to high and vice versa, it forms very subtle networks. *On ne part pas, on ne revient pas*, written for the theatre, presents

aspects that are knowable by everyone and can be ascribed to banality: a woman comes to see that she has never been able to leave, or to realize her desire to write; that she has submitted herself to her husband's career as an orchestra conductor. At the same time all this takes place on the opposite side from banality because it is said with an extraordinary system of resonances: the back of the conductor becomes a metaphor of the 'wall of incomprehension' in the couple:

> One is wrong when one claims
> To see the face of the conductor.
> The conductor turns his back on us.
> The secret is in this turned back.
> [. . .]
> For thirty years
> I never thought about it.
> About this back.
> But three years ago, this back – became a wall
> What I suddenly saw: a wall.
> [. . .]
> To have a wall for a lover is unbearable
> [. . .]
> All of a sudden I saw: a wall.
> It is a misfortune. An accident.

The text says right away what it is doing, emphasizes the metaphorical displacement:

> One should never see with one's eyes of flesh
> The metaphors hidden
> In human beings.

<div align="right">(pp. 17–18)</div>

We then hear the writing proceed word by word: the back, *dos*, of the conductor is *consonant* with Schumann's madness: 'with the note do in the ear, night and day / do burning in the ear',[8] while Clara's desire to depart is tuned to 'the colour of the field of wheat' and to her 'body capable of a field of wheat', an image that emblematizes at once the poetic state and the desire to write.

Such is the weaving: at the limit, in a sort of exaltation of the possibilities (of what is possible) of the text. The exigency of the writing is not a question of humanism. I think it is important to make the distinction between the 'human theatre', the 'faulty condition' as you explore them with linguistic creativity, and the 'humanist' narrative founded on the pre-established values of a

writing of representation. To avoid misunderstanding, I would like to make clear what you mean by the 'human' which constitutes your fictional writing.

Weaving, interchanges, reticular system, non-mastery of a subject of writing, all of this brings forth an exigency of the reading: it is on the order of the image of Blake you evoked. To be at the edge of the earth, facing the stars. Aster and disaster; as in these lines of *Déluge*: 'In the middle of the story of her life, exactly in the middle, and in the middle of the soul, a hole, the size of an asteroid crater. Living was an immense effort every day to stay on the thin edge of the chasm' (p. 224). The text digs 'an asteroid crater' in the reading – at least in mine. It makes it fragile. In turn, the reading becomes awaiting, aspiration, exaltation of the senses and meaning.

> *I miss* Ambi, *the word: ambi – two,* tous les deux, tous deux, les deux[9]
> *amphibology*
> *ambiguous*
> *ambivalence (a word that is not in Littré!![10])*
> *a modern word (1924)*
> *Both sides*
> *Thinking of/on both sides*

H.C.: Fear of traces, fear of memory: it is clearly a fear *in the present.* We are always afraid of seeing ourselves suffer. It is like when we have an open wound: we are terribly afraid of looking at it . . . and at the same time we are perhaps the one person capable of looking at it. What do we fear? These are metaphors, are they not: if we have had an accident, with very serious wounds, and above all with an open wound, as soon as we see an alteration of the body, we see something else: we see death, we see that we are someone else, we do not recognize ourselves, we do not recognize our own arm, our own foot, and the fear becomes incalculable. I am using realistic referents here but these are also metaphors of all fears. At their root they all have the fear of fear. These fears can be understood and they can be not understood. They are what engenders a retreat, a flight before reality insofar as they are harrowing. And sometimes, in fleeing, it is life that we lose. We believe we're saving our life, but we lose it. Because all the harrowing events are an integral part of life. And they constitute it. Julius Caesar: 'Cowards die many times before their death' – and this is true. You die a thousand deaths before your death if you are afraid. And yet, everyone is cowardly.

Cowards die many times before their death

So one might as well know that the principal enemy in life is fear.
To write only has meaning if the gesture of writing makes fear
retreat. As always, it is double: we must be afraid and not be afraid
of writing for the sake of writing, and at the same time we make
fear retreat. Regarding *Déluge* and the jubilation of writing: *Déluge*
recounts, tries to note these experiences of mourning which are so
difficult to note, and which are situated in a place into which we
are rarely thrown. The fact that there is a jubilation of writing
should not reduce the experience of mourning, or delude people.
It is not: mourning is small, writing is large. Not at all. Pain is
always, unfortunately, stronger than everything. What happens is
not the jubilation of writing; it is the strange feeling, the
outpouring of joy we can have when we discover (and not only
in writing): I ought to be dead and yet I am not dead. Or else: this
death which ought to kill me did not kill me. It is the jubilation we
feel to be still living, the excitement without pity of the narrow
escape. When I was little, I was told about the death of a cousin of
my father, which happened shortly after that of my father and in
the same way: I burst out laughing. Death went through me and I
laughed. I became frightened until I understood. The phenom-
enon of great nervous hilarity was this: I was alive! Exactly that
meritless victory which makes us giddy – and which can manifest
itself, by the way, otherwise than in bursts of laughter – when we
have been brushed by death. We ought to have the courage to tell
ourselves something which can be disturbing: there is an infinite
difference between brushing death and dying. At the mo-
ment when you cry out, when you say 'I am going to die',
five words that belong to the always saved register of writ-
ing appear. It is to avow – to avow life. Let us say that I
bear witness to it; that others bear witness to it.

> *What ties me to my elective relatives, what holds me in the lure of my spiritual guides, is not the question of style, or of metaphors, it is what they think about incessantly, the idea of fire, over which we maintain a stealthy silence, so as not to stop thinking about it. No complacency. Only the admitting of the fear of fire. And the compulsion to confront the fear. We need fire.*

The always saved register of writing

For a long time I wondered what became of this in the concentration camps, when there is really every reason, every circumstance to be without hope, does there still remain this triumphant feeling – because it is a triumph! And then, meeting Resistance fighters and discovering works, I saw: yes, there is triumph up to the last minute. Up to the last second. Our true nobility: there is a resource in us, even when we are reduced, when we are crushed, when we are despised, annihilated, treated as people are treated in the camps, a resource which makes the poetic genius that is in every human being still resist. Still be capable of resisting. That depends on us.

And this is not what one might think: it takes nothing away from the immensity of the pain. At times we also have this fantasy: this wanting to respect the pain, making it a magnificent and funerary procession. 'If I am not already in my coffin,' one says to oneself then, 'it's because my pain is not as great as I think it is.' Not at all. It's life which is greater than we think it is! In these moments, in any case, we are not the masters of writing: but the passivity comes to its limit: which is to say that we are in a state of activity. And furthermore, when we write in these circumstances, it's because we are another person, we are the other. Perhaps I am going to die: but the other remains. In this situation, it is the other who writes.

The word interchange: an entirely operational word here. I have the feeling, perhaps mistaken, that the intense use I make of metaphors is not arbitrary or capricious. For me, the origin of the metaphor is the unconscious. First of all, for a long time I have permitted myself to use the writing of dreams to conduct a certain research in writing. I assume, in saying this, that the dream does not cheat with metaphor. That it is impossible, by definition. That in the dream there is a production which is necessary because it is dictated not by a wish or a consciousness of writing but by the drama that is played out behind thought and of which I know nothing. A force that does not belong to me goes through me. A force that I am not recounts my story to me. At this point, the costume, the objects, the scenes of the unconscious are aroused by affinities that are not deceptive, and that reveal relationships between a particular object, a particular scene – according to the

work Freud described, of course. When I write, it always happens in this manner. Either I sense that I am in this stream, or I let the metaphor come, exactly as if I were dreaming. I do not take it from the exterior. It truly comes from the inside. I do not see how one can write otherwise than by letting oneself be carried away on the back of these funny horses that are metaphors.

These funny horses that are metaphors

On the other hand, I write texts that are very much in movement. *Mouvementés*. Eventful. That is what I imagine, at least. There ought then to be a metaphorical grouping, or collection that stems at once from the registers of transport, but also that always goes through the first of the means of transport which is our own body. What we are able to do as an exercise in translation with our body or as a translation of our affects in terms of the body is unlimited. I am not saying anything new. The central interchange is the body in metamorphosis. What the dream shows us in its theatre is the translation, in the open, of what we cannot see, of what is not visible but can be sensed in reality. I am fascinated by the apparitions in my dreams of characters who are the characters of the theatre that is my life during a certain period; because they always appear modified, altered, in how I think of them or what they do to me. And this teaches me many things I did not know about my own secrets. As if my soul were painted on my face. I come back to Tchikamatsu, the master of Japanese theatre, who knew that the mask is the soul rising to the face.

The (sufferings) pains are inside, hit there between the eyes. The body has become gaol, inside, narrow.

(It does not move forward, it begins again)

Pain of the legs who cannot believe they are cut off: pains in the legs.

As for this weaving you spoke of a minute ago, here too there is nothing voluntary for me; I do not take an element *a* and an element *b* to connect them. This happens in my deepest depths. The signified and the signifier work together without my being able to say which one leads, because the one calls for the other. And vice versa. How? A kind of work takes place in this space that we do not know, that precedes

writing, and that must be a sort of enormous region or territory where a memory has been collected, a memory composed of all sorts of signifying elements that have been kept or noted – or of events that time has transformed into signifiers, pearls and corals of the 'language' of the soul. Elements of language, like Schumann's *do*, that have been stored up. There must be a sort of magnetic 'force' in me that collects, without my knowing it, jewels, materials of the earth, that are propitious for a future book. It is my memory of writing that does this. I say 'my memory of writing' because it is not the memory of life, or the memory of thought. It happens with sound elements, aesthetic elements, etc. Perhaps there is also a recording surface deep in me receiving micro-signs – it must guess that these signs are not solitary and lost, but emitters; in communication with other signs. An example: I had been struck, without realizing it, by the red geranium that lights up in *The Possessed* of Dostoevsky. It was as if, quite by chance, I had picked from the ground a key that opened a magic world. In the end, the geranium was absolutely not accidental, it was overdetermined. And it was not only my own mania or my own memory, but in effect a clue that functioned in more than one unconscious. Not only my own. Many others.

What gives force to a sig-nifying network is that it is not gratuitous. What is sur-

> *Photo of a dream: Dream is capable of flashes of lightning – I would like to be able to take a photo of a dream.*

prising is the distance covered between two signifiers that ally themselves to produce a certain meaning. The conductor's back does not come to me from Schumann's *do*. It stands out when one thinks of a conductor. One does not always think about it but it is first of all this: two homophonic words that happen to signal to each other across a very large number of elements of meaning. As for the departure that would have the colour of the field of wheat: I think that all the acts of our life are accompanied by a sort of aura, of poetic song, with visual representations. The almost invisible horses of the chariot of the sun in the sun, in Turner's painting that depicts the passage of Ulysses escaping from Polyphemus: one sees the power of the flight being painted. It suffices to pay attention to see the accompaniment of a departure, of a return being painted, the colour of the sky at that moment. That is to say: the little figure in its cube of light.

> *Title:* Séparéunion
> *N.B.*
> *to write//Broken*
> *I write//broken (The rupture has happened to me)*
>
> ---
>
> *In pieces*
> *(write by violent fragments, by splinters.)*

The word human

As for the human theatre which is not a question of humanism. Yes, the word human comes up very often with me. I see no other word to speak of that direction, of that development, of that progress, of that growth, which happens or does not happen in the course of the length of our life. After all, what do we do? We live, but why do we live? I think: to become more human: more capable of reading the world, more capable of playing it in all ways. This does not mean nicer or more humanistic. I would say: more faithful to what we are made from and to what we can create. The question that I have asked myself in the face of History and which crosses all that I write is the question of the choice people make between two major attitudes. Major and opposed. One is an attitude of protection and upkeep; the other is of destruction.

I continue to be surprised by destructive and self-destructive behaviours. Even if I have understood for a long time that destructive and auto-destructive people get something out of it. But what is it that makes human beings find satisfaction in destruction? It is certain that the people who are in destruction are there *because* it is their *means* of living. In an ultimate way, all human beings choose life. Choose survival, their own survival. At times, to survive, certain people think they must kill the other; at times, to survive, certain people think they must absolutely save the other. It is the origin of all the conflicts. Most often human beings choose to kill the other. And it is a bad calculation.

The heart is the human sex

When I speak of the human, it is perhaps also my way of being always traversed by the mystery of sexual differences. By the sort of double listening that I have. I am always trying to perceive, to receive, excitations, vibrations, signs coming from sexed, marked, different places; and then, in a certain place – barely a point, a full stop or a semicolon – the difference gives way to (but it is rather that the two great currents mix, flow into each other, so as only to be) what awaits us all: the human. This is how I have come to distinguish 'the sex' and 'the heart', saying that what the sexes have in common is the heart. There is a common speech, there is a common discourse, there is a universe of emotion that is totally interchangeable and that goes through the organ of the heart. The heart, the most mysterious organ there is, indeed because it is the same for the two sexes. As if the heart were the sex common to the two sexes. The human sex.

M.C-G.: What you call 'more human' is an attempt to tear the human away from humanism, that is to say away from anthropomorphism and from anthropocentrism. It is the love of all species.

H.C.: We must absolutely not let go of the word 'human'. It is so important.

> *Fortunately I am not always this vacillating and climbing insect, or this fish that descends in spite of himself in spite of myself. These are pains reserved for the author.*
> *In this world where I was born of my mother, born of my dreams of my mother and where I am born again of my mother in her . . . I am a woman.*
>
> *I have always said*
> *In what way am I a woman?*
>
> *In this* *(wetnurse)*
>
> *And in that I am not a man. Nothing seems stranger to me than a man.*
>
> *But on the other hand nothing is as close to me as a being that writes, man or woman (because of the interior). They are* animals *[bètes]. All of them, all my brothers and sisters. The* bètes, *the animals. And we are all* bètes *(Dreams of animals)*
>
> *Saying this I cry. Because*

Better (at being) human

When I say 'more human', I mean: progressing. I ought to say: better human. This means, while being human, not depriving oneself of the rest of the universe. It is to be able to echo – a complex but magnificent labour – with what constitutes the universe. I am not saying that one ought to do it as a researcher, as a scholar. But I think that we are not without an environment, one that is human, personalized, personal; and terrestrial, urban, etc. ('political' comes afterwards for me). We are all haunted by the question of our mortality. And thus haunted by the question of what it is to be human, this thing that speaks, that thinks, that loves, that desires and that one day is extinguished. Everyone incessantly goes towards this term which is lived in diverse ways; and which brings us back to a part of the universe that in general we scorn: dust. But dust can be something else entirely: energy, sublime memory, etc. . . .

To be *better* human is also: not to be closed in one's small duration, in one's small house, in one's small car, in one's small sex, but to know one is part of a whole that is worth the trip, the displacing of all our ideas.

M.C-G.: Is this 'better human' not connected to the vulnerability of love? In one of your latest books you talk about hate; about how we stop hating when we think that the person who is the object of the hate can die. *Déluge*: 'Knowing that, one day, I will die and that he will die one day suffices for me to lose my angers and my illusions. A great human tenderness had reappeared. All of us who, sensing dying approach, throw ourselves on the nearest big chunks of meat, and hasten to eat down the wrong way' (p.223). Vulnerability, that is to say mortality, makes us more human in your eyes: to become conscious that the other, like myself, is liable to be dust is to 'disarm'. To step back, to put human relations in a less cramped perspective?

H.C.: A small commentary on that sentence of *Déluge*. There is the limit of hate. Hate has a limit? How can that be? For example, how could I stop hating Hitler? The person who is going to die exits from this time which, seen from the centuries of centuries – not to say from eternity – will have been an instant, an error, an illusion. The human being who was bad and worthy of hate, exits from the

stage where his meanness was active to go onto a stage where all that makes up historical destruction has simply disappeared. There will be a time when those who believed they were powerful people will have joined an extinguished, disappeared humanity, of which we know nothing, and they will take their place among the ordinary, the unsorted. They will be one among the unsorted goers. At death, at the moment of death, this scene is being produced.

This does not mean one should pardon war criminals. There is the unpardonable. I believe that there ought to be the unpardonable in the

> *Hate = it's the plague. One catches hate. Hate hurts the haters. One hates the person who 'gave' us the plague (sickness).*

History of peoples and of states. But in the personal and intimate order, it is good that the fight to death be extinguished. Death extinguishes death, certainly. Love subsists in memory, but hate, which is a formidable defensive movement, falls by itself . . . As for that species of vision I often have of our era, seen by someone who could be outside of time, who could travel round it and thus sees its limits: it transforms my evaluation of the world or the relationship I have with others. I always see myself as that ant, that little letter wandering through a book whose end one cannot see. And that ant, that little letter does not see the end of the book. But someone who could see the end of the book would have a different life. I imagine that someone . . .

M.C-G.: In a way, to seize the present instant, one must go the distance. Which writing attempts to do. Writing sides with life. That is what gives force to your fiction. If not, how would one be conscious of the present which is already past? Or already hypostatized: a distant block.

H.C.: To live, one must live in the present, live the present in the present. At the same time: the sensation of forming one body with all of time, all the living substance of time. Everything conspires so that we do not manage to live in the present: it is Sunday and we think of Friday. The worries which are the masters of most people prevent them from ever being in the present. Instead, they are in a menacing future, in a projection that destroys everything around them and beneath their feet; or in a rehashing of a baneful past.

M.C-G.: This relation (that you force yourself to have) with temporality allows the writing of death: the life of death. Because in our vocabulary, and our stereotypical way of hearing words, death is finished, past. On the contrary, you never stop recounting the thousand deaths lived in the present.

H.C.: Death is nothing other than that, by the way. What we are able to experience of death is only allusions to death. What we inflict on ourselves, our innumerable suicides and our way of being absolutely beside our own time; ahead of ourselves without having lived what is behind us . . . Admittedly, being able to live in the instant all the time is nearly impossible. But one can live very often in the instant; it is a practice, a necessity. Perhaps the enemy of the present is something one could call ambition.

> *What I have discovered: how the dead suffer during decomposition*
> *Suffer on the one hand . . .*
> *And keep mulling over (Cf. Hamlet)*
> *their powerlessness.*
> *They* cannot *believe it so long as they still have marrow to*
> *not-feel*
> *not-be-able-to.*

One could also call it: will to power, etc. We are like the fisherman's wife who can never live in her house . . .

I will reconstitute. A fisherman catches a very big fish who says to him: listen, if you throw me back into the water, your wishes will be granted. So the fisherman puts him back into the water. He returns to his house, he says to his wife: I threw a fish back into the water; in exchange, to thank me, he gave me this possibility. Since they are in a cabin, the wife immediately asks for a house! Behold: all of a sudden they have a house! And then, once they have their house, she goes around it and she says: all the same, I should have asked for a palace . . . and there is the palace! So then she becomes emperor of the world, until she passes logically into the void. This story had a terrorizing effect on me when I was little. I must have understood the stakes: that woman never lived in her house. What is annoying is that the story is misogynous. So we must change it! Let us say that it is not the wife of the fisherman but the fisherman himself who . . . to be able to use this fable. The secret of our eternities: one must manage to live in one's house, inside one's time . . .

M.C-G.: Inside the time of writing . . .

Returning to (our) time

H.C.: In this sense, yes, the practices of reading and of writing are an extraordinary help. Because there, in this place, we stop, we return to our time, it is here, we live in it, it lives in us.

M.C-G.: We play with it also.

H.C.: Yes, seriously. Because as soon as one is in time, one sees that it is not what goes by but what stays, what opens itself. What deepens itself. All this is not easy. By definition, we do not have a gift for the present. Because from childhood we begin to fear loss, to see nothing but loss, out of fear.

And to return to the story of love: you said that you love the person with whom you can be vulnerable, yes?

M.C-G.: Or who knows that I am vulnerable, or with whom I do not fear their knowing I am vulnerable . . .

H.C.: In the face of love we disarm ourselves, and indeed we keep the vulnerability. It does not disappear, but it is offered to the other. With the person we love, we have a relationship of absolute vulnerability. Why? First of all because we think they will do no harm to us at the same time that we think and we have the experience that they are the only person who can do all the harm in the world to us. Through death: either by dying, or by killing us, that is to say abandoning us. But also, and this is the childlike and magical side of love, we think that the person who can kill us is the person who, because he or she loves us, will not kill us. And at the same time, we (do not) believe it. In love we know we are at the greatest risk and at the least great risk, *at the same time.*

> It is the word to love that precedes us and slips from our lips . . .
> We live, we sleep, we dream and
> across // the beds | four-different-leafed love grows
> | pierces

What the person we love gives us is first of all mortality. It is the first 'thing' they give us. With the person we do not love we are much less mortal.

M.C-G.: We are always playing at being immortal. It's a must!

The person we love gives us mortality immortality

H.C.: Ah but we are immortal too! The person who gives us mortality gives us immortality. Immortality that has been given can be taken back: we feel it; but we do not enjoy the immortality that is only the absence of mortality. It is inert, apathetic, dead immortality. In a trembling and an anguish of joy, at each moment we feel, taste, etc. the immortality that is given.

M.C-G.: It is love's capacity for enchantment: because of the knowledge of the greatest risk, I also live the greatest tension. Enchantment renewed each moment that the other does not abuse my vulnerability.

H.C.: That is where you risk your life. You don't risk your life elsewhere: you risk it only there.

> It is the fault of this word to love which
>
> *It is because of its innocence, of my innocence, of my need to name so many emotions that are violently familiar but violent and always as surprising. . .*

M.C-G.: In that sense, it's true that we have the greatest bereavement when the vulnerability is abused by the other.

H.C.: It is irretrievable. Because in love – if not, there is no love – you give yourself, you trust, you entrust yourself to the other. And, contrary to what one might think, this is not at all abstract. It is true that one deposits oneself. *There is a deposit*, and one is deposited in the other person. And if the other goes off with the deposit, one truly cannot recuperate the deposit. What was given can never be taken back. Even if we do not know it at the moment we give; even if we do not imagine that what we have given cannot be taken back – while most things one gives can be taken

back. So in reality, virtually, when we love we are already half dead. We have already deposited our life in the hands that hold our death: and this is what is worth the trouble of love. This is when we feel our life, otherwise we do not feel it.

It is an extraordinary round: what you give, that is to say yourself, your life, what you deposit in the other, is returned to you immediately by the other. The other constitutes a source. You are not your own source in this case. And as a result, you receive your life, which you do not receive from yourself.

M.C-G.: We come back to the narrow escape, *l'échappée belle*. You said: writing does not reduce mourning. With the oxymoron mourning and joy, it's in the in-between that everything is played out, it's the *and* that carries us off because the two poles remain present; the one does not reduce the other. There is neither bypassing nor pardon. There is risk, chance and loss. It is the *narrow escape*, it touches at once the question of love and the question of writing which are of the same order because we take every risk there. The *narrow escape* is not without menace. This relaunches desire: desire for the other and desire for writing. Because there is preservation of the between, ambiguity.

An example: the last sentence of *Déluge*. There is the voice-character of Ascension, the shooting star, a metaphor, and to end with: '*Elle va bien tomber*'.[11] Which has a double meaning, at least: she will fall well: it will be good, right, just at the right moment. But also: she will end up falling; the fall will be inevitable. And this is inscribed at the exact point of the end of the text, what is called in poetry the '*chute*'[12] . . . or the '*pointe*'. And it also says that the end escapes us. For me, this is the notation of the *narrow escape*: at once fall thus loss, and benefit.

H.C.: I like this 'well'. The adverb. This little word. It is everything at the same time. Equivocation.

M.C-G.: Narrow-escape-writing: this is how I read you. A writing that is not mastery, but that 'lets itself go' or 'leaves itself go', *se laisse aller*, as in the nice formula regarding Clarice: '[. . .] all the expressions with *to leave* [*laisser*], this is the signature (of Clarice). She's a person who most often *leaves herself go*. And she goes' (*Déluge*, p. 216).

The verb 'to leave oneself [*se laisser*]': signature of the writer. I would like you to explain this: that the signature is not a mark of property, that it is to

leave a trace, a deposit of oneself, to deposit oneself – again we find the words that say love. But for all that, non-mastery is not passivity. She 'lets herself go. And she goes': it is another way of 'going'.

H.C.: You say things very well, so I will accompany you. Writing is not a mastery; it is nonetheless an exercise of virtuosity – because we must not incite misunderstandings – but a virtuosity that is not artificial, that is organic. There is a relationship to language which is such that all the seams, all the veins of language, all the layers, all the resonances are in activity, are in tension.

> *And always the secret work of the word (cf. Love) – the words that work in the garden of our thoughts-fantasies-desires etc. . . .*
> *And that plot on top of it all.*

In the middle of language

I do not think one can write without having benefited in childhood from a gift of language. Without finding oneself in the possession of an extremely well-developed linguistic instrument that precedes the act of writing. This must be said: there is an origin of this art, an inexplicable grace that makes one not be condemned and chained to the linear, univocal, reduced use of language; but rather, right away, one is in this milieu: one is in the middle of language. One is in this milieu and one knows how to play with it. It is a question at once of linguistic knowledge, of apprenticeship, of having an ear, etc. . . . It is as if one knew how to play language like a musical instrument, one that is composed of a large number of instruments. And without having to make an excessive effort, there already comes to one's lips, to one's fingers, a whole flow of expressions, of sentences that are full, rich, bearing plural meanings, playful . . . But without mastery. In place of mastery, an aptitude that was received and that was not lost.

What was not lost: it is also the exercise of a freedom. We no longer know what freedom means: we sense that freedom finds its limit in other people, that others prohibit us etc. – which is true. But also, we interiorize the interdictions and we

> *The word innocent is innocent – no scent nose know in sent oh sin in no cent [our bloods weddings] . . .*

deprive ourselves of our own freedoms. We are our own censors, our own correctors, our own masters. While the height of writing, the paroxysm is produced when one leaves oneself in freedom; when one does not master oneself. When one has faith in what is not knowable: in the unknown in ourselves that will manifest itself. This is something so strange that to speak about it always seems to me almost illegal. It is the secret of the *ability-to-write*. There are people who want to write and cannot. Who put on the brakes. They are dealing with themselves, there is a stranger living in them, inhibiting them, countering them.

To leave oneself in freedom

So, one must leave oneself go. One must not be afraid because when one sets oneself in writing, or sets oneself to writing, one sets off, without brakes, without harness, etc.; this phenomenon which always remains disturbing will be produced: the manifestation of a force expressing itself much more powerfully and more rapidly than ourselves. It is disturbing because it is accompanied by contradictory emotions. Emotions of jubilation, because it is like a gift. Disturbing emotions, because we are not the master of this writing which gallops well ahead of us, and we tend to be wary of it. To tell ourselves that it is completely airy, insignificant, because after all we do not know it. Or perhaps it is crazy because we do not control it. It is frightening. One must be able to: let oneself make one's way; not prohibit oneself. One must trust in: that is to say be in a sort of passivity, of faith. And also to let oneself go to exceed oneself. To exceed oneself in all ways.

> *The silk grey of the* contre temps
> *The troubled grey of time*
> *The grey the grief.*

What is not fair – because it is not fair that there are some people who write and others who do not – is this question of *originary faith* [*confiance*]. Because it was nonetheless allowed or inscribed by something or someone secret, that we do not know. What is it that makes one dare? *Who* is it? This is a mysterious scene. Where does fairness hide? There is luck, which comes from the other.

M. C-G.: It is in part cultural.

H.C.: Without a doubt, it begins there. In particular for women. If there are few women who write, it is for that reason. Someone, 'fortune', has not wished them well. And after that, it is singular, it is accidental. A question of encounters, of family, it's infinite. At times some small thing or a person is all it takes for someone to write or not to write.

> *to surpass oneself: to be more strong*
> *less strong than oneself*
>
> *more rapid*
> *more slow than oneself*

M.C-G.: These are the pages I particularly love: those that write (from) the overflowing of writing. Not pages of reflection, but those that tell the story of the overflowing of writing – and that use unorthodox formulas on the way: 'it gallops, it gallops me' you say of this writing-galloping. So there is a race, incredible force. And at the same time, the feeling of not going fast enough, strong enough. Writing does not manage to write lightning.

Another contradictory overflowing that gives something miraculous to the writing: the gallop and nonetheless the readable vigilance of the work. It gallops, and in spite of it all, somewhere you are holding the reins. You let yourself go and also go your own way.

H.C.: What does one set off writing with – when one is little, when one begins? One sets off with a certain number of aptitudes. First, with the fact that one was thrown into language and that one knows how to swim in language. Then, with athletic aptitudes. Writing is a physical effort, this is not said often enough. One runs the race with the horse that is to say with the thinking in its production. It is not an expressed, mathematical thinking, it's a trail of images. And after all, writing is only the scribe who comes after, and who has an interest in going as fast as possible. To go fast – and I am sure that one must go very fast, which does not mean to write just anything, on the contrary – we must vie in force and intelligence with a force that is stronger than ourselves.

> *The word grievance*
> *peak*
> *nutty*
> *These are the words that* (whisper) . . . *this text*

And here, the body also has a thing or two to say. It is very tiring to write. It is a high speed exercise. I do not allow myself to write if I am not 'in good shape'. If I do not have all my strength at my disposal, I would write, of course, but a bit less, a bit below. How did Kafka do it? How did he do it with the fever sapping him, the weakness . . . But perhaps fever is in the end a sort of superior intensity, a drug that lights up instead of putting out?

But I rather think that it puts out. And so my mournful question: if he had not had to suffer from such a state of the body, would he not have written even faster, higher, stronger . . .?

One needs a passivity that is, as always, active. Passivity is the secret: it is either the passivity of the numbed animal; or, on the contrary, a way of preparing oneself for a superior activity; it's a paradoxical activity.

> The position of writing
> *The initial position is a* leaving oneself go, *leaving oneself sink to the bottom of the now. This presupposes an unconscious belief in something, a force and a materiality that will come, manifest itself, an ocean, a current that is always there, that will rise and carry me. It is very physical.*
> *When I begin to write, that's what it is, it is physical. It is the same thing for Clarice Lispector.*
> *As for reading: reading feels to me like a making love, the strong element in reading is the 'leaving oneself (be) read', to be read by the text.*

M.C-G.: I note, yes, paradoxes and convergences. On the one hand, the activity of writing happens at the deepest level: but you also emphasize the meticulous work of the corrections on the page. I wonder: how does the concrete intervention occur? I imagine you with your pen going very fast, but that vision is halted as soon as I think of deletions and alterations.

On the other hand, the language that a minute punctuation mark can overturn. There is more than written writing: playing with/on/against the letter are the inflections of a voice with many modulations; the accents of the sentence that vary according to the fluctuation of the syntax and the grammatical punctuation. One sees a double use of these elements at work, simultaneously and at the limits of each one. Writers often choose: primarily one, primarily the other, they make a sort of division. Your writing on the contrary, sets up a relay, launches the one with the other, the voice with the letter, and vice versa. Before our eyes, in our ears, we have discourse in the process of becoming voice, becoming speech: what dominates is the impression of thought in movement. Text in movement.

There is, in all ways, a writing *at work*: work of the body in writing, work of memory and memoirs, work of sexual difference, work *of gender*. These are biases of your writing that one ought to investigate.

my applied thought

H.C.: I think that – even if the word 'thought' bothers me – I begin by thinking. But what does that mean? (I use the word to think, it 'thinks' for me.) I do not begin by writing. But when I begin to think, it is always applied to. It is: *my applied thought*, which I consider to be the work of reflection, of meditation, applied to something that presents itself to me as unknown and as mysterious. And when I said the material is there: it is every day. The unknown and the mysterious – as in *Déluge* – consist in the strange manifestations, scenes, affects, etc. . . . that surround a moment. An event that makes one mourn, for example, or a transport. Take

> *Thinking deeply*
> *Waiting*
> *Where does this thought come to us from: from the body*
> *It is the place that writes*
> _____
> *What is it called*
> *To follow the course: of the blood*
> *of the wind etc.*

the phenomenon of tears. It is almost the origin of science: I observe a phenomenon. Except that it's a human phenomenon. I am surprised, at first, by the phenomenon of tears. *A priori*, I have nothing to say about it, I can only observe. I make observations and, of course, what attracts my attention is what is extraordinary about the manifestation: the floods of tears; the fact that there is no apparent logic between a shedding of tears and a particular event. I remember an old friend who had just lost her husband (a man I liked very much). And she said to me, with an utterly surprised air: you know, at the corner of *boulevard Jourdan* and *rue Deutsch de la Meurthe,* all of a sudden, I started to cry. Well, that is the point: it takes place quite exactly at the corner, at the angle. She did not understand herself. She might have cried in front of a photo. No. It was there, in a precise manner, inexplicable. And it is

there that I begin to work: where there is no explanation; and where it's a question of fortune, good fortune, or bad fortune, that arises deep inside, of an intimate shock. I do not work on the insignificant: the shedding of tears is a mystery throughout all our life. We do not know why we cry, when we cry, how much we cry. Tears are not in a direct relation with the apparent cause, etc. Who cries? Who do I cry over? Who makes me cry? How does it cry, orgasm, overflow, how does it indicate a sexed source? What is the relation between these fluids and death? What is the relation to sexual difference which is a partially cultural difference? The Romans had lacrimatories. There is also a culture of the tear.

> *Why in this place? in this moment?*
> *Tears = call tears: veil over representation*
> * Loss is always the child. The child-me*
> *Tears = melting of words.*
> *Steam engine: one releases tears*
> * The relationship wet and dry / tears and words.*

In fact, we do not know: and yet it is a production of our body. It is from this point that I begin to work. I go back up the stream of tears. When I begin to write, it always starts from something unexplained, mysterious and concrete. Something that happens here. I could be indifferent to these phenomena; but in fact I think these are the only important phenomena. It begins to search in me. And this questioning could be philosophical: but for me, right away it takes the poetic path. That is to say that it goes through scenes, moments, illustrations lived by myself or by others, and like all that belongs to the current of life, it crosses very many zones of our histories. I seize these moments still trembling, moist, creased, disfigured, stammering. When I write a book, the only thing that guides me at the beginning is an alarm. Not a tear [*larme*], but an alarm. The thing that alarmed me at once with its violence and with its strangeness.

Not a larme but an alarm

Then there comes the aid of writing. It is as if I tried to make a verbal portrait of this phenomenon that is concrete, and physical and spiritual. What do I do? I listen to this phenomenon, I listen to

> *Tears*
> *It is women who weep*
> jouissance *– tears*
> *– one does not distinguish them from the number*
> *all passion*
> *associations*
> *rain, C.L.*
> *Something is sp . . . and the world that is in continuity – and that is of the*
> *nature of flowing, of spreading, of pouring, of releasing.*
>
> *It is salted milk.*
>
> *If we give ourselves over to it, this is because it is a response*
> Resistance to mourning
> *– Tears of pain*
> *One responded to loss with a flood, a libation*
> *something one gives nobody to drink*

it with my eyes, with organs I do not know, that are in me. And then the activity of writing tries to transpose what I perceive. It is here that the corrections will intervene: at times, I have the feeling I am understanding something in flashes, in dazzles; and since it goes extremely quickly, always, since the moments of revelation are moments that light up and go out, I note at full speed, telegraphically, on bits of paper, what I have just understood and which, right away, will disappear. And this will serve me as a support to move forward. But when I begin to go deeper, that is to paint the picture of the tears, it can happen that I feel I have not painted right; that I feel I do not recognize, in what was just written, the vibration, the truth, the music of the thing I have glimpsed. And I know it is a weakness; it is a *less* in language. It is that the machine did not do its job well. Did not furnish me right away with the expression, the word, the sentence or the rhythm that would have been the closest possible to that experience. And I sense it very well.

> Niobe
> *crying = it's a call – it's an act of*
> *faith.*
> *One gives oneself over, one* admits *the*
> *pain, one does not harden oneself, one*
> *does not petrify oneself to prevent the*
> *pain from coming back home . . .*

M.C-G.: Does a lot of time pass between these two moments of writing? First there is a phase of writing with feverish intensity, then an activity that requires the distance of reading. It is not easy to avoid being indulgent towards the expression of the first sketch. To keep a cool head in the fever.

H.C.: I sense right away that it's false . . . not false in the manner of a lie . . . but it's off to the side. I correct it right away.

M.C-G.: It does not ring true?

H.C.: It is off to the side. The arrow was sent and it touched a centimetre from the target. So I correct right away. But I can correct at length. Right away: what does that mean? There are rhythms that I do not control. They are sequences. Probably organic sequences. In quantity, it must correspond to a half-page or a page. But in reality these are sequences of recording the thing I am pursuing. And it is not worth continuing if I am not where I must be. If I begin to take a path which is below, I will never get there. Let us say it's the correction along the way. According to a compass: we rectify incessantly. The cuts come much later: since I adjust incessantly – I am constantly moving closer – sometimes I leave 'rough copy'. I leave traces of the adjustments that are not necessary. And I cut them when I reread.

M.C-G.: There is also the architectural work on the whole. All your books are . . . I would not say organized, but composed. Assembled with subtitles, scansions.

H.C.: But the subtitles, in reality – because they are indeed not titles [*laughs*] – are the seeds, the embryos from which something collected itself and allowed me to go ahead.

The subtitles are the seeds

M.C-G.: They are not names that you give 'afterwards'?

H.C.: No, along the way. I am on a quest and there are stages – that I see very clearly; not beforehand, as it happens, they unfold. They have strange titles because they are stages on the road of strangeness.

> *I write on all fours in the dark.*
> *I write below earthlevel.*

M.C-G.: It is this racing, 'telegraphed' writing, that obliges the discourse to come out of joint. There is the rhythm of the voice, the cardiac rhythm that in a certain sense goes off to combat organized discourse.

H.C.: Organized discourse is of no use to me. Of course, what I do is nonetheless grammatical, but everyday language is no good for this. It's even bad for it. Indeed, *because* there is this everyday language, which is useful, too often one goes no further than every day – when one must go to eternity.

> *Our dialogues are often mute.*
> *This does not prevent them from*
> *taking place.*

As for the voice: I work at something that remains mysterious to me: that is, the part of language that is music. I need the song, the musicality of language in the manner of a confirmation. A non-musical paragraph would be a sign for me that I had not adjusted well. The music and the meaning are absolutely indissociable. I have the impression that the truth sings true. Is going to sing. And it sings, what is more. But that is the mystery. Why do we love music that is without words?

The truth sings true

Because it engages a discourse that goes through the belly, through the entrails, through the chest. I do not know where music enters. And it plays its own score on our own body. And we respond with all our body because it is *true*. Everyone. There is a sort of extraordinary, sublime universality of music. A part of my work has its source in the same material. The sonorous material. To write is to note down the music of the world, the music of the body, the music of time.

M.C-G.: I have the impression that it is counting out the measure, that it is counting time. Many imperatives play: the memory of writing, its micro-signs; but also a sort of rhythm that marks the tempo.

H.C.: Which is not regular: which plays on those differences. There are sentences that need to have the density and the brevity of a pebble . . . It varies. And it's related to the signified. It is never

dissociated. There is a non-verbal message, and nonetheless it evokes. The cello is the instrument that is the closest to the quality of the human voice. Well, writing is the same thing: there are cellos, there are oboes. There are the voices. Writing writes in quartets, in octets.

> *Telephone – music – voice*
> *What makes me cry – listen*
>
> *Penetration without violence*
> *Innercy, no outside*

M.C-G.: Writing is a matter of breath, of respiration. It is also a writing in effects: it produces, it produces itself according to the effects happening in the course of realization. Not by preliminary calculations or predetermined choices of forms.

H.C.: It is the music that is not noted down musically but that is in language, that produces uprisings in us, humours, hungers, births. If I were in danger of dying, and I heard a certain music, I would not die. The great question: I would have to be able to go and find that music, when I am in danger of dying, and listen to it. That is the paradox!

M.C-G.: Is it with the same ear, that is to say with this music, that you put sexual difference and the genders to work in language?

H.C.: Because difference constitutes music, yes. Sound is a difference, is it not? It is the rubbing of notes between two drops of water, the breath between the note

> *Voice that transports: (cf. Tancredi)*
> *Straddling the voice, I take the voice. To be transported on the back of a body – without seeing the face of the carnal force.*
> to become Indian

and the silence, the sound of thought. I think that one perceives sexual difference, one receives it and one enjoys it in the same manner: like relationships between notes coming from instruments that are different but that are in harmony, of course. Music is also a sexual difference.

M.C-G.: I have in mind a variation you do on 'the stone that flies [*la pierre qui vole*]': the stone [*pierre*] becomes Pierre, the name, then, pushing the logic and the music of the differential to the limit: '*Pierre Vole*' would fly and reach his/its secret goal, every one would receive one pierre or another, what is

important is that '*Pierre*' should fly, he or she, coming from a he [*il*] or from a she [*elle*], or from an isle [*île*] or from an el' (*Déluge*, p. 196).

It is at once the inscription of gender and the smallest variation which overturns syntax, lexicon, meanings, by shifting a letter, a breath.

Copying reality

H.C.: By copying reality: living, non-repressed reality. If one could x-ray-photo-eco-graph a time, an encounter between two people of whatever sex they might be, by some extraordinary means; and if one could conserve the radiation of this encounter in a transparent sphere, and then listen to what is produced in addition to the exchange identifiable in the dialogue – this is what writing tries to do: to keep the record of these invisible events – one would hear the rumour of a great number of messages that are expressed in other ways. The glances, the tension of the body, the continuities, the discontinuities, this vast material which at times carries signs that contradict the message contained in the dialogue properly speaking. It is the art of writing or rather the art of theatre to know how to make this appear, at sentence-corners, with silences, with mute words; all that will not have been pronounced but will have been expressed with means other than speech – and that can then be taken up in the web of writing.

> *Ancient voice, voice come from else-where (very rare voices).*
> *Enemies of the voice: the false voices, borrowed voices, topical voices.*

Telephone, for example: we will never again be able to imagine love without the telephone. What did we do 'before' to make the most exquisite, the most intimate, the most delicate love, the most delicately loving? Love always needs telephones: this passage of the most naked voice, the most real and sublime voice directly to the ear of the heart, without transition, the voice never dares to be so naked as on the telephone. What I cannot say to you in the full light of presence I can say to you in the common night of the telephone.

What do I say to you on the telephone? I give you the music, I make you hear the originary song. Love loves to return, to bring back to the origin, to begin loving from the first instant, love wants to love everything, wants to love the other from the maternal womb.

> *Telephone* | *is the far near*
> *it's the outsideinside*
> *= relationship that a* | *pregnant (mother) woman has*
> *with her child*
> | *mother has with the uterine child*
> *Cannot be closer, cannot be farther.*
> *In a certain sense this is the definition of the mother–child relationship,*
> *above all mother–daughter: one cannot imagine closer to farther (more*
> *similar to more strange).*

In the person, the voice is what finds its source at the most ancient layer.

On the telephone – of love, it is the root itself that speaks.

On the telephone I hear your breath, – all your breaths that sigh between the words and around the words. Without the telephone, no breath.

On the telephone, you breathe me. Friends speak to each other on the telephone. The far in the near. The outside in the inside. The telephone is the imitation of the loving aspiration to be the one in the other. This is why we love the telephone cord so much: it is our umbilical cord. It is our windpipe.

Souls make love by the narrow interior canals, by throats, by arteries.

The voices that touch us most strongly are the voices that come still naked, voices from before the door of Paradise, from the time when we knew neither shame nor fear. The telephone undresses. Thanks to the Telephone – we call ourselves, we call each other, without violence. From very far, we launch the most restrained, the most murmured call.

Overstepping

M.C-G.: The voice launched into the absence, into the distance-difference from you to me, this is the heart's voice par excellence? Because it has disarmed and named, the passage 'from you to me', this telephoned voice, place of a possible community, can be the space of an encounter for the two sexes? The place of the seeming union, of their communion: the very place of your texts which are worked by the differential logic of sexual difference.

> *Pythia / Apollo – navel*
> *first switchboard operator*

You have sometimes said, and written: 'We are all bisexual. What have we done with our bisexuality?' To avoid flattening out the question, one must connect it to that of the 'neuter' [*neutre*]. The term is attached first of all to the beautiful novel you published in 1972. The title on the cover is a sort of provocation: *Neutre. Novel.* Where the coexistence of the terms rescues theory from theory and puts the novel in erasure. Inside, the treasure of the texts that are assembled and the weaving between them, conjugating prose-poetry-philosophy, show that 'neutral' is just the opposite of neutralization. We find ourselves in 'the country of the Phénixie' where one is constantly being born and reborn from one's ashes — with the magic of a writing that accentuates potentialities and multiple faculties. Neutral, which is neither the one nor the other, neither one nor two, is in fact always more: *a plus, one plus, one more.* In the sense in which you write, in *Déluge*: 'I was the passage, I was the air.' Neutral: what is upstream, what allows differentiation, sexual difference. To differ is to inscribe something else: it is the subject that smoulders under the embers . . . I am collecting these elements taken from different periods of your work because the *neutre* opens the possibility that the text is *in progress*: in gestation. That it can hesitate — step over. To over-step: *outre-passer*. This term is of your register, it is one of your favourite practices in writing. *L'outre* is the title of the story that opens *Prénom de Dieu*. This is how I hear the question of differentiation or of the differential in your texts.

H.C.: I do not see how I could say it better [*laughs*]. There remains only to respond by echoing this. For example, the remains of writing I perceive in the citations you yourself take from my own texts. Giving a sort of path: the word 'bisexual' does not belong to my universe of writing, I believe, but it comes from a language of the time. It was a time when there were reactions to the existence of a women's movement or of feminist demonstrations in practically all places of discourse. There was for example a special issue of the journal *Psychanalyse* on bisexuality. Women questioned themselves or women questioned others about the existence or the value of what is called bisexuality. There was also the concept of androgyny which was in circulation. So these words come up in a text that belongs to this field of theoretical density rather than to writing. If this term, which is so dated thus so obsolete, had appeared in the field of writing, I would have made fun of it I would have played it: I would have turned it in all directions, I would have shown its

connotation, its topical weight, thus its already outdated side. But nonetheless, if it came up, it is indeed that at the time – because it is really the past, for me at least – I had to deal with very violent manifestations and effects of sexual opposition, to which, by the way, all of Derrida's texts were responding, in undoing the opposition.

> Bi: two – only??
> *Why not* all *the twos [***tous** les deux]*
> *and the between/s*

As for *Neutre*, as for the question of the neuter that is to say *neuter*: neither the one nor the other, you did well to suggest that obviously I do not want to keep it in a usage that would be marked by the negative and thus the exclusion of reality – neither this nor that, then what? In a certain sense, I do not like this word. It is rich in meaning possibilities, that is why I made use of it but I could not content myself with it. In the text, which I have very largely forgotten, I remember that one of the themes I tried to treat was the difficulty of defining human 'nature'. In our uneven life of human beings, one of the first questions that comes into conflict with our destiny is: to what extent can one call human nature human? What is legitimately to be called 'human' in the fields of ethics, biology, law, etc. . . . In *Neutre*, the questioning was engendered by anomaly. Take the example of chromosomal mutations. What is a being who has an extra chromosome? Or who is not precisely adequate with respect to the genetic code? Is it still human? In this way the question is constantly moving; it's that one cannot define, finish, close human definition – no more than sexual definition. On all sides there are vanishing points, points of communication, points of more and of less. It is we, with our language, who operate the closure. I remember having heard the following sentence: a Down's syndrome patient is a vegetable, at best an animal. One can ask oneself what that means. That sentence was the expression of a doctor. It is we, with our language, who make the law. Who draw the borders and produce the exclusion. Who grant admittance. Who are the customs officers of communication: we admit or we reject. One of the roots of *Neutre* was a reflection on the destiny of the 'human' mystery – a mystery that is settled violently most of the time. Because ordinary human beings do not like mystery since you cannot put a bridle on it, and therefore, in general they exclude it, they repress it, they eliminate

it – and it's *settled*. But if on the contrary one remains open and
susceptible to all the phenomena of overflowing, beginning with
natural phenomena, one discovers the immense landscape of the
trans-, of the passage. Which does not mean that everything will be
adrift: our thinking, our choices, etc. But it means that the factor
of instability, the factor of uncertainty, or what Derrida calls the
undecidable, is indissociable from human life. This ought to oblige
us to have an attitude that is at once rigorous and tolerant and
doubly so on each side: all the more rigorous than open, all the
more demanding since it must lead to openness, leave passage; all
the more mobile and rapid as the ground will always give way,
always. A thought which leads to what is the element of writing: the
necessity of only being the citizen of an extremely inappropriable,
unmasterable country or ground.

> *It is not the movement of throwing off track* [dépistage] *– (it's a question of
> losing the reader).*
> *It is the movement 'towards the far East'*
> *cf.: Ingeborg. Grosse Landschaft bei Wien*
> *'Asiens Atem ist jenseits'*
> *The breath of Asia is | over there*
> *| beyond*

There is no jouissance *without difference*

So at that time the accent was placed on the question of sexuality
in so far as it was disputed. To say that I believe in sexual difference
is a statement that, with the decades that have past, has taken on a
sort of political value, a sort of authority that is all the more
insistent since it is denied by a huge number of people. But to
believe in sexual difference is to know that difference is the
differential. It is precisely – and this is wonderful – that there can
only be difference if there are at least two sources. And that
difference is a movement. It always passes, always comes to pass,
between the two. And when there is opposition, an awful thing but
one that exists, there is only one: which is to say nothing. So to
believe in sexual difference comes down to what we were saying
just now in a sense. But this time, it is not the exterior edge that is
in question. In the case of chromosomal anomalies we are at the

edge, at the limit of human nature; when the question comes up: how far? Sexual difference is 'the middle'. It develops, lives, breathes between two people. What is intoxicating, what can be disturbing, difficult – is that it is not the third term, it is not a block between two blocks: it is exchange itself. And since it goes from the one to the other, it is ungraspable, even if one can try to follow it. It cannot be seen. What we *see* is only appearance, not difference. The visible does not make the difference.

We make the difference, between us. Between ourselves also. It is our reading. And like all readings, it varies, between us, between me, inside of me, to me(s), according to whether it is more or less lively, sleepy, irritated, according to the place, the circumstances, whether it is evoked or repressed. And at times we experience it as a suavity in the mouth, at times as a bite. It is innumerable, obviously never reducible to a sex or gender or a familial or social role. It is a wonderful myriad of differential qualities. It passes. It surpasses us. It is our incalculable interior richness. But if we cannot know it, define it, design it, can we enjoy it, can we feel it? Yes, in love's book of hours, in those extreme moments where separation is extinguished in the tightest embrace. It is there, it is then, in the infinitesimal and infinite space of proximity (the word approximation!!!), in the instant we approximate ourself, in the embracing, it is there at the point of contact, that we feel it, that we touch it, we touch difference and it touches us, in what form? It is the ultimate, voluptuous and cruel point of temptation: if only I could pass to the other side, if only I could one time slide myself in you, and get to know that thing of yours – by which you belong to a world I cannot enter – refused to me from the beginning and for eternity, that *jouissance* of yours to which I am and I remain an enchanted and unknowing witness. But I cannot, because we were created to desire (to enter) and not to enter. And to be protected and to protect ourselves. And to safeguard the double secret of *jouissance*. Moreover, it is all well made: we cannot 'betray' ourselves, we cannot communicate ourselves mutually in translation. We cannot 'give' ourselves. If not the inexhaustible resource of a desire: I would like to know masculine *jouissance*; I will never know it; I would like to know the *jouir* of the other sex. What I know is the point of contact between two impossibilities: I will never know, you will never know. Both at the same time we know

that we will never know. In that instant I touch at what remains
your secret. I touch your secret, with my body. I touch your secret
with my secret and that is not exchanged. But smiling, we share the
bitter and sweet taste (regret and desire mixed) of that
impossibility.

> *Scenes of love = scenes of origin*
> *Love brings back to the origin. Return*
> *Rising*
> *Love: its effect or its proof is to bring back to the origin.*
> *You love the loved starting from his or her origins, from the belly.*
> *Love reestablishes the totality of existence.*
> *It is only in love that we want to know the origin, the genealogy of someone.*

In the exchange: the inexchangeable

M.C-G.: So there is always the inexchangeable in the exchange. And that
inexchangeable perpetuates the desire for exchange. Perpetuates the desire.

H.C.: In that instant where we hold together, in this point where we
would give anything to exchange ourselves and the exchange does
not happen, the inexchangeable makes its strange and invisible
presence felt. How we want to 'explain' ourselves: to say: to translate:
to show: to paint: to add the one to the other, the one in the other,
there, precisely, in that unparalleled experience, precisely that
experience where desire and impossibility have never been so acute.
So acute that a sort of paradoxical miracle is produced: right where
the exchange is impossible, an exchange happens, right where we
are unable to share, we share this non-sharing, this desire, this
impossibility. Never before has what separates us united us with such
tender ties. We stand separaunited,[13] tasting separately-together the
inexpressible taste of sexual difference, as it gives itself (without
giving itself) – to enjoy in the *jouissances* of the one and the other
sex. Sexual difference [*La d.s.*][14] is truly the goddess of desire. If she
does not give 'herself', she gives us the most of us possible. She gives
us to me by you, from you. She gives us the *jouissance* of our own

We hear without eyes, we scratch the night with our eyelashes.

body, of our own sex and our
own *jouissance plus* the other
one. *Plus* the mixture.

At the same time, yes, this inexchangeable is again at the source of desire. The fact that, for example, there is something that I, as a woman, will never know: what masculine *jouissance* is, intimate, organic, carnal masculine *jouissance* properly speaking, and what accompanies it. Because it is accompanied by a sort of interior discourse, a thought – if I can put it that way. Not a philosophical thought, but a *self-thinking* that is undoubtedly serious, that is in relation with the image one has of oneself – a self-imagination. I am speaking here of a man, but I could turn it around to the side of a woman. The way a man lives his body: I imagine it for that other powerful powerless animal self. And also how he has a history with his body; how what is at once himself and his house, his interior and his exterior, is subject to thousands of events – either simply on the order of its functions, or on the order of dysfunctions, sicknesses, accidents. This forms an immense weaving, it is an interior destiny that runs through a whole life and out of which behaviours appear, either in the present, or in the future, in terms of future projects, in relation to the story one tells oneself: concerning one's own vitality, one's own mortality. For me this is totally fascinating and remains mysterious. I see, I guess, but I do not know. There are so many little secrets and big secrets that remain forever inaccessible to me. And that I would love to know, because of a sublime superior necessity: as a painter of intimacies, if I could know, I would be extraordinarily happy. But there is also the curiosity of love: if I could be in a man's body, I would be able to love *better* because I would also be better able to locate the needs, the worries, the threats and the joys. If I loved a man. And in the same way there is what is inaccessible in every woman, to every man.

> *The always singular body of the other: every time a history, a memory, sensations, scars, ways of perceiving – in sum of reading the book of the world with one's body.*

I ought to sing of curiosity, this first state of desire: this drive to know what you feel on your side, when you *jouis*, this craving to know how what is good for you is good, without which there is neither desire, nor love, nor *jouissance*. Because the secret of *jouissance* is that even while being not-exactly communicable, it is nourished by the unknowable-*jouissance*-of-the-other. That is the mystery: this *jouissance* which escapes me (mine, yours, escaping

me differently, mine escapes my attempt to transmit, but not my flesh), I want to give it to you, I want you to give it to me, it is indeed the only one, it is indeed the only pleasure that is structurally indissociable from this dream of sharing. Double and divided joy. (We do not feel the same painful need to share other experiences of the senses it seems to me, at least not in the same mode of decisive necessity. This is what gives the act of love its venerable character as it is absolutely without equivalent.)

This urgency, this need to decipher what cannot be said, what is expressed otherwise than in verbal speech which nonetheless arouses the desire for words, this is our human drama. We are always in fine messes.

An urgency that arouses the desire for words

M.C-G.: Is this not what fiction writing as you practise it, and even the choice of the fictional space, is looking to do: to give speech to what does not speak? To what is mute, *infans*-infancy in our speech and works it with non-speech? To what has no constructed discourse? Considered in this way, the enterprise of writing attempts to have a role as enlightener: what can poetry do, what can dreams do that theory cannot?

H.C.: I also write in order to go further, further than what I say, and this is not impossible. I can go further than myself because there is further-than-myself in myself – as there is in all beings. This further-than-myself in myself can only be a mixture of others and myself. Traces of others, the voices of my others – but who? We are full of voices, like all islands. So if I manage to give passage to this further-than-myself in myself, I will end up myself knowing a bit more about it. My mother has always told me about my Talmudist great-grand-fathers: I have imaginary images of these old men who spent their nocturnal life studying the Talmud. I see them – there are photographs – I see these old men with their skullcaps, an enormous book before them that they have studied all their life because one can neither learn it nor know it, one can only read it, study it and interpret it. The Talmud is as infinite in its commentaries as our experience of sexual difference [*la d.s.*] and its translations . . . I must be a Talmudist of 'reality'! I have the

impression that I am before an infinite, but unusual book: in the Talmud the words are written; in my book the words are not there. It is by dint of contemplating and listening that I see words appear. That's it. That is how writing begins for me.

> *But in another story Milena truly loved and loved to be loved . . .*

M.C-G.: By listening?

H.C.: By listening to a big book that is covered with not-yet-visible signs. And it is in listening that I come finally to see.

M.C-G.: As if it were necessary to make a clean sweep of ready-made discourse, answers-to-anything, so as to be ready to hear something else. To do something else, to invent. It is no longer even a question of demolishing already-existent discourse: it's another approach. Another language.

H.C.: It is language, once more, that speaks first. For me, everything is first of all experience. Then there is an experience that comes from elsewhere: the one I see inscribed in certain texts. The books that I love are not masterful narratives but journals of experiences. They are books that have recorded, and indeed left intact, *the emergence* of an experience that has been located or noticed for the first time. This writing, yes: it comes, it meets, it reinforces what I write. Or else it enters into a dialogue. Because what I am sensitive to is either the analogous or the different: in any case the different in the analogous. For example, I have worked a long time, and I am far from having finished, with a book of Stendhal I find enchanting, the *Vie de Henry Brulard,* and the *Souvenirs d'égoisme*. And I find myself always coming back to the same reason and to the same place of writing with all writers, that is, to the most intimate: to the preparations. As soon as there is a part that is journal and a part that is novel in a work, I am on the side of the journal. That is my place. I am a reader of Kafka's journals and correspondence, much less of his novels.

> *What I love (reading-writing):*
> Notebooks. *The earth before the book.*
> *The* Notebooks *of Kafka, of Dostoevsky, of T.B., of C.L., the breaths, the cries, the pebbles.*
> *When I read, I look for* the notebooks of the book.
> *There is notebook in J.D.*

So, to speak of Stendhal and of these two sublime texts, which are both the same and not at all the same: here is an example of difference inside an apparently identical space – Stendhal did something that I find almost unique. In an enterprise that presents itself as autobiographical (I say this to go quickly, but it is not true), he gave himself an incredible liberty. To give oneself this liberty, that is, to proceed by association, adrift, to write 'whatever comes into his head' – to let oneself go without being inside a *re*constructed structure like the interior monologue which was refabricated on this model as a genre (while it is not a genre in Stendhal) – one must have a purity of the heart, one must have extraordinary courage: to be without modesty and without immodesty, beyond superego, without calculating what is proper and what is not. He went further than Rousseau in my opinion, and with more lightness, in the direction of free adventure (this could be megalomaniacal, which he guards against in a very charming manner). Rousseau writes; Stendhal notes. I adore the way he notes, the way he takes down what engenders, what causes, what will be a book.

> 'New York has not changed' – a thought that comes because I was expecting New York to have (changed) disappeared. New York is still there. The thought of the disappearance of New York: New York so provisional. Near the end. Eschatological. The crowds treat the city as if it were dying. Frenetic in dying. No longer even worth tidying, cleaning, restoring – since it will be the end. As if everyone knew (thought). After us the deluge.

Here is how the beginning of the *Vie de Henry Brulard* began: Stendhal tells how on a certain day, at a certain hour, he is in the Italian countryside, and he lets a double plural time unfold, a passing present past: on the one hand, the contemplation of a marvellous landscape arouses numerous affects; on the other, and from hill to hill, one thing leading to another, from present to past, from past to present, he comes to think about *The Transfiguration* of Raphael. He is overcome as he says: and to think that this painting was closed up for 250 years, and that now it is exposed in a way that makes it visible. What is magnificent is also that without his saying it, without our perceiving it, what he sees – this is where the secret work of writing is done – is a motivating metaphor of what is going to happen. Thus: *The Transfiguration* comes to his mind, it had been buried for 250 years, and now here

it is visible; and the whole book he is going to write will be exactly that: it was buried for 250,000 years, and there will be transfiguration of all this material. Now he does not pick this out. Which then gives a depth to what he will write that he himself has not calculated. Or rather, no: if he did not calculate it, he is wily: he sees the metaphor pass by and he jumps on it.

An unforeseen discovery

M.C-G.: This means that writing . . . writes. Reflects and reflects itself outside of us? By means of signifiers?

H.C.: It materializes before we write. It *materializes*: obviously, there must be the substance. And Stendhal does not exploit. On the other hand, he hears: 250 years, two hundred and fifty, two hundred and fifty, fifty . . . That says something to me . . . Good God, I'm going to be fifty years old. All of a sudden and precisely by means of a signifier, there comes to him from this exterior that is interior, this interior that has gone out and that returns to be interior, there comes a signifier to him that he had never thought of. It is as if it were his own name, his proper name: it is his proper age. Who teaches him that he is about to be fifty years old? The Italian landscape. The book of the Landscape, which he is in the process of writing, and which reflects back to him, by differential refraction, his own interior portrait.

M.C-G.: The echo of the landscape, the echo in the landscape: that is to say he himself sprouting from the landscape. The subject sprouts everywhere: it is the echo of the landscape in him, which turns his own vision around.

H.C.: The echo in himself verbalizes a certain vision . . . And he says: this unforeseen discovery. To say that it is an unforeseen discovery is the genius. Which is to say that this is what's intact, what has not been corrected, what happens. Because in general we do not allow ourselves to tell ourselves that truth. It happens to many people to realize, on a certain day, at a certain hour, that their fiftieth birthday is coming up on them. We are fashioned in such an atrophying manner, formed for clichés, that even if

something unheard-of, absurd, happens to us, we reject it as soon as it happens, to replace it with ready-made thought and perception. If by chance this miracle occurs – discovering one day that our fiftieth birthday is arriving: not the fact of being fifty but that this should be an unforeseen discovery – we annul it. And the Talmud remains blank.

> *And yet to her surprise* New York was still there.
> *The same powerful, magic, malefic city, the feast during the plague, the dance at the edge of the crack, in the street the Black Chorus Good Night Beautiful – Good morning. The newspaper salesman, alone, in the middle of the network of toll lanes, as if on a rock, alone, abandoned, so resigned that he is not even resigned, dirty, limp, holding his bundle of newspapers – on his chest, cap, no one buys, he awaits chance, gain –?? unthinkable. The man attached to the newspapers, with a detached air, does not look at the cars passing without looking, a scene that wrings tears, the man at the extremity, (– like in India: one sells 'nothing', to sell is a pure, immense, absolute act, one sells a pencil, a newspaper, per half-day, to sell is an act of faith, an act without triumph, without glamour, an act on this side of all humility) – he sells – and does not beg – the man still in the enormous flood of exchanges, – o, human immensity and tenacity, passive tenacity, adherence to destiny without hope, without despair. The man is turned towards the cars, the cars encircle him, drive, without stopping. The man is still there.*

But on the condition that we liberate ourselves from our own interior despots, we are the most poetic beings, the newest, the most virgin in the world. Millions of things happen to us every day: it is we who do not receive them.

M.C-G.: Because we do not have the language necessary to know them. Or rather: you say it, we do not let ourselves be worked in our bodies by language. Stendhal reminds us: it is always on our own skin that we write. And we do not take the risk of shedding our skin, of being skinned alive. In French we say: I *have* a certain age. We employ the verb of possession to slip into a ready-made situation of mastery.

H.C.: But this is not because we do not have the language. We have it. If we accept it.

M.C-G.: It is already fixed in idioms; it speaks without us. It remade us even before we attempted to do or say by ourselves.

H.C.: It's that right away we rush towards clichés. It is not because we do not have the language, but because we do not have the body. The language is there, one can do what one wants with it. But it is our bodies: right away we are well ordered, already dressed.

> *In Washington Square the people of squirrels: doesn't stop living – nibbling, going up, going down, busy, very busy squirrels – eating, principal activity, life is to nibble, dodge, danger, go back to the chestnut tree, the acorn, with two hands gnaw quickly, the squirrels in rapid feeding, fast food, it is serious. At the centre the squirrels. Around, the towers of the university.*

M.C-G.: We use a ready-to-wear language.

Can we come back to the question of the novel? You say: between the journal of experience and the novel, you are on the side of the journal, of the unfinished, of the preparations. This leads to many things. On the one hand, the question of sexual difference puts grammatical gender, but also literary genre, to work in your texts. You do not let yourself be defined inside a literary genre – on the contrary, canonical literature likes distinctions, not to mix genres, to maintain forms. This is a specificity of the fiction you write. If I try to understand how it works, I see first and I hear the language. You make a breach in the unimaginative daily idiom; but there is the *manner of doing it*, which is never just anything or just any way. Example: you reverse the grammatical gender of an ant (*un fourmi* instead of *une fourmi*), an eagle (*une aigle* instead of *un aigle*), the dream (*la rêve* instead of *le rêve*), but never of a writer (never *une écrivaine* instead of *un écrivain*), an author (never *une auteure* instead of *un auteur*), a professor (never *une professeure* instead of *un professeur*) . . . all of which I hear in Canada. These are two different territories: to say *une écrivaine* is to attack the institution, professional titles. This is not the project of poetics, of imagination.

upper case, lower case

On the other hand, as for the drives and rhythms that are the source of writing, perhaps I should be more specific. For some people, the drive is viscerality, or automatism, or mimicry. These vectors also operate in your work, but if I look for how the rhythms work, I find first of all, the 'ringing true' and a writing in '*repentirs*':[15] not in the manuscript but in the printed text – we see that it is still moving, that there is evolution. The text corrects itself, turns back on itself,

advances in recycling itself. Reusing words that have become banal and that your scriptural activity puts in erasure. One way of writing-rewriting is the use of upper-case letters. The upper-case letter usually marks the irruption of allegory in the literary text. And there is a way of writing with upper-case letters in your texts that makes everything be a character, not only the human: each object, each gender, each thing can be a character. And conversely: the characters can become banal. In *Déluge*, Ascension is not only a woman's first name, but the ascension, which rimes with attention. David appears as a david and a *da vide*.[16] Etc. In short, the use of the upper case consists above all in expressing forces in the text: it is a kind of vectoring, lines of variable intensity: where *current* passes; bifurcates; interrupts itself.

In such a way that putting an upper- or lower-case letter on a word gives it a different resistance. It gives a variable *resistance* to the text and allows the modulation of different intensities. It is in so far as a body *resists* that the intensity is greater or smaller. Considering this aspect of vectorialization, I see that this organizes long circuits and short circuits in the book. At the beginning we are in waiting, practising a kind of reading in the dark – you require that the reading follow behind the text at the beginning – then, at a certain moment, we grab on, we lose nothing for having waited: it begins to germinate, to scintillate. A great overdetermination is at work. David, in *Déluge*, is the main thread, if only because he is the telephone line in the course of the book; and all of a sudden there is a crystallization, *David* leads to a whole network of meanings: D as in Desire, D as in Deluge, he is also the star, and thus marginalization, the giant dwarf, David and Goliath. Then, there is a whole series of language feats, a linguistic epiphany: '*le coup de* D',[17] that is, poetry; a stroke of 'D dur',[18] that is, musicality; the 'D-minishing', that is, inflection . . . In short, what I call vectoring, for lack of a better word, drawing lines of force. This offers still other elements to be read where the novel is at once short-circuited, parasited, exploded. This novel, as you say, is a body where two bloods [*sangs*] circulate, in opposite directions [*sens*]: 'One body and two bloods that drive in opposite directions' (*Déluge*, p. 37). The linearity of the novel is constantly in contradiction and in explosion.

Le fourmi. Fourre m'y

H.C.: What you just said was quite beautiful.

I think it is necessary to separate the domains of practice. The use, particularly in Canada, of the words '*une écrivaine, une*

auteure' etc., is a militant practice. One can think what one wants, but this belongs to a certain field that is overdetermined, dated. And also to a certain culture, because this is a phenomenon of Quebec. It is to substitute one institution for another, a fixation or a grammaticalization. After all, one would very quickly come up against aporias: I do not know if people have fought for *une facteure [a postwoman]*.

All of this has nothing to do with literary practice. You take *un fourmi*, *une aigle*: a grammatically male ant is perhaps more remarkable than a grammatically female eagle because in French there can be such eagles. *Un fourmi* is less common. When *un fourmi* appears in my texts, it surprises me and it is surprising, this is inevitable. *Un fourmi* attracts attention; it puts into question: *la fourmi, le fourmi*, ourselves – everything. As soon as something of this type moves, everything vacillates. With *un fourmi*, one can make the world tremble, if you think about it. With, in addition, all that can be deployed as signifying associations: this is what Derrida does; he has gone very far straddling *un fourmi*. [Cf. Appendices, excerpt 1.]

> *Still this problem of the law and the language.*
> *Feminist question:*
> *Imagine a 'corrected' language. I am against it.*
>
> *The grammatical effects are precious. Indeed, they allow us to play. We would not play any more; We would not shift things around any more.*
> *The fact that language resists me, hampers me, is a good thing. There is a profit.*
> *And what to do with the word philosopher? How to 'correct' it?*
> *I could no longer play at the moone and the other [*la lune et l'autre*].*

This is not arbitrary; it is *the* confusion, it is *our* own confusion with respect to sexual difference and to what it can produce in the grammatical genders, that is inscribed in this way. *Fourre m'y*.[19] When *un fourmi* or another insectuous signifier appears, it is never alone in my texts: it leads to a whole scene; and in this scene, there are destinal stakes. It concerns the destiny of a woman, of love – of insectitude.

As for the question of drives, of rhythms and of usage that could be posed in terms of viscerality: it is true that I had not thought in these terms, but it is good that you should be careful. Drives, by all means, are a mysterious thing. It is a physical phenomenon, one

could compare it to the contraction that is more familiar to us, that is to say the heartbeat, the diastole and the systole. Drives are a bit like that: the body-soul contracts itself and relaxes itself. It is the body in action in writing. This is why I have never understood people who pretend that writing is not absolutely indissociable from a living and complete body.

One writes with one's ears

When I refer to music, it's because music lets us hear directly that language is produced in an interplay with the body. One writes with one's ears. It is absolutely essential. The ear does not hear a single detached note: it hears musical compositions, rhythms, scansions. Writing is a music that goes by, that trails off in part because what remains is not notes of music, it is words. But what remains of music in writing, and which exists also in music properly speaking, is indeed the rhythm, it is indeed that scansion which *also* does its work on the body of the reader. The texts that touch me the most strongly, to the point of making me shiver or laugh, are those that have not repressed their musical structure; I am not talking here simply of phonic signification, nor of alliterations, but indeed of the architecture, of the contraction and the relaxation, the variations of breath; or else of what overwhelms me with emotion in the text of Beethoven, that is to say the stops, the very forceful stops in the course of a symphony. Suddenly, my own breath is bridled sharply by the reins. We are suspended up there, above ourselves in the soundless air. And. We restart, in a leap, a path or a heart higher up. Who writes like that – like emotion itself, like the thought (of the) body, the thinking body? I have a passion for stops. But for there to be a stop, there must be a current, a coursing of the text. Always the mystery of difference, of *différance*. Never the one without the other.

As for the work of correction: my texts recycle themselves, but I don't think they repent.

> |*little girl*
> *I write like* |*the child learning to walk: she rushes, faster than herself, as if the secret of walking were ahead of her.*

Writing recycles on hearing (itself)

I do this work of 'correction [*se repentir*]' in my rough drafts; the
work of 'recycling [*se reprendre*]' remains in what is given to be
read.[20] What is called '*repentir*' in painting or drawing is often
correction, adjustment. As if the painter were mumbling: it's not
quite that, still not quite that. It is work by approximation: in the
end one keeps 'the-closest-possible'. And that is what I do. But I
think that what remains in my texts – perhaps there is some of this
'repenting' – what remains is the 'recycling'. The implicit
discourse is not: 'it's not quite that', but rather: 'that's it, but that
proposition, that sentence, also says *more than that*'. And it's the
'more than that' which at times I want to make heard all the same.
Let us speak now of this 'making heard': it recycles or I recycle,
writing recycles when it hears itself: when the author has just
written a sentence and I hear the prolongations. Prolongations of
meaning. I hear it continue vibrating. For me, everything is in the
vibration; and I say to myself: will our ears hear the vibrations? That
is to say: will the economy of the text, its woven construction, allow

J.D. (= Jacques Derrida*)*
*Notsosimplicity [*passisimplicité*]. Spiral thought, one more turn – in (the)*
place of the other.
 For *the other (semantics of the for [*pour*]. . .)*

How little French he is. Is ancient. That is to say first Archimedes.
(way of drawing on the sand of the text)
Innumerable thought like sand is lost. But it had time to crystallize . . . an
attitude of thought.

Integrity: no fluctuation, no opportunism. He has his own laws (faithfulness,
*exactitude . . .) He is very [*très*].*

He who does not lie: all his effort to adjust the fire, and the target is his own
heart (but his own heart is the human heart)
thought that goes off not perusing but pursuing, pressing, pursuing
*[*serrant*], more closely.*
*– Willbeing [*Serant*] – (And if a present-future participle existed)*

His cataracts*:*
Biblical: locks that are supposed to contain
the celestial waters.
Cataract: opacity of the crystalline lens, or of its membrane, etc.
Ambroise Paré: cataract or sliding door:
 closure –, sliding door that closes.

the vibrations to be heard? For us to hear the vibrations, there must be silence. Poetry works with silence: it writes a verse, followed by a silence, a stanza, surrounded by silence. In other words, there is time to hear all the vibrations. As for prose, one of the differences with respect to poetry is precisely that there are no silences. Most of the time, pages leave only a little room for silences, ruptures, spaces. Ideally, I would prefer to write my texts as I hear them: that is, as poetry. I would write them in a column: then there would be white space which would allow the vibrations

> *Why did Vinci not finish his paintings? Because he had first seen and painted them in the seven minutes of a dream. The time to copy them after . . . No!*

of the sentences to be heard in reading. If I don't do this, it is because the volume of the book would be multiplied by four; the poem would be too long.

Since I am in this *medium* called prose, and since I write in resonance – and I want people to hear the vibrations – on occasion I will reinscribe them. I will follow a statement with its vibration: a vibration that is obviously not purely phonic, that is on the order of meaning. Let me give an example: I would write a verse, it would be: '*tu viens de partir*'.[21] Either this verse is pronounced in a recognized space, or it is legitimized as poetry. And then it is the richest verse in the world: I hear tonic accents, caesura. I hear nostalgia; I hear the semantic subtlety of the you-come-from-leaving; I hear the subject go off, and come. From leaving. If I want to make all the vibrations of this statement heard, I will do a retake. I will write: *tu viens de partir, tu me viens de partir* [you come *to me* from leaving], etc. Theme and variations.

The musical and silent environment

Another example. I write the sentence: '*L'heure vient d'écrire*'.[22] If it's a sentence followed by a space – suppose it is 'the last sentence' (like the '*Elle va bien tomber*') – the space, the sonorous free space will allow it to vibrate, and the reader will hear. If on the contrary it is in the interior, if it is interned, in my opinion it will not be heard, or very little. Now if it resonates, I would hear: it is the hour to write. And I would hear: The Hour with an upper-case

letter, but I do not need the upper case here: the hour – the subject – just wrote. And: writing is the origin of the hour. So this is part of my work. It is situated in the musical and silent environment of the text that produces effects in my writing. It is because I hear writing write.

> *This is how I write: as if the secret that is in me were before me.*

Let us speak of upper-case letters. In your description, I recognize something of the physics of writing. First, it is the mark of the subject. But I do not want it to be a proper name, clearly. The mark of activity. You speak of forces: that is indeed what is in question. The forces are variable. The causes of the forces, to speak in physical terms, are variable: a word like 'hour' can have no force, and then, in a situation, can take on a monumental force; and attain the allegorical power it had with the Greeks. In Greek times, a number of altogether ordinary words were invested with what they carried in reality: that is to say with secret forces. And could even acquire the status of a deity. It was thus with Hours. The Term, Fortune, the Oath, the Law, the Truth, all things that have fallen into abstraction for us, were lived as such psychic or destinal powers that they were attributed the crown of the capital letter. It is a principle. A force, it is a sort of mysterious and faceless Person, but just as concrete as 'His Force Achilles', as Homer says.

Upper-case letters do not come to reinforce the domain of the proper, they translate the existence of a population of accentuated individuals in us. From David to a david, the subject loses its privilege, its royalty, its capital status, letting it be seen that it's only the non-singular example of a species. According to the point of view of the enunciation. But this is not a procedure; only the recording of an alteration. Thus a reading. There must be reading, one must be in a state of 'readingness [*lisance*]', wide awake if one wants to be witness to human life.

About the short-circuited novel: the novelistic dimension is displaced for me. There is nonetheless narrative. But the adventure is not situated on the exterior, it does not manifest itself with linked scenes, it is not in the chain. It is in the between-scenes where what are the essential things for us, tormented humans, always take place. In a scene, nothing happens: events happen. We are particles without depth in the scene of the present.

The deep effects arise in the aftermath. The roots grow afterward, first the shock, then the nerves. The richness of a story is in the interstices. In great theatre, the most moving scenes are always the afters or the befores. Before the crime, before the betrayal, after the separation. The theatre is before and after the novel. In the night before combat.

> *The fire spreads throughout the text.*
> *The text flames. The fire lives. The text*
> *laughs with all its teeth of fire.*

The between-scenes of the novel

M.C-G.: Classical theatre lives on the vibratory dimension. The rest, the events, does not take place on the stage.

H.C.: I write where it vibrates. Where things start to signify. To self-ignify. Very far beyond the simple moment of vibration. There is sending, dispatching, there is jostling together and reverberating; it echoes through our memory, through our body, through foreign memories with which we communicate through subconsciouses. What is of interest to all human beings is what we call the affects, what we are preoccupied with: the *pre-* of the occupation, or the *post-* of the occupation.

M.C-G.: The 'repenting' is before, it is the moment of corrections, of preliminaries. The 'recycling' is the inscription of displacements, of movements. It's a question of textual economy. The recycling marks the textual differential, not a sound but rather the resonance, not meaning but rather the re-born-meaning [*renaît-sens*], the resurgence. Reinscribing is writing reduced to its minimal gesture.

Of course, you can feel cramped in the novelistic genre, in the ready-to-read-write of the literary genre, while you are looking to *make* place – invent place – for a writing that has every latitude to construct an economy as it goes.

As for the space, or the silence which allows vibration: the lack of white space is the weakness of the novel. You have metres, in the poetical sense: the indented paragraphs put space in the text, the writing makes columns, makes its way, makes the passage. This is clear in *On ne part pas, on ne revient pas*, where the device is even more surprising because we are in a situa-

tion of theatrical dialogue or monologue: and suddenly we find ourselves in *poetic justification*. I use the term 'justification' on purpose; it means not only typographical assignation: it is also the justification of the characters in that situation; of what they say, of their discourse on the stage.

As for prose, it can play with the two systems, you do not deprive yourself of this. If there is a between-scenes of the novel, it is because there is at once the filling effect that permits the continuum of prose, and the resonance chamber made of the silences, the spaces of poetic writing. This is very sensitive. Sensitizes the reader.

> *You receive nothing if you do not receive 2 times. Between the two times, there is death. There has to be this.*
> *(You give nothing if you do not give 2 times)*

Another element makes you be cramped in a pre-established genre, founded on the illusion of representation: 'the novel forgets its rubble' (*L'ange au secret*, p. 226). While you want to write before everything is put in order, arranged, labelled: 'I want the lavas, I want the boiling era before the work of art' (p. 225). This is again recycling: approximation and unfinishing. In your texts there is not only writing in resonance, but also a kind of powerful gesture of a torn-away-writing. Which is a trial. *Déluge*: 'I write my sombre texts that I tear from the interior rocks' (p. 216). In this way a writing-gift takes form: not a gift . . . due, but a gift-debt, tied to the incompleteness of the infinite recycling. It is for this reason that a certain novelistic genre is not suitable. Of course, there are innumerable forms that are much more supple. Diderot with *Jacques le fataliste*, Sterne with *Tristram Shandy* are hardly novel-forms. There must incessantly be the overflowing, the flood of writing that is in effect a flood of being. To the point of indecency with respect to the normative forms.

> *To go I take the magic stairs, the ones I descend.*
> *I invented that nearly fifty years ago.*
> *Rapid method. Always surprised to see that I was the only one to use those stairs.*
> *Slope*

H.C.: I prefer Stendhal's non-novels to his novels, which I adore. The novel that I love is incidentally the one that has kept a portion of non-novel.

One can imagine novels that struggle against classical form, or else, that tear themselves away. Or that make fun of the novel or that take the novel by the hair, or that bend over the gestation, at

the cradle, that question the essence or the nature or the origin of this strange object: is it a plant, is it an infant, is it alive? They are magnificent, these moments when the novel is still young, and when perhaps it threatens to grow old. And because we are still in the youth of the novel, we can inflict all sorts of torments on it, or else play with it. It is not yet tamed, not yet broken. For *Jacques le fataliste* or for *Tristram Shandy*, what will be put into play is the deferred. It's not even the aftermath, it's deferred: the before-math of the novel.

The cellars, the attics, the cupboards of the heart

Clarice Lispector wrote novels: they are shattered novels. Because I feel closest to her, in thinking-writing, it is with her that I can gauge my differences. There are the texts that I prefer, the ones where the subject of enunciation is I, even if we do not know who. There are also extraordinary texts with characters that are so interior, that have so little surface, appearance, sociality, that they verge on the eternal. What is it? It is 'a woman', 'a man'; or else women. It can change places. All these characters are made of the same dough – it is the dough of Clarice. There are 'events'. There is 'narrative'. Chapters begin with 'one day'. But all of this is extremely tenuous. And the circumstantial events plunge the reader into the cellars, the attics and the cupboards of the heart. But in order to set out the web, to unravel the space in which she will catch the vibrations of the secrets hidden in human relations, she proposes novelistic situations to her characters – apparently. They are often imperceptible situations. The 'novel' will be reduced to: a woman (in *The Besieged City*) gets married. We never see the marriage, but it is announced and then she is married. And straight away we are inside the mystery, the privacy, of what happens in the depths of what we superficially call 'marriage'. Three chapters later, she is a widow, in three lines. What will be worked on then is coming-to-know the intimate effects of what I gather under the word 'widowhood'. No sooner is the word employed than it takes on an extraordinary dimension; it begins to shine. Saying this, I think to myself: this is perhaps what I do. I have the feeling, perhaps it's

false, that there are more novelistic remains – remains that are a device in effect – in Clarice's work than in mine. Perhaps I have this feeling because Clarice's characters have names while my characters go about bare-being? I do not know how to give names.

M.C-G.: [*Laughs.*] Your characters have very strange names. I always thought it was done on purpose, precisely so that they would not seem too much like characters; so that we would not believe in them completely.

H.C.: It is not done on purpose. So I do not look down on this ultimate form of the novel; which has not broken all ties with what was formerly the novel. But . . . For me, there is only Clarice who is in that zone.

M.C-G.: It is the zone of the sublime: where the novel, on the edge of the abyss, takes every risk. Rises another notch: a degree, a tone. Has paroxysms, bursts, rifts. Faints.

Apocalypses

H.C.: What interests me is what I do not know. And it leaves me first of all silent. It strikes me with surprise, with a certain silence. But at the same time, it strikes my body, it hurts me. I know that a search, or an exploration will unfold in this direction.

It is always what is stronger than I am that interests me. This seems paradoxical; but it is not paradoxical. (I prefer saying this to saying 'sublime': what is more than I.) Does that mean it is impossible for me to report it? No. Because we can always be stronger than ourselves; we move forward. I am going to make a confession: when I began writing, I had fulgurent impressions. It was already my procedure, I went towards the things I did not know; I glimpsed dazzling scenes before me, where what I do not know, what I do not understand begins. All of a sudden, it revealed itself to me, absolutely, like in the Apocalypse. And then, on the one hand, obviously, I was jubilant – obscurenesses and thus weights in my life finally dissipated. As always in these cases, for everyone, this gave me additional strength. But on the other hand, for a certain amount of time, I had an anxiety that seems comic to

me today: and if all of a sudden you see everything, I said to myself, there will be nothing more to say. There will be nothing more to see, I will have seen it all! I am very happy to remember having this fear; the fear caused by the idea that I would have nothing more to write! It has been a long time since that fear left me. I have another one in its place [*laughs*] . . .

M.C-G.: . . . the one of never finishing!

H.C.: Of course, this is no longer a fear; it is a sorrow: there are so many things that escape me. What we have still to discover is endless. I will only discover a thousand millionth, and I will be delirious with joy. But I grieve for all that I will not have the time, the force, the capacity to discover. And that is life. The thought never leaves me. I say to myself: it would suffice for me to turn around and consider the years I have just lived . . . A year is full of years. Time is infinite. Centuries have gone by this year. So I could write for thousands of millions of years: because the human thing is . . . it is divine. It is god who fabricated it – on god's scale.

M.C-G.: I often have the feeling that you have scenes – you have scenes with *yourself*. Starting with minuscule elements, that we all know, that you raise to a paroxysm, like a manner of seeing better, grasping better. As if the narration had the effect of a magnifying glass: put the human condition through an enlarger, worked it, gave it resonance and intensity. The enlarging lens of narration permits one to discover what is lived too quickly, already past, badly seen not seen.

H.C.: Actually, it *begins* with intensity. I don't have these scenes with myself: they are had for me. They have themselves. They only enter the universe – a universe to which writing will be added or on which it will work – *because* they have called attention to themselves by their intensity.

M.C-G.: These paroxysms have accents that are close to certain works of Dostoevsky. *The Possessed*, for example.

H.C.: It is perhaps there, at the point of incandescence, that I feel happy in reading Dostoevsky. I have a passion for Dostoevsky that is

different from my passion for Clarice. What Dostoevsky gives me is not directly useful to me in writing: but rather in emotion. There are two or three authors that bring something to my soul, in the domain where the resonance is in the form of emotions, of passions. There is Shakespeare, there is Dostoevsky, there is Kleist. It has to do with stories of love: the scene on the stage of the heart.

The stroke of de+possession: D(ostoevsky)

Dostoevsky: I think he is the only one to have worked in the territories that are only approached by psychoanalysis. There is also some of this – less, or in another form – in Shakespeare. For example, ambivalence. Dostoevsky's ambivalence is absolute, glaring, unprecedented. Now ambivalence, that's what we are! We are made for it! To kill each other in ourself. But we do not want to know it consciously. The unconscious is there so as 'not to know': to reject half of what we are. In Dostoevsky, there is the whole of us. All his characters are diabolical. That is to say they are all possessed. We are possessed beings. We are possessed and depossessed. Depossessed of ourselves but also depossessed of possession . . . and this is indeed our misfortune. When I write, what I try to do is to not lose – I am not saying to take back – the phenomena of de+possession and what they teach us. The stroke of de+possession, this is D(ostoevsky): losing and gaining embrace each other undeniably and *endlessly*. And Dostoevsky stages them. I also think that he stages them with possibilities we are deprived of, that are novelistic possibilities; but that are also, perhaps, cultural possibilities.

> *Without Shakespeare, without Homer, without: the Bible, Kleist, Kafka, Dostoevsky, I never could have lived, and later on without O.M.A.A.C.L.P.C.M.T.N.S.J.D. – I never could have lived.*

M.C-G.: Dostoevsky stages 'impossible' possibilities, 'impossible', unbearable characters, who are produced by madness. What do you think about the novelistic reading and writing of madness?

H.C.: What makes me crazy about Dostoevsky is that in his works there are the people who live on the moral plane, the general

plane, these are good bad delirious dramatic people, the most complete human fauna, all having reference to moral law. And then on the absolute plane there is one: the Idiot. The one who has renounced. This is perhaps not clear at first, because he is described with such vivacity, he is so present, that one may not realize that it is the Idiot himself, *idiotes*, come down from the planet of the absolute onto this earth. He is someone who has renounced. The origin of the renunciation is situated behind the text, before the text, it is told to us. Certain events are collisions between the plane of the absolute and the plane of the 'general'. The most spectacular event is the end of the book: the Idiot (the prince) loves Aglaya, he is going to marry her (while there is an incessant call coming from Nastasya Filippovna, the lost woman). We have the feeling that something that had begun in chaos in distress, pain, will find a happy resolution, that what will triumph is love as happiness and simplicity, that those who love will marry each other. This does not take into account the ever-present devil: the prince (the divine devil, the devil as excess of God) brings Aglaya to see Nastasya Filippovna. Between the prince and Aglaya there is true love, and between the prince and Nastasya there is passion. He does not love her, he is 'in passion' with her. And in a violent theatrical scene, he is ordered by the two women to choose. This does not mean anything, to choose. But since he is ordered to choose he chooses Nastasya Filippovna whom he does not love, he says he will marry her although he is engaged to marry Aglaya whom he loves. On the plane of the 'general' it is a monstrous scene at all levels. It is an assassination, a carnage. But it is not the moral plane that dominates at this moment. The last chapters are a long preparation for the marriage of the prince with Nastasya Filippovna. The whole city participates. The friends have their doubts, because they belong on the plane of the 'general'. In a sense they love the Idiot blindly, and from time to time, they open their eyes a bit and wonder what all this means? They ask him why he wants to marry this woman he does not love and to abandon the woman he loves. The Idiot responds. It's that he has given himself up long ago. There is a murderous shock between the two planes, the plane of the 'general' and the plane of the absolute, which cannot meet without a disaster. There is a shock between he who imitates Jesus Christ on this earth and the others. This means that

one cannot imitate Jesus Christ on this earth. Whoever imitates Jesus Christ on this planet kills. The plane of the absolute lurks, divides, cuts, kills, on this earth.

> *Nastasya Filippovna's misfortune is that she no longer knew who to abandon, who to abandon herself to.*
> *– It's a game*
> *– In the game between victim and executioner*
> *There is someone – I got over it.*

M.C-G.: And names, are we speaking of names?

H.C.: You were telling me that the names disconcert you . . .

M.C-G.: The names are particularly unbelievable, or bizarre, or complicated, and I thought it was done on purpose. You say not, indeed you have a problem finding names?

H.C.: I cannot manage to give names to the characters. It's a blind spot; it resists so much, it's so complicated. I have explanatory hypotheses, but they do not satisfy me. At times I tell myself I have a true inhibition. That the force or the capacity of nomination has not been given to me. It is so profound, so obscure, it's as if I came back to the interdiction of the Jews: you will make no idols. Each time I write a text, I find myself grappling with this. I loathe all the names, they seem to me like violent appositions. I have a suspicion: perhaps I do not want to detach the characters from myself? However I do not have this problem in theatre. To name, I say to myself, is presumptuous. How could I dare give myself the (divine) right to put people into circulation?

What one sees in my texts is not the result of a desire to attract attention, not at all! It's a compromise. It is what I have succeeded in obtaining of myself. Fictive appellations. A false name. A mask. A mask-the-real-name.

M.C-G.: A false name, that is the impression one has. I would like to advance another hypothesis . . . It is not the interdiction of the Jewish religion . . .

H.C.: But no, I don't believe that! . . .

The name is the outside,
the characters are interiors

M.C-G.: . . . but it is perhaps equivalent, because it's also a refusal of coun-
terfeiting. The character, in the novel, is what resists, the hard core: it forms a
unit. If you put a plausible name on it, it sticks right away, it crystallizes. I think
that what you would like, more or less obscurely, is names that can be torn,
like the tissue of the novel which can be torn. Names that are not quite 'for
real', that can play with the rest of the text, that can have the same supple-
ness, the same fluidity as the text. That do not lead to a psychologization of
the story. In this case you would be attempting to avoid being cornered in a
certain realism that the proper name immediately imposes.

H.C.: Ah! That's quite beautiful.

M.C-G.: For this, the figure of the character must be in the domain of the
'figural'. In *Déluge*, we come at the end to true geometric or algebraic fig-
ures. There is no longer Ascension and David, but A and D, points, motives,
movements that form descriptions of vectors, of drives also, desiring forces,
libidinal forces . . . and not representations of characters. If these elements
had a recognizable, normalizing, *proper* name, one would no longer enjoy
such a spectrum of possibilities. Of scenarios. Nor would one have the im-
pression of elementariness, of ex-
emplariness that suddenly gives
an account of something funda-
mental. One would have only an
illusion of the real. One could no
longer disarticulate the character
and give it this 'figural' value.

> *Why do I love Dostoevsky so?*
> *Because in the end we never know (the*
> *truth) if the Prince loved N. (with*
> *love?)*
> *Loved with love?*
> *or with passion?*

H.C.: It is perhaps that I resist fixation as I resist the title that will
fix a text.

M.C-G.: This does bring back the difficulties of giving titles: you try to stay in
the making of the text, you do not want forgery.

H.C.: Moreover, to take an example that is not my own, I love the
fact that in Clarice Lispector's texts there are characters that have
names and characters that do not have names. We have: the father,

the mother, the woman. I can't tell you what a relief this is to me! [*Laughs.*] It is true that they do not come apart because of this. But perhaps they also do not counterfeit themselves. Clearly, if we began having a caricatured father, or the caricatured grandmother, it would be simplistic. But this is not the case. I do not use the expression 'the father', 'the mother', 'the brother', 'the sister', but what I do comes from something analogous.

Déluge ends with a scene in a train where the characters become algebraic. But this is not at all because that is my dream. It is because in the scenes of our existence there is a mathematics. This mathematics is always at work in reality. But at times it is more pronounced, and ultimately, it is perceptible in all the scenes of intersubjectivity properly speaking. That is to say: I see you, I see you seeing me, I see myself see you seeing me, etc. And I the author seeing this specular shuttle that leads to modifications of the subjects, I'd certainly like to be able to have an instrument permitting me to mathematize, to collect an exchange that multiplies itself. I watch you watching me watch you watching me . . . How can one describe this, which is something that exists? There are scenes where we begin to be in such intersubjectivity that the subject is only intersubjectivity.

In the Cerisy text for Derrida, I did the same thing, in a very brief way: take the scene I describe of two lovers who are at opposite ends of the world. And all of a sudden this appears to me as a problem of mathematics: how can (I), A, here, live a time that is no longer my time, that becomes a time altered by a time B that is at the other end of the world? This is literally what we calculate when we are little, in school: problems of mathematics, of different velocities, etc. . . . And in certain cases, I can also situate the scene at this problematic level. That is, not in intimacy, because there is also an exteriority that leads us, that encircles us.

> When a story ends badly
> *must tell it differently*
> we are the authors of our stories
> *'happily' & 'unhappily', we are the ones who say it.*
> *What makes us suffer is when the story goes mad.*
> *Must heal it (tell it differently) must find* its other narrative *(change points of view)*

M.C-G.: I follow you in this attempt to say the greatest complexity. Counterfeiting erases complexity. You do not want the characters in novelistic fiction

to be able to counterfeit (themselves) because you rebel against assignation, to a precise name or place, which puts us in the system of representation from the outset.

H.C.: My enemy is realism in its banal form. And at the same time, I sense that there is also a resistance. I think this is a weakness on my part.

 This business of names, I admit to it! I want to say it just the same! [*Laughs.*] In fact, all you have said is right and it justifies me and I am very happy with it [*laughs*]. But I think: *a name is an outside.*

M.C-G.: It's a skin, a threshold. A designation from the exterior but not without inside echoes.

Writing in the present

H.C.: Perhaps what I do not manage to operate rapidly enough is the passage between the outside and the inside. That is to say, the round trip: going out and returning. But perhaps this cannot be done. Perhaps this is among the structural impossibilities writing comes up against. Can one write inside-outside? Can one pass from the one to the other in the form of a woven writing like mine? There are impossible things that I try to do with writing. Thus, I want to *write in the present*. Now one cannot write in the present because one writes after the present. And yet the dream of writing is to write the present. Trying to realize the dream leads thus to transformations of writing. In all ways. But also, it moves the place, the time of the enunciation, etc. As for names, it is certainly the same thing. I probably also write at a limit. I am on that limit. And sometimes I have the impression of crossing it, and sometimes of not crossing it. This is not an inability to create a character because, as I said, I can do it in theatre. In the writing of fiction, probably, I cannot do better. Besides, what are these texts called? What

> *Question of the floor where we install the painter's easel.*
> *Upstairs: semblance, order. If one goes downstairs below the appearance – it is seething.*
> *Dream floor: a different order: the most satisfying perhaps because it is a basement, but which has a form.*

name should they be given? I have to manage to hang on to what I did in *Déluge*: which is to say that the name of the characters functions also as a sign of writing. Even if it's a possible name, a plausible name.

M.C-G.: Our interview is also produced by an inside–outside relationship. The resistance you feel is on an intimate level; but as I read, from the exterior, I think of another resistance, on a philosophical level. Let us return to the example of the separation of two people who love each other: you say that this comes down to a mathematical problem; but it is also philosophical problem.

H.C.: Absolutely.

Poethics

M.C-G.: This resistance constitutes the demand of poetic writing. Much has been said about ethics, about its relation to the text: one could put your work under the sign of poet*h*ics. But also at the conjunction of poetry and philosophy. Where writing frees itself of a form of 'realism', that is to say simplistic conventions, to give itself full latitude to think. To become a 'thinking-writing'.

In this respect, I see a clear kinship: between your writing and Derrida's approach. A symptomatic kinship of the poetry–philosophy relationship as thinkers, notably Heidegger, have explained it: poetry can go where philosophy – not where it stops, but . . . suspends. Hearing certain echoes between your texts and those of Derrida, I see you on the two slopes of the same ridge. I am referring to the symbolic narrative you tell of your 'encounter':

> The first time I saw Jacques Derrida (it must have been in 1962) he was walking on the crest of a mountain at a rapid and sure pace, from left to right, I was in Arcachon, I was reading (it must have been *Force and Signification*), from where I was I saw him clearly advancing black on the light sky, feet on the edge, the crest was blade-thin, clearly traced, he was walking on the peak, from afar I saw him, his progression on the limit between the mountain and the sky melted the one in the other, he must have been following a path no wider than the mark of a pencil tip. He did not run, rapid, he *made* his way, *all* the way of the crests.[23]

> *(Quelle heure est-il?)*

> *Why I see him on the crest: because he is situated at the point of contact between two slopes, versants, inclines, sides → at the reversal point of climb into descent, of desire into mourning, of mourning into burst of life, of you into me, of he into she . . .*
> *J.D.*
> *Could only have inhabited language, place where the two sides can coexist with their in, their between, their exchange, space of amphibologies. Language only medium that gives the time at once stopped and mobile to inscribe the interstitial.*
> *The* inter**re** sticiel.[24]

The exigency that summons the two of you is rather well expressed by the image of the crest: each one from a different slope.

H.C.: Poetry with philosophy: I must say that for me this is the most difficult. To tell the truth, I cannot really talk about it. Why? I'm going to say why I cannot talk about it [*laughs*]. Perhaps because I have a very great proximity with Derrida whom I have always considered to be my 'other'. It happens to be this way: because he is alive, thank god. Clarice, with whom I have an extreme affinity, perhaps the most extreme affinities, is dead. It is the luck and the horror of writing that one is only free with words, with one's dead.

> *Certainty that C.L. gives me my hidden 'resemblance' (hidden in the difference) –*
> *And J.D. gives me my difference including all my differences.*

So I would say that I have infinite thinking freedom with Derrida; I have much less in speaking on or about him. Nothing is more strange than this proximity: it's what 'catches my attention' once I'm out of the zone of familiarity. (At this moment I am saying what I think. It fills me with terror: thinking is peaceful and without risk, saying bursts the peace into violence and unpredictability.)

What reassures me is that you saw the crest and the two climbers. So I did not make it up. From where you are (my nose is so close to the cliff that I do not *see* clearly, I only *guess*) you see resemblances?

We are of the same garden

M.C-G.: I find the same preoccupations in your themes, your approaches. One should almost say the same pains, the same concern with the gift, the debt, forgetting, blindness, memory . . . These are a few of the paths you

have in common. A certain manner of making your way. Almost a twinness, even if these approaches, yours and his, are situated in specific domains.

Thus, independent of the Derridian approach, your writing, after running for a while, comes into a mythic dimension, all woven in its elements, a form of exemplariness that goes by way of the *fable*. For example, Kafka's door; Ingeborg Bachmann's fire; Celan's cello; TB-Thomas Bernhard's tuberculosis. These elements do not only give rise to a relational interplay in the fictional text: in depositing, in accumulating, they form echoes, strata of meanings, they reflect, they make intervals. It is poetico-philosophical writing: at once practical, concrete – and fabulous. It goes, it takes off, it takes flight.

H.C.: Perhaps you are right to say that. Perhaps what unites us is also, apart from a series of fertile coincidences – because it happens that I've known Derrida since he began writing, and that was decisive – perhaps if connections that are perceptible to the reader can be made, aside from by him on his side and me on mine, it has to do with the fact that we are often attracted, interested, questioned, moved or disturbed by the same mysteries.

What strikes me with him is precisely to what extent he is different from me; that is to say, to what extent, *barely* different from him, I am different from him. Which I can only feel from out of a sensation of resemblance. It's as if, coming from very far away, having covered the same path in the same direction for millennia, parallel, sometimes moving apart, sometimes coming together (or: *pare à l'aile?* or: *pare à l'elle?* or: *part à l'elle?*),[25] there were the trace in us,

> *I notice that, when I say 'he', I do not separate the man from the writing. No more than he. Because he is the-man-who-writes. He steeps his pen in his own blood. He is always in the process of writing (even when he is not writing). I ought to say: thinking with words, phrases. Writing is his nature. And that writing is an extreme fidelity.*

each one on our own side, of the long path. He must have the same impression. For example, the relationship he has with death: he interrogates it, I interrogate it. He is in an absolutely tragic relationship with mortality. Faced with the anguish, I feel myself to be entirely different (from him).

I am not expecting (myself in) death

The relationship to death is fundamental. It's the cause. We live, we write starting from death. Both of us.

But: for me, death is past. It has already taken place. My own. It was at the beginning.

Him: death awaits him, or he is expecting death in the future.

Of course this distinction is too clean, too rigid. And undoubtedly the positions exchange themselves. Of course death also has a future for me. But I am not expecting death. I am expecting to cross it, to spend it. Him: death will bring to an end; all of life flows towards him from this ultimate term. There is an intense feeling of finitude in him – which perhaps either engenders or maintains his infinite racing.

For me, neither beginning nor end, that is to say neither end nor end, everything is always right in the middle, if there was a first end, a 'beginning', it was a yes, a smile, it was two recognizing each other.

Me: life flows towards life. Between life and life there is an unknown passage. Him: he fears his own death for others. Me: I fear the death of others. My own death will arrive last. After. That is why I cannot not desire it. (But it is living that mobilizes me: living is such work.)

> 'De-construction' is the gesture of thinking that permits the discovery of the quick of life under the immurements.

These 'readings' of death, of life, of survival, or afterlife, of time, of love, of the other, would lead me to unroll all the parchment of our works. I will stop.

Deconstruction is the approach, the axe, the means. What he aims at, what he auscultates, is the destinies of the heart, behind the armour. On the one hand, he has the philosopher's dream of infinite mastery and he laughs, he laughs at the ordinary limits of ordinary thought, he laughs at mortals' small human ambitions, as his fore-seeing and pre-dicting power is so vast. On one hand, living, he touches posterity. On the other, he sees his death all the same and he cries.

M.C-G.: There is a similar accentuation, a similar accent: the language is different: but the thinking recycles itself endlessly. You share the writing of the

undecidable. And a fundamental relationship to the biographical. Or rather to the *intimate*. Derrida is one of the rare philosophers to question the intimacy of the relation to the body. He puts his body into play with a questioning that has the strength not to lie. Although it is with the experiences and the signs of a different body, this is close to the questions you ask with the exercise of poetic writing.

The undecidable is the other's chance

> J.D.
> *A born **un-liar, dis-manteler**.*
> *He has the secret of non-lying.*
> *The secret is:* one-step-more. *When you arrive 'at the end' (of a thought, of a description etc.) take one more step. When you have taken one more step, continue, take the next step.*

H.C.: Why I like the 'undecidable': because it is the other's chance [*la chance de l'autre*]. Because the person in whom the undecidable breathes can only breathe goodness, that is to say: taking into account or concern for what is other than myself.

The thinking that addresses the undecidable is the thinking of tolerance, the thinking that does not sever, the thinking capable of concavity, of turning in on itself to make room for difference. The undecidable thinks all the possibilities, all the positions. In the writing of J.D. the multiplicities of places, of voices, of identities are always inscribed, not because J.D. wants to be everything, but because he does not reject the uncertainties of who and where. He never knows. One never *knows* with him. Apprenticeship of humility.

In an inaugural way, when I began to write, the first person I showed my texts to was Derrida. I was in such a desert, an absolute desert that no one in the world, not even I, could imagine now. A desert leading to an effect of atemporality. There was no time. The presence of J.D., whom I read, was inscribed in the timeless space where I was, as the contemporary presence of Montaigne is inscribed in me – or even better of Archimedes, as he appears to me, evoked by my son, quite alive on his sand, writing today as 2,500 years ago, and still discovering the experiences of thought, the secrets, the cosmic levers.

And oddly, it is with the appearance of time, from the moment I left my absolute desert – even if there remains an interior desert for me – and when I moved into a scene that was overpopulated, crawling with texts, with the products of this half-century that I was discovering, that there was suddenly another form of desert; a sort of overpopulated desert. What I read had an exiling effect on me. That epoch was so much not my place! I was inside a foreignness. If there had not been Derrida, I would have thought I was crazy. So the first moment was: total familiarity. The second moment affirmed itself in relation to an environment. As the time passes, I continue to say to myself: if there were not Derrida, I would feel very alone in the world – in the space of the French language . . . There is someone who has this effect on me, but differently, and I have said it a lot: it's Clarice Lispector, in the space of literature in general, and because she is incontestably a woman.

To return to writing that recycles, reconsiders itself: it is entirely true. There is a relationship to writing in which I find my primary exigency, I would say, and which is his primary exigency.

We read languages by the roots

He has a way of listening to the French language that is meticulous, vibratile, virgin: new, young. He hears as quickly as it speaks. Like a second language: as one reads languages by the roots. Talking is a marvellous act that escapes us: it is to hear Language speaking its languages in language. To hear oneself, to overhear oneself, to catch one's own hints. To accept this surprising phenomenon: when we swim it, when we gallop it, language always tells us volumes more than we think we are saying. I recognize his foreign relationship to the French language. I also have a foreign relationship to the French language. Not for the same reasons; but from the start it was there. He has himself made the portrait of his own foreignness. My foreignness is all-powerful in me. When 'I speak' it is always at least 'we', the language and I in it, with it, and it in me who speak.

> *Language: forest with all the roots/audible.*

To write is to have such pointy pricked-up ears that we hear what
language says (to us) inside our own words at the very moment of
enunciation.

> *Archimedes is the thinker: as displacer.*
> *He thought the world – actively, transitively, the world in evolution. The*
> *world is not something to contemplate, to think the world is to make it. It is a*
> *movement without end. To perceive the world is to think it that is to say to*
> *work it.*
> (Conversation with my son)
> *Archimedes is someone who never believed in the truth of something: that*
> *something was the truth, no. To believe in the Truth as tension, as movement,*
> *yes.*
> * giant of displacement like Einstein.*
> J.D.: *appears as inexplicably.*
> Never without other
> *cf. With thermodynamics one discovers the operation of difference.*
> * Thermodynamics: can only be movement if you have 2 sources, if you have*
> *difference, an above and a below, cold and hot. To create displacement, what*
> *was above must descend, something must evolve.*
>
> *Hegel also tried to fabricate a mechanism of perpetual movement that*
> *was an attempt to kill movement. (Hegel behind his scientific period.)*
> J.D. – *Archimedes never stopped.*
> * Always further.*
> J.D. *was born in Syracuse in 260 BC.*

As for what you said about the philosopher who risks his body:
that was what made him so familiar when I read him at first, it was
the fact that he was present in the flesh, in the bones, the
respiration, the organs, the voice timbre, in his texts. But this
seemed normal to me. It was afterwards that I discovered: it's not
normal, in our age it is unique. He writes, he has always written
from and *with* his body; with the experiences carved in his body
and from what goes through it; from the secret scene that feeds the
scene he accepts to make visible in his text – the scene of the text.

It is true, this is exceptional: for me, he has been from the outset
a living man. And not a show-off. Someone who works with his
entire body does not lie. He is the rare person who does not work
in a histrionic manner to capture the public eye by faking. J.D. is
the human, the human agony, the amazement of thought before
the incessant double passion that is our life, the tragedy: we who
are guilty-innocent, we who are guilty of being parents guilty of
being children, we who are at the same time parents and children,
men and women, we who – we who are unfaithful so as to be

faithful, we who are a wound, by the other, of the other, for the other.

> *Unprecedented, unworn-out language, virginity or childhood of the ear. Galvanic lexicality. We hear the least sparks.*

J.D., 'all by himself', is the tragedy of all the others in each one of us. No need for blood on the stage, or parricide or matricide or regicide, no noisy events. The tragedy is not where we think it is. It is the secret subtle work that weaves every good, every link, every my-own with its opposite. And every come-here with go-away. Every offering with every taking.

M.C-G.: Taking-untaking. The tragedy of intimacy arises with*in* my unknowing (and not with*out* my knowing): in this place that constitutes-and-weakens the self – mobilizes the emotions. Are tragedy and the mental work that tries to weigh it and to think it then indissociable from the biographic link? From the earth.

But one cannot reach the earth, cannot land, no more than one can paint the self-portrait. You go off writing with experiences, notations, wounds. But you are explicit: 'This is not a confession' (*Déluge*). And indeed it cannot be an autobiography, not because there is fiction – every autobiography is fictional – but because it will never be anything but the self-portrait of a blind person – you say it in *FirstDays of the Year*. The self-portrait of a blind person: it is always the other who makes the portrait, in an endless play of referral – from you to the other to the other you(s), etc. The portrait of the flayed person. There cannot be autobiographical writing here because the 'autobiographical pact' which codifies the genre is inoperative. *The voices* make it fly into pieces, the staging of voices in the text, which goes against all the novelistic rules of identity.

What is the status of writing that draws its elements from as close as possible to lived experience and yet does not do autobiography? You have said things about Derrida and *Circumfession* that I would say, it seems to me, about your texts: 'I leans on my elbows at the edge of me and stretches my neck, pokes my head a little bit outside of time so as to study my self.' 'Circumfession is to stick one's head outside of the silk tent, to go beyond one's skin, to go beyond one's death so as to grab one's life by the hair.' (*Quelle heure est-il?*) I would write that about Hélène, I thought to myself. At that point, rereading ancient things I had forgotten, I found a word in *Sorties* that is surprising today – that I could not receive in this way before – the word: *circonfusion*.

H.C.: Oh yes? Where?

M.C-G.: In *The Newly Born Woman*: there is the 'wall of circonfusion', a sort of line of separation that writing tries to shatter. This word is now in consonance with Circumfession; I said to myself: there, she's making circonfusion! [*Laughs*.] I hear at once fusion and confusion: you speak of yourself by way of the others, you go back through the texts of Clarice Lispector, of Marina Tsvetaeva, of Kafka; can only circumvent yourself, go around yourself with the irruption of the others. In relation to the biographical starting point, writing seems to take a double path: to the periphery of me by means of the others; to the intimate by means of the intersections of these yours-others. Of course, these are questions.

The blind person's version

H.C.: The origin of the material in writing can only be myself. I is not I, of course, because it is I with the others, coming from the others, putting me in the other's place, giving me the other's eyes. Which means there is something common. You say that there cannot be autobiographical writing, I am quite conscious of this. There can be those intriguing fractures of the self that are called confessions. For me these are works, books. We can call this autobiography, but it's one version. The blind person's version.

> *What I love in him as I love the* truth itself, *is the expression of the truth, the* flection *(the genuflection, the ingenuflection) the way his thought always forms a single* body *with the objects (of thought) in their flexibility, the way he never thinks as a spectator standing (or sitting) on the exterior of the trail of the world, but he always thinks the world in the world, embracing the movements, the courses, not separating himself from the sometimes rapid sometimes immobile dance of beings.*

When you said: I could have said that about Hélène, I thought: perhaps. And yet I sense that there is a difference here between Derrida's position and my own. For example: it seems to me – but perhaps I am mistaken: you see, here, as I am obliged to talk about myself, I go into uncertainty [*laughs*] – that I describe him differently. His attitude at the window of himself: it is a way of making the jealousy of oneself work, the jealousy of me with regard to me. This is what he expressed in the regret of not having been

present at his own circumcision. A mourning relationship to oneself. This is what I find in Stendhal: Oh how I would like to know him! (This Stendhal or this Beyle, or this Brulard.) It's too bad, that is the only person I will never know. A magnificent and cruel envy: it is something incredible to think that the observer of human beings, Stendhal, Shakespeare, 'the mirror carried along the ways', will have been the only one not to have been observed by the observer. I do not believe that I have this affect. My curiosity – because it is a question of curiosity, of desire – is not orientated towards: ah, I would like to have known that person, but towards concrete, present phenomena. It is not a jealousy of the past or the jealousy of the future anterior.

> *Archimedes thought like this: each time he found something he started criticizing his mode of discovery and searching other modes of demonstration. He deconstructed himself.*
> *searching to make the demonstration independent of the discovery. Not to take the discovery as proving Took* subjectivity *into account.*
> *Archimedes says: these are 'experiments of thought', in other words it comes* from me. *'Give me the fulcrum and I will lift the world' — and he knew that the earth was round and that there was no fulcrum; there is no fixed point.*

For example, in *Circumfession*, Derrida evokes 'what will have been, for me, the question of blood'. Throughout his whole life. It is a fascinating movement of bringing together. I see in him this brilliant explorational cast, which brings him to discover structures or logics that have never before been thought, to sketch the course of rivers that flow in the '*in(terre)conscious*'[26] zones. Now I sense that, while being fascinated by this path-making, I would not go that way: this is, I believe, the lengthy and broad gesture of bringing together, the diachronic aptitude that I do not have.

In other words: I have a different relationship to preservation, to loss, to the persistence of the past, etc., to all the affects, emotions, attitudes aroused by the mysteries of time, to forgetting, memory, anamnesis. These are themes that occupy me (him also), and to which I respond with a music that is different from his.

But what will mobilize my thinking attention is the appearance of a sign, of an insistence, in the vital river, a new haunting, the apparition of an unknown feeling. Fantasies, phantoms, figures (of dream, of thought), we change, we ourselves, in the present, are the site of innumerable events. I have an instinct for spotting

things. I am an astrophysicist of minuscule stars. Clearly, this is a metaphor. It's also the desire of a nearsighted person [*laughs*].

M.C-G.: The desire for the telescope?

H.C.: Telescope and microscope. And binoculars (for the word).[27] I owe some of the most fantastical hallucinatory experiences of my childhood to my extreme nearsightness: vanishing streets, substitutions, metaphorization and metonymization of the world and of people. And above all the need – indissociable from my very nature, from my way of seeing and thus of thinking – to go see everything very very close up *so as* to see, and consequently, the development of a vision that is hyperattentive to details, my approach as a scrutinizing ant, my sensitivity to the least sign. I also have the ears of a blind person; because I use my ears to see better. I also have the imagination of a blind person; because there are nocturnal hours when I do not see. I have always known that my foresight was born of my blindness; that my passionate desire to think further came from the desperate effort of my eyes to pierce the darkness. And also: my myopia is like my writing: these are fertile congenital disabilities. I have never known the state of a person whose eyes see 'the world-as-it-is-supposed-to-be-seen-by-seeing-human-eyes'; I have never known the state of a person capable of living without the aid of a magic instrument like writing. (N.B.: the complicated combination of myopia and astigmatism has always meant that I could not be 'corrected' – as they say. I am incorrigible.)

> *Very complex to develop – all that is lost is not lost – what is lost is lost – No fear. No regret: so be it.*

Yes, I owe a lot to this ocular chance. My myopia is my daily secret. I see the invisible more easily that the visible. So I close my eyes, and I see the landscape of the soul, its hell, its heaven. And I say to myself: my god, there is a 'star' I had not seen. Even though it was there, clearly. I say 'a star', it is more punctual. For example, you spoke a little while ago of Kafka's door, of Thomas Bernhard's tuberculosis: clearly you will tell me: it is the story of Thomas Bernhard's tuberculosis. But I prefer not to say it in this way, it is true that my role is closer to the *theatre*, to the *scene* of the body than Derrida: I will not do the philosophy of tears because I will

use my strength to work on the physical phenomena that accompany tears (but that are indicators of the direction of the passions). That will then connect up with a philosophy, etc.

M.C-G.: Not biography: which is understood as history, collecting . . . and from this point of view, it does not correspond to your approach. On the other hand, it seems to me that I catch a glimpse of you in a certain present of writing, 'sticking out your neck', sticking out one of your heads which tries to look towards the other.

> *Question of the time of mourning: I do not cry in advance – I do not precede –*
> *Feeling of grace stronger than everything with me –*
> *In the combat between joy and mourning:*

H.C.: Not the head. The body. The entrails. Of the soul also. I think I am more contained. What Derrida expresses at times is a vital curiosity with respect to those types of primitive scenes that elude us, and that have caused him. I think that I do not have such a vast desire or project in me. I do not have that sublime physicist's intelligence. Which is to say that it is less the 'enigma of myself'; it is rather the thirst for the phenomenon of an instant. Of course, at times I 'go back' towards the source. But I am perhaps more inclined to the study of symptoms.

Perhaps I am mistaken. Perhaps what I feel is entirely false. I do not know myself, I should not say anything about myself.

Myself as the first other

M.C-G.: Symptom is right. In connection with the attempt to grasp something that is on the order of the instant. But you are nonetheless the scene of this event . . . You are the material, the body, the nerves, the direction . . .

H.C.: 'Knocked off my feet', it was only words, until it happened to me. I can only try to understand, I can only work on, or take note of *why* and how one is knocked off one's feet, I can only ask myself what that means, if I begin by noticing it in myself; myself as the first other.

As for going by way of others, this is sometimes the case; not always. In many of my texts there is no crossing through. It seems to me that in *Déluge*, the presence of others-in-literature is weaker, no?

M.C-G.: There is Clarice.

H.C.: That's a fiction . . . It is a name. Clarice is a synonym.

M.C-G.: We are always in fiction: you rewrite your-others-in-literature, you restage them. You move them, transport them onto your own stage and onto others, you extend them, echo them.

H.C.: I wonder if I don't do that for secretly ethical reasons: I allow myself to borrow characters that are at once true characters, that have consistency (which Shakespeare does), that have existed and that, at the same time, cannot be hurt. They cannot be hurt because they are dead – and because they are strong. Because they already have, in themselves, at their disposal, that other world which is the world of writing. So I do not feel guilty: even if I invent lives for them, they are first of all defended by their own work (i.e. their own life), which is available, one can go and verify it. While if I took hold of a real character that has not left memoirs or archives, I could do him harm by inventing.

> When one begins to see oneself in the other. One looks at oneself gaping, one sees one's gapingness.

M.C-G.: They are strong because they are at once fabulous and exemplary beings. Your rewriting puts them in an overdetermined situation such that we can reach the mythical level with them, the legend.

H.C.: Undoubtedly. They surely come in place of Shakespeare's characters, historical, mythical or legendary characters. Borrowed from Plutarch . . . I cannot borrow characters from Plutarch. The only 'heroes' that are left are artists; with writers predominating. But there are also painters.

M.C-G.: Painters, writers, but not only: their written life is woven with everyday things. The R5[28] for example, is a presence that is as singular as the characters: this little car becomes fantastic, fabulously tied to Russian adventures, unexpected paths . . .

H.C.: The R5 is Othello's handkerchief.

M.C-G.: Staging your others is a way of 'writing *à l'étranger*'[29] – in the sense that Rembrandt is always 'painting *à l'étranger*', as you say. Tsvetaeva, T.B., Clarice, it is like the little door, in the background of Rembrandt's painting. Anything can come in, anything can happen.

H.C.: I feel great freedom with them, a freedom that is perhaps even excessive. I have the sense that they are safe with me. Either I say things I think are true: for example, I see structures appear like Ingeborg Bachmann and fire – but this seems to me to be readable by anyone. Or I allow myself totally fictive scenes knowing that anyone who is familiar with my character will know from the outset that it is a pure fiction. It is not a simplistic or degrading fiction, by the way.

M.C-G.: We are in the theatre of writing. So: why name writing? Why give it a name and give it the name of Isaac as you do in *Déluge*?

H.C.: Ah! [*Silence.*]

M.C-G.: It's a first time, it is one step further. 'I love. "Isaac": it is the name I have given my love, so he can have a name. Because if I say simply I love "to write", that's not it. It's such a mystery. It's the other. It is not I.'

H.C.: Yes, I do not know. It is surely a stroke of writing, or of fiction. Perhaps I should not elaborate on this. Does it seem inconceivable? To call writing 'Isaac'?

M.C-G.: It is surprising. Gripping. It gives an unsuspected *presence*. Absolute presence. Without our knowing what. At the same time, it is very conceivable in the network of the book. David can become minuscule, and ascension, and other things: in this 'logic', why should writing not have the name Isaac? It is beautiful: mysterious.

I could not live without my books

H.C.: It ought to keep its mystery.

But even so, I can say for example that this name translates the effect of incarnation, an ambiguous effect that little by little I saw

> Without my books I could not live. *It is my definition. Each time I say that,*
> *it seems I hear an explosion of voices.*
> *I would have committed suicide.*
> *Each time I have expressed myself on this subject, I have been sharply attacked*
> *by the mute looks of those who are close to me.*

emerge – across years, across lives – and that is something I encounter a lot; that I cannot resolve and that perhaps I will never resolve because I am not in a position to: it is the question of the presence of writing experienced as a third party: of the fact that someone writes and of what consequences that presence leads to in interpersonal relations.

Life has obliged me to ask myself this question in a painful form: how writing is experienced as a third party in all dual relationships. For me it is not a third party – I am not separate from writing, I only began to become myself in writing. But it has a separating function. Which reaches very far, in my opinion. I will begin with the relationship of love, of friendship, the familial relationships. There is a third party. I do not see it but I see that the others see it. And I do not know what effect it has. I suspect that it produces things that are not very good [*laughs*]. That is *one* response. There are many others.

M.C-G.: I do not know a stroke of writing of that order: that takes what goes beyond us and which is a desire, a drive to write, and makes it concrete in a relationship of love, of passion. I don't know where this will lead.

H.C.: I don't know either. But I thought that the moment had come to inscribe it.

M.C-G.: Writing has a separating function, that is true. It also has a repairing function.

H.C.: It repairs the author. But it does not repair the relationship. The person who writes feels innocent; innocent of writing. What comes back to him or her in the look of the other is not at all that. Something comes back that is not said. Cannot be said. Because it is not clear how the friend, the other, could openly accuse the person who writes of writing. (It is not an explicit fault or crime.) And yet, in little-explored zones, with a lot of shadows, I sense that it does not

go well. That in a certain way, it hurts. It is very cruel. It's received as the existence of an elsewhere. It is an elsewhere. How is this elsewhere harmful? I have talked about this with my mother, whose generosity is absolute. She said to me: to every man his own elsewhere, after all. When someone works . . . a doctor for example, he has his profession. But in fact, that's not right.

> *Without – I could not live. I would be dead. But now I no longer want to keep quiet for fear of reproach. It's a betrayal of truth 100%. To not say what one thinks for fear of disapproval is a suicide and an assassination.*
>
> *It is why I dare: without – I could not live. What would happen? It is yet to be imagined.*

M.C-G.: This is not a job of the same kind.

H.C.: Every practice, every activity that takes place outside of a couple can engender jealousy, concern. But maybe art more than all: in so far as, it must be said, there is an infinite *jouissance*; and it is produced between you and writing, you and painting. And what is more, it is non-communicable. Because it remains mysterious, so that the other has difficulty appropriating it; and that perhaps he or she does not want to appropriate it, moreover. There is an undefinable 'intimacy'; by the fact that it develops, that it emerges, it's as if it were a great threat, first of all to the other's capacity for appropriation and even his or her desire for appropriation. Because *I* does not always want there to be too much private you, too much in reserve. A lot of you and a lot of your intimate life is less of me.

Of course there are people who love the elsewhere of the other in this form. There are such people. But often it engenders all sorts of forms of death, of denial, of repression, of flight, of anguish. As if one felt that the development of a series of works were the continued engendering of a second person – whom one has nothing to do with.

I am sure that the apparition of this character called Isaac is overdetermined.

M.C-G.: The very choice of the name constitutes an overdetermination.

H.C.: It is also dictated by systems of signifiers that I do not entirely control. Isaac means laughter in Hebrew, etc.

M.C-G.: You say: writing is living. This is already a certain response to the question: why does one write? That response inscribes itself, readable in the energy, the rhythm of your writing; which goes very fast, seems to operate in great urgency. As if it is urgent to write. Another word comes to me: surviving. Writing is a question of survival: living in spite of, living more, escaping. Multiplying existence.

In the writing that is racing to catch the instant or the lightning flash, does the *jouissance* not come from a sort of competition with time? Does it have to do with gaining time? Giving *oneself* time?

Gaining time, gaining ground

H.C.: That question is too big [*laughs*]. For me. It is so originary that I don't know if one can say anything about it . . . that would not be a sort of projection out to infinity – and thus nothing . . .

Firstly, I have no memory of a time that would allow me to respond to the question 'why?': since the need to write goes back as far as my memory, if you ask me: why do you write? it would almost come down to responding: because I live. It is non-dissociated. Because I cannot not write. But these are two different things. Because I live. And because living-writing were mixed up for me right away. When I was a young child. At that time I did not know what would become of me. But already I lived with two worlds: with the world and its writing; with the world and what was written on it.

And then, I could tell stories . . . it would be a sort of autobiography [*laughs*]. Like for example the apprenticeship of words I had with my father. My father played pedagogically with us at word-and-seek. So it is tied to the wonderful beginning. When I was two years old, I was in the middle of the written: working with the signifier. It was indissociable from my very life.

Later, I got out of secondary school and in front of me there was: existence. And I said: in any case, *not without* books. The refuge-value has always existed. The reality of the world to which I was witness was so violent. Like today: the world comes at me with such violence that I could not stand it without a shield. That is fragile. Invisible.

It is out of fear, despair, against reality – because there was the war, because there was death, because there were massacres,

because there was betrayal, because there was barbarity, because there was no language, and too many languages and not enough

> To not return:
> *I will not return to Oran.*
> *Do not like coming back?*
> *Like to keep embalmed embalming*
> Memories of spices. *Manégat Street.*
> *Name with odour of spices.*

languages, because my father died, because the Jews were massacred, because the women were exploited, because the Arabs were expropriated . . . I gathered up twigs, magic words.

Gaining on time, competition with time? Gaining earth, fabricating a ground, rather than gaining time. But maybe I'm just telling myself stories.

M.C-G.: I associate gaining time with the work of writing which attempts to bring back to the present, to reanchor all activity in the presentification of the book. To write in the present.

H.C.: Then it would be to gain the present.

M.C-G.: To gain the present. That is to say being present to the passage of time. Writing-living the passage.

Jahre Jahre

H.C.: Being absent to its passage is what would make me sad. But the fact that it passes is a phenomenon among others for me. How I love those lines of Celan! *Jahre* (one line, new line:) *Jahre, Jahre.* Years. But what is years? One can experience it as something horrible, which is to say years that have passed, that are lost. And it can be the opposite: one can think that we never lose anything, that we are in a continuity, in a succession of full times that add up.

Years. Years, years, a negative accumulation: years and years: less and less time if one thinks one has a capital that is wasting away. One can also think: years and years, it takes nothing away; what it has accumulated, on the contrary, is time to think. One can think of years as extremely variable units: little ones, big ones, empty ones, years full of years. Years. Years, years, in general we think these are past years. What keeps us from thinking of it as years to

come? Etc. But I also know the time that is neither living nor dead. The time that no longer passes at all. The halt of time that fills the expectancy of the heart with an eternal immobility. The waiting that becomes a clot in the heart.

As time passes, I am less concerned with regret than with urgency. The urgency of being there. There-being. Perhaps one day I will change [*laughs*].

M.C-G.: The only true loss, perhaps, is that it goes by and we have not seen, have not felt, have not thought. Writing allows us to replay it – to enjoy it.

H.C.: Writing allows me to *jouir*, it does not allow me to take back the past. I never read my books – precisely because they are done.

> *It is the same as with my notebooks: I do not want to know, the past to return. I like the past past. I like to have lost. I like Oran which I never saw again and will never see again*

M.C-G.: It is the book in progress, the next one that counts.

H.C.: What is in the course of, in progress. It is less gaining time in the exercise of writing than . . . the work of being present to the present . . . Of attempting to be as close to the present as possible, and to have thought of it as being a source of richness – whatever its nature. This is part of our endowment, we must honour it, receive it. All that has been lived, all that has been thought, including the worst, regains its status of production, of action – if we are not in a state of passivity, if we are not rolled under the waves, crushed. So it is not so much *gaining* time; it is being active; being the subject of one's life. Not being what remains.

There is not only this. There are so many other causes. We also write for reasons that are much less heavy and more joyful than that. Because of the pure pleasure, the joy of discovering. I do not know how to account for this well, who will ever account for the nature of the pleasure that emerges from the creation of a work of art: at once for the creator and for the receiver? It is a mystery that we can be transported with happiness by a painting, by music or by a literary work. Because I do not separate writing from reading.

writing and reading proceed from the same region of pleasure

M.C-G.: The two activities trigger one another reciprocally.

H.C.: At times I have pleasures in reading that are as intense as in writing. But that could not be enough, it is true. When I read, I put myself into writing.

> Notebooks – *full of treasures*
> *However: do not open.*
> *As soon as I open, I close. I do not want*
> *to see the true face of the past???*
> *Its beauty??*

M.C-G.: The two activities are especially connected: rewriting, displacement, and the differential mechanism merge with the incessant coming-and-going between the two activities.

H.C.: They meet up. At times I'm doubled up with laughter reading Stendhal. Reading and writing proceed from the same region of pleasure. That's what is mysterious. There is always the feeling that something has been found again, a fragment of human nature; or else that something has been saved. What fills me with joy is that this thing that was found again or saved with the instrument of writing is a life factor and not a death factor. Because I think that what daily life brings us, to a very great extent, is death. It is hate, contempt, rivalry, arrogance. While writing, at least the writing I love – all its effort is an effort for rehabilitation or for salvation of what risks being lost or being debased, scorned.

In writing there is also a function of raising up what is forgotten, what is scorned. Not only the great things that have been forgotten – not only women – but the little things that have been scorned, seen as detritus. And which are nonetheless part of our lives. There is not only the well-dressed, the noble in writing.

What enchants me: my experiences in buses. In *Déluge* there is a crossroads experience. It was the story of a dog. I think that writing serves also to do this: to collect what Joyce called epiphanies. Moments where reality, in its most modest form, joins in a single stroke a possibility and a promise of eternity – an instant that resists death.

M.C-G.: It is a safeguard. Writing saves: the writing–reading connection, your readings of other writers. And the readings that people do of your texts?

H.C.: I don't know them.

M.C-G.: You don't know them?

H.C.: No [*laughs*]. Not at all.

M.C-G.: You fantasize them? Do you write *for*: someone, a reader, an ideal reader, an audience? For those you are close to?

H.C.: No.

M.C-G.: You spoke of the reading you do; not the one that is done of you. One can think that someone who writes, writes for other people. That the readings, the reception, the echo would be important to her. This could possibly produce an effect in return on the writing?

H.C.: Do you think so?

M.C-G.: I do not know.

H.C.: I'm asking *you* the question.

M.C-G.: No, I do not think so. When I write, I do not think about the readers. It happens between me and me, me and language, the page, the images, the books: it is an overflowing to which one must give form, a certain order. In writing I understand, I discover the possibility of understanding. In working on the page, the internal necessities of the text are sketched out. I try to set up harmonics, to weave variations where each of the sections is read by the others. The text is written in its (re)reading. This demands a mobilization of elements, there is no room at this moment for a virtual reading from after-text or from outside-text.

On the other hand, when I think I can stop (there is always the feeling of not having finished), there are readers who are important to me. Who offer me a lot: by affinity. I like what they think, read, write. They have a face. There are not many of them. I do not write *for* them, but their reading is necessary. And sufficient. 'The audience' does not exist in the text. I am going

to admit something ridiculous: the first time I was asked to read 'in public' a fictional text I had written – at Cerisy, an informal meeting – I was unable to do it. A friend who liked the text read it – and I was terrified by this . . . exposition. Still today, I would not like to have to do this exercise.

It is important to me that the book exists, that it comes to be a viable organism. That it lives. Vibrates.

I do not think I have ever written for anyone

H.C.: I ask myself that question because it exists. I would respond subjectively and tranquilly: I do not think I have ever written for anyone at all. This does not mean that I scorn the reader; quite the contrary. He or she is free. He will come or he will not come. Or she. I do not know who it is. I only know: there is one. (But who?) *Before* whom I write. *Lui devant l'écrire.*[30]

This does not mean that there is not a potentiality of reading: because I also write thanks to the existence of other writings that make a space – that make a space of reading. The fact, for example, that Derrida was on the horizon when I wrote meant the possibility of writing and of reading.

> *J.D. Modern 'scientific' thought: for ages there has not been a philosopher whose thinking has been scientific in this sense.*
> *He himself always calls on the point of view of the other in himself. The other speaks (loud) in him.*

M.C-G.: You had him read your first texts: you needed an exterior reading?

H.C.: It was something else, it was absolutely inaugural, particular; it was 'my friend in truth'. I was in the same state as Stendhal seeing himself once he was dead going to see Montesquieu to ask him: So what do you think of my book? I was dead, I had nothing to fear, I desired the truth: 'Where have I been during the night? Was it in madness, or was it in the darkness of writing?' I asked. I showed him my first texts because I did not know if it was text. And if I showed them to him, it was because I had read him. I showed them perhaps *to the space of writing* that he was. I had no interest in writing for someone that I would not like to read, even a great writer. Moreover, one can only really write a text to God (not *for*, but *to*).

M.C-G.: We were saying in sum that writing is not subordinated to reading. Reading-and-writing: a single delivery. One gives oneself over to the book. Audacity and loss in an act of addressing beyond all measure. The reception of what has been written is an elsewhere of the writing? An other-writing? Writing oneself by the other?

H.C.: To come back to the reading of the texts one has written: of course one writes for others; but the first other is oneself. No one can be so severe as oneself in writing. This is why one corrects. One also writes, as I have said, for all the others one has read, that is to say in their honour. But I cannot think it is for contemporary readers.

M.C-G.: In any case you have the experience of the theatre which gives you an audience, reactions, immediately.

H.C.: In the theatre, there is acting out right away: you write, it is played: there is the audience. And when I write for the theatre, and for the *Théâtre du Soleil*, the actors ask me questions of reading – if you will. But in a different way. When you write, do you think about us? And I said no. They existed and I loved them but I wrote for the characters I was in the process of staging, and according to their destinal and theatrical demands.

In the same way when I write, I write for the text. It is the text that is my first reader. My only reader, in effect. I know that this surprised them very much. But I

> *It's a book of many angels.*
> *The train carried it off.*
> *I sense the plane in me. The plane is taking me. Off.*

think that what I was saying was true. Conversely, in playing the text, they made me discover things that were hidden from me in the text. All the time. Occasionally in a startling way. I remember extraordinary experiences; being doubled over with laughter seeing them play a scene I had written thinking I had made an extremely tragic scene. Hearing this interpretation, I was captivated: what a lesson! We do not know what we do. It was very beautiful: to have the experience of point of view, of point of hearing. Hearing and not, yes and no. Hear, hear.

N.B.: In the theatrical text, the audience is implicated, it is actively present *in* the space of language. The audience is an

essential *character* without whom no character would speak. Would speak (to himself, to herself). The audience is the reflexive *Self* of all the characters.

M.C-G.: The fictional text can have many and unexpected readers, an audience – echo chamber, whether they are heard or not, is it above all a body in itself, that does not need a reading projection or incarnation?

Writing is beyond us, always going forward

H.C.: Ah yes, but like all texts, it is very happy when it is read [*laughs*]. I do not think that one can subordinate the writing to the reading; this would be truly terrible. All the more so in that writing by definition is beyond us. True writing is always going forward. So reading should also be . . . in that direction. With Stendhal I love rediscovering the freshness of his discourse on reading. There is the famous metaphor of the bottle on the ocean, which Celan uses, which Mandelstam uses. It is really the fantasy of the poet who confides his written heart to a vessel, but the most lost vessel in the world, to the smallest chance.

You know Stendhal's version: I will be read in 1910 – I think. And he says it with such veracity of imagination. It is so concrete. One day he says: Ah, I hear a whimpering, it is my reader who was just born in the house next door. It's a calculation all the same!

M.C-G.: A poetic calculation.

H.C.: It is the bottle on the ocean, but the bottle is right here . . . and the ocean [*mer*] is the arm of a mother [*mère*] [*laughs*]. To know that the reading is not for today not for the day after tomorrow, but for tomorrow, not sending it off to distant eternity, is a form of incredible courage. An act of faith and self-assurance. My eternity will begin in 1910. Such confidence merits reward.

What we write on

M.C-G.: While we were speaking you wrote: *what we write on*. On what?

H.C.: On the waistband of our trousers. It's Stendhal. It is the story of the beginning of writing in the *Vie de Henry Brulard*: 'I was exhausted. I was wearing trousers . . . I wrote on the waistband inside . . .' What is sublime is first of all the harnessing. I was exhausted . . . I was wearing trousers . . . One cannot write writing better than that. This is what writing does: it harnesses. People who harness make me burst with laughter. Because it is life itself: the bringing together of two live elements. The leaps of thought. The discontinuities in the continuity. The third one beats all: I was wearing trousers made of white English [cloth]. I wrote on the waistband.

M.C-G.: A nice lesson. To begin to write is to begin by dealing with oneself; or with one's accessories: it is to write at the periphery, on the edge of one-self, on oneself. One's double, one's lining . . . or that of one's waistband!

H.C.: That is what we write on. The beginning of the *Vie de Henry Brulard*: why and how he begins to write the-life-of-Henry-Brulard-by-himself: I wrote on the waistband, on the inside: I am going to be fifty. I think that all my life I will laugh about this. I will not stop laughing, I'm sure of it, about this marvellous scene. About the fact that this scene took place, to begin with, because I do not doubt it. On the other hand, that this scene was told to us, that it was transcribed. That it passed from the trousers to the book . . .

> *The whole body,*
> *the whole being is a theatre.*

All my life I will ponder the secret and the force of this moment. Because I do not think there are many writers who will have been magic enough, child enough – who will have kept such a childhood – to have both lived and transcribed such a clandestine, personal moment. There is clandestineness in the scene, at all levels. What is marvellous is that this clandestineness was externalized (outside of the conscious) but no further than to the limit of the self constituted by the trousers. As if a book begins

to be written precisely in a zone that is not at all what one might imagine: that is neither the reader – we have talked about this – nor between myself and the reader, nor between myself and the body of the paper. It is there between me and me. It is brilliant that he carried it out because when we do not carry it out, it's because there is inhibition. We do not admit to ourselves the truth of the gesture. There is something that makes us guilty. We act as if we were altruistic, we act as if we wrote the book first of all for the other – which is not true. Because we write the book for the skin of our belly. [Cf. Appendices, excerpt 2.]

M.C-G.: Which leads no longer to analysing the 'why or for whom one writes', but to consider the concrete circumstances that reveal the coming to write. The coming to writing.

H.C.: I began to daydream about that: the hour of writing, the place, the concrete localization. The localization: the trousers, the waistband of the trousers, the braces, etc. Or again, about what Clarice Lispector did. She did not write on the waistband of her trousers because she did not have trousers. But on equivalents: bits of paper she had in her pockets, envelopes, cheque-books. I know that people do that. I remember having often done this when I began to write. And this happens to me still. But when I did it, often it was out of anxiety. A sentence went through me and I would say to myself: it will disappear. A naive anxiety: it disappears and then others appear. Clarice Lispector did that when she was fifty years old. She scribbled something on a bit of cardboard if she was at the cinema: I think that there it is obedience: writing dictates with such power that you do not say I'm not ready or I have no paper.

> *Sometimes she was on the other side*
>
> *Child in the bus how she watched the mirror world in the external face of the window. Voyage in the other world.*

So: on what? I will not go into the infinite details of the signifiers, of the uses of paper etc., but perhaps one must consider the attitude of submission to writing. That this submission, so as not to be transformed, so as not to transform itself into a resistance, needs to be assured of or equipped with the means of its own docility. Materiality must not resist. I always try to have pens

that I don't notice. It must flow. If you start being in conflict with your pens all of a sudden you are called back to the exterior. You leave the trousers.

M.C-G.: You mean to talk about a sort of desacralization of writing? Some writings are attached to a place, to a time; can only be produced with a certain pen. They ritualize the gesture to the point of making it something magic. With Mallarmé there are notions of this order. It can also be the necessity of marking a separation from the everyday. A kind of retreat.

H.C.: I can imagine it, there can be a magic to it. That is not what I am talking about. Of course there are propitious places. I have never understood – because I cannot do it, because I need to descend, to go behind thought, under the table, underground – I have never understood the authors who write in cafés. I could not do that: the noise attacks me, the exterior world calls me to the exterior. On the other hand ritualization is not my case, but I can understand it.

M.C-G.: You search, on the contrary, for the flow, the absence of material obstacles, you organize yourself for that?

As if I were writing on the inside of myself

H.C.: I try to organize it: beginning with silence. With the conditions of retreat, yes, the conditions of an interior voyage. With the least resistance possible. This is why I exclude machines. I have never been able to. It is as if – what is imperative for me, without my formulating it – it is as if I were writing on the inside of myself. It is as if the page were really inside. The least outside possible. As close as possible to the body. As if my body enveloped my own paper.

So perhaps the 'on what' goes with the question of the time of writing. At what hour one writes. Very often I write at crepuscular hours. Why? I cannot write in the dark, in fact, because I need light. But I take notes which for me are seeds. Sometimes I do it late at night, when I am in bed. These are moments of collection, at these moments things gather themselves together. Notes,

succinct. And the morning – before daylight. Between night and day.

M.C-G.: Between dog and wolf [*laughs*].[31]

H.C.: You could say between dog and wolf. It's not what I would say. I see where you want to go with that [*laughs*]. No, it is truly still inside; still in the night, on the inside of the night. And while the medium, written words, still has the quality of a dream. That is to say a power of natural condensation: which I must later go searching for in full daylight.

> *They are people without faces*
> *Visions without images*
> *Running without footsteps*
> *We lean we would like there to be something to see*

M.C-G.: I understand better when you write: 'the Night my impersonal mother' (*Déluge*, p. 223), which designates the night as a privileged place where the person becomes blurred, a place of non-person. It is a state of greater receptivity, of reduced will.

H.C.: For me, it is the time of least resistance of everything that is an obstacle to writing: of the self, of organized thought. This does not mean that I write at night. I sense that these are the strongest moments, the moments where the critical instance, the conscious instance is weakest – I do not want to use the psychoanalytical vocabulary – the moments of proximity to myself. I am in my bed in a greater proximity to my body.

M.C-G.: Stendhal's waistband indicates the proximity to the body; but displaces it and makes us laugh; we write on our skin, but it is not always the one we think it is. It's more complex: my skin is all the layers of my skin. My carapaces. My disguises

To have writing trousers

H.C.: Clothing is skin. It is adopted skin, adoptive skin.

M.C-G.: What is brilliant with Stendhal is that – we were talking about the body of the paper – he plays the parchment. The skin of the other on which I write (myself) is also an origin of writing and the original writing: the first skins that were a medium for signs.

H.C.: Moreover, he says it. In this mode that is marvellous because it is concrete. He says: I was wearing trousers made of white English . . . the word indicating the material is illegible in the manuscript: let us say, cloth. It is certain that the properties, the features of the trousers were decisive. If the trousers had not been white and perhaps if they had not been English . . . So he had *writing trousers*. This is the revelation of a secret. Of course I am talking about a *true* text. All the false texts are outside.

The story of the wolf who loves the lamb he does not eat

M.C-G.: I would love it if you would tell the story of the wolf and the lamb according to the fable of Tsvetaeva: the wolf who loves the lamb he does not eat. There is also playing on inside–outside here and it is a fine metaphor for writing. We could end our interviews on this story which comes back to what we said about love, about vulnerability, about the fact that it takes a lot of love to write.

H.C.: This splendid sentence, which needs some explanation, belongs to Tsvetaeva's libidinal economy. It refers to a character that reappears in all of her texts and which is the character she loves: it is the devil, the fearsome Cossack impostor Pugachev. It is the character of Pugachev who looms in Griniov's dream in Pushkin's *The Captain's Daughter*; in the dream of this sixteen-year-old boy, he arises in the figure of the adored father; and when the young adolescent approaches the bed of his father who is dying, the father – tender, loved, respected – rises suddenly, grabs an axe, and with gleaming eyes jumps on his son. And the son then realizes that it's the Cossack Pugachev. He is half dead with terror. At that moment, Pugachev does not kill him. He says to him: Do not be afraid. With his gleaming eyes that terrify him and fascinate him.

So a magnificent figure is presented here: the figure of the assassin who does not kill. Even better: of the violent, bloodthirsty father, who loves you, *you* exclusively. You are the dear child of the murderous father who saves you. This is the loving structure of Tsvetaeva. She loves the wolf. She does not love the lamb. Well, on this I agree, I do not see who in the world loves the lamb.

M.C-G.: It's not interesting! . . .

H.C.: What interest is there in loving a lamb? In the scene or in the fable, explicitly, the lamb bores her and the wolf fills her with enthusiasm. Not just any wolf. She loves the wolf that is capable of love. It is even more complicated: she loves the wolf who loves the lamb he does not eat. That is to say: who loves the lamb *thus* he does not eat him. It is a paradoxical figure: the wolf who contains, hides or reveals an unexpected sweetness in his violence. Clearly, the fact that there is sweetness in the wolf makes the sweetness sweeter than the banal sweetness of naturally sweet people. The sweetness of the cruel is a greater sweetness. And then, it says something also about the secret of the wolf.

M.C-G.: What is lovely is: the lamb that he does not eat. A lamb on the edge of disaster, spared, but at any moment liable to be (re)eaten. This is precisely why he is loved. The wolf does not eat him: *that's why* he loves him: a lamb-that-is-not-eaten-but-that-could-be.

H.C.: The wolf loves the object he does not eat and thus to which, on the occasion of which, he manifests his magnanimity, his generosity, his capacity to deprive himself for the sake of the other – to do without both food and the exercise of an activity that defines him. He is capable of 'unwolfing' himself [*laughs*] out of love. But at this moment, if he loves the lamb it is also because he receives in return the brilliance, the irradiation, the emanation of his greatness, of his abnegation. And he feeds on his spiritual brilliance, rather than lamb flesh.

> *Why*
> The word innocent is beautiful
> *and*
> *why*
> the word guilty is ugly
>
> If one called the guilty innocent,
> wouldn't it seem less repulsive

We love the other to the extent to which we love to love. We love to love because it is an activity which, as a rule, let us say half the time, is a generous activity. The other half is just the opposite: it is an activity that is avaricious, capturing, destructive, etc. But the generous part is gratifying: we are happy with ourselves. We love ourselves. We love to love because, in loving, we love our loving selves. It is even perhaps the secret of love: the narcissistic satisfaction that can develop in so far as it is engendered, it is maintained by the best there is in us. We are very happy when we can be good – and that, obviously, it does not cost us very much. Well, that is our economy . . .

N.B.: We love ourselves loving. We love ourselves loved. When we are loved we gain (the best of) ourselves. But we only gain it, naturally, by meriting it. And we merit it with the sweat of the heart. But the sweat of the heart is sweet.

M.C-G.: The sweat of the heart is tears. Poets have rhymed bitter-love [*amer-amour*]. The ones you evoke are without bitterness: we navigate in sweet, fresh waters. According one's heart, according to the slope: gentle, sweet-sloped love?

H.C.: In the end, love is very easy. When you love, it's easy; all that is difficult is easy. Because you are continuously paying yourself, without any difficulty you can renounce what you do not renounce without love.

M.C-G.: That makes love a component relationship of the loving subject. There is narcissism, but paradoxically it leads to a surpassing of oneself.

We love ourselves big, surpassing ourselves

H.C.: We love ourselves big. We love ourselves surpassing ourselves. All the things in love that seem to be exercises of virtue, are in reality self-satisfaction.

M.C-G.: It's nonetheless *better.*

H.C.: Ah, yes it's better! So much the better! Because thanks to love we can do anything. We do ourselves good in loving. And

perhaps, if we knew it we would love more, because loving is very
. . . very profitable.

M.C-G.: There is the other way of looking at it: if the wolf accepts to be non-wolf, or is fascinated by the non-wolf in himself, he also consents, in a way, to expose his vulnerability. To no longer make use of prerogatives, of force. The lamb-that-isn't-eaten-but-that-could-be points up the (spared) fragility of the lamb but also the (consented) fragility of the wolf. This makes love the exchange of two forms of vulnerability. That's it's force.

H.C.: I am saying things that can appear to be harsh, or belittling of love. No, I simply want to express a certain truth: it's easy to love . . . *once you love!* You have to get there first! [*Laughs.*]

M.C-G.: Exactly: first you have to be in the other world. Transported by magic!

less self

H.C.: To get there, one needs strength, the real strength of abnegation which is renouncement: before all the other renounce-ments that will follow, in particular the renouncement of the affirmation of an identity. One must open oneself, one must make room for the other. Accept an entirely amazing change in economy that is produced: *less self.* A reduced resistance of the ego. It is also to no longer be the first character of one's life, but the second. Even if the second can become the first in the 'tornament' of love. Even so, one needs an immense narcissistic force to begin, and afterward, one is rewarded! [*Laughs.*] Once you have passed the threshold and you find yourself in the world of love, then everything becomes easy. It is the passage that can appear to be difficult.

M.C-G.: In love, this situation that demands renouncement and that gives gratification supports the paradox: at once the desire to assimilate, to anni-hilate, and the refusal to do so . . .

H.C.: It must also be said, of course, that we are all wolves in love. I am not sure that we are also lambs. I think we are above all

wolves. It is known that love is devouring. It is the great drama of love: we want at once to devour the other and not to devour the other. To not want to devour the other is not a mark of love, but a mark of disinterest. So it's the two at the same time: we want at any price to devour the other, and so it is an homage (the desire for the other, in this form, is a sign of love), and at the same time, we know that if we devour them . . . there will be no more . . . We must perform this double movement all the time. One must desire above all, be ready to kill for it, and at the same time be able to renounce the satisfaction of one's desires *in extremis*. In extremis. Just before destroying. But *even so it's easy*. The difficult passage is easy too: it happens in a flash. In a leap. Without transition. It is the lightning movement of trust. Without reserve and without calculation. We must realize that to love is not of this world, but of another planet. What can be confusing and misleading is that the other planet, which is ruled by the absolute and by faith, is nonetheless located in this world. So that when we love, we are subject to a double regime: that of the ordinary world with its economy and its common laws, and simultaneously that of the singular planet where everything is different. And what is impossible in this world is at the same moment possible in the sphere of love. Words even change meaning when we change levels. The word lamb, the word eat. In the sphere of love, all is grace, free, without price. All is 'easy': nothing is easy: all is given: all is to be given. Because this sphere must be created, at every instant. In reality, the misfortune is that we do not always see the limit. Sometimes we are already in the process of having destroyed without having noticed that the limit was crossed. In any case, to love well, to belove, is relentless work.

> If someone asked me what do you prefer: to abandon or to be abandoned, concerning a person dear to me, I would not hesitate, I prefer to be abandoned.
> However nothing frightens me more than abandonment, but at least in abandonment I do not abandon myself.

M.C-G.: What is fabulous is that it is never definitively settled.

H.C.: That is why love is fragile. Because very often we rest! We stop. And we no longer love.

M.C-G.: The story of the wolf who loves the lamb he doesn't eat could also be a parable of writing in so far as, in writing (as we have been speaking of it), there is the necessity of abandoning oneself, of abandoning a conventional image of oneself, of letting oneself go, of practising a permeability, a vulnerability with which writing nonetheless works?

H.C.: I think that what one abandons in writing is one's resistance. One must at once be afraid, have or keep fear, and cross through fear. In principle, writing leads to enrichment – not of the self but of the self of the person in labour. But in writing, we do not love anyone. Or rather *we love (no)one. On aime personne.* Niemand.

M.C-G.: I do not want to suggest forced coincidences, but in writing the subject must forget itself a bit (him or her) so as to enrich itself from its non-subject, something in itself that it can only encounter by going out. Outside.

(It is only in the act of love that we are present)

H.C.: But in my experience, forgetting oneself is not a sacrifice. It is exalting in a certain way. Besides, it is only making room. Making room for the other part of myself who is the other, who can only exist, of course, if I am there to receive. In other words: becoming a receiver, withdrawing, putting oneself way in the back – this is the condition *sine qua non.* Perhaps this brings us back to love. That is: to love the other more than oneself. But doing that is of course the best way of augmenting oneself, indirectly.

M.C-G.: This comes back to the difficulty of removing resistance and obstacles. For someone who has never written, this must be as difficult as the beginning in love: removing the resistance that prevents our going towards the other-self. The dawn of another self. Where we become inventors: (dis)-placed in a scene that gives us the unknown (person).

H.C.: I think we probably love more easily than we write – which does not mean that we love well. But we have more numerous experiences of love than of writing. Because we cannot not love

when we live. It is our motivating force. That is what living is: the search for love. And its substitutes. Because we also discover how few possibilities there are to exercise love. The scarceness, incidentally, is related to the scaredness: the fear everyone has of losing. Of losing oneself. I also ought to say, counselled by human prudence: we cannot not be *tempted* to love. Most people flee the temptation. Some do not flee, knowing, as does everyone, that love is dreadful. As dreadful and desirable as God. But no one *chooses*: the two possibilities – to flee, to succumb – carry us off. It is stronger than we are. We are all subjects of the fortune called grace.

Notes

All notes have been supplied by the translator.

1 Buses in Algiers had open platforms from which one could lean out to watch the reflected city in the windows.

2 *Dès qu'il est saisi par l'écriture, le concept est cuit*, playing on the bivalence of *saisir* (to grasp/to sear) and *cuire* (to finish off/to cook).

3 Literally *betweentwo* (or perhaps *entertwo*), meaning the space or the time between two things, points, events.

4 Unless 'the one' refers to an explicitly feminine antecedent, this expression as a rule takes the masculine pronoun *un* rather than the feminine *une*.

5 And the *altérité*, translated here as otherness, even contains the earth (*la terre*) in its French phonetics.

6 The noun *jouissance* derives from the verb *jouir*, which says with particular economy 'to orgasm' and 'to enjoy' (including the sense of possessing or having the use of). Translated primarily as joy/enjoy in this paragraph and the following one, these words will often be left untranslated in the text.

7 . . . need third party, false third party, mistake yesterday, need yesterday, false witness, true witness, need falsehood/forgery/ scythe, forgery fault, scythe fails . . .

8 The words for the back, *dos*, and for the first of the sol–fa tones, *do*, are homonyms in French.

9 All three of these phrases can be translated as 'both of them'. Literally: 'all the twos', 'all two' and 'the twos'.

10 French-language reference dictionary.

11 A possible translation: 'Well indeed she will fall'.

12 Literally: fall.

13 *Séparéunis*, a Cixousian neologism that says: separatesreunites, separatedunited, separatesandunites . . .

14 The initials of *différence sexuelle* are phonetically indistinguishable in French pronunciation from *déesse*, goddess.

15 The noun '*repentir*', meaning 'repentance', or 'regret', is also a technical term in painting (cf. the Italian *pentimento*), and has generally been translated in what follows as 'correction', as has the reflexive verb '*se repentir*' (a new meaning Cixous confers on the verb).

16 'Empty Da(sein)', or perhaps 'yah void' . . .

17 The lettre D in French pronunciation and the word *dés* [dice] are homophonic; cf. Mallarmé's *Un coup de dés jamais n'abolira le hasard*.

18 'D major' in German.

19 Approximately: *stuff me in*.

20 The elegance of the distinction between '(*se*) *repentir*' and '(*se*) *reprendre*' suffers in the translation. '*Se reprendre*' has been rendered for the most part as 'to recycle (oneself)', although it also suggests (thanks in part to the non-reflexive '*reprendre*') to take back, to resume, to reproach, to reconsider, to recompose, among other things.

21 In English: 'you just left', but the idiomatic expression for 'you just . . .' i.e., '*tu viens de* . . .' could be translated 'literally' as 'you come from . . .' which would give here: 'you come from leaving', for instance.

22 As we will see, this sentence supports three different readings: 'The hour to write is coming', 'The hour just wrote', and 'The hour comes from writing'.

23 *Le chemin des crêtes* is a road in Algiers that climbs from the port to the neighbourhood where Cixous lived as a child, overlooking the city. Derrida lived halfway up.

24 Written this way, the word contains both the earth and the sky (*la terre* and *le ciel*).

25 Three phrases homophonic with *parallèles*, approximately: 'attend to/prepare for/ward off the wing', 'attend to/prepare for/ward off the she', and 'she should get her share/(he should get his) share of her/go to her'.

26 *Zones in(terre)conscientes*: unconscious, interconscious zones, with a parenthetical earth, perhaps unearthed- if not buried-conscious zones.

27 *jumelles*, meaning also 'twin girls'.

28 Common acronym for the Renault 5.

29 *À l'étranger* could be translated by either 'abroad', or 'to the foreigner'.

30 *Devant* is both a preposition 'in front of' and the present participle of the verb *devoir* meaning 'to owe' (transitive) and 'to have to' (auxiliary), which gives us: 'He (the reader) in front of the writing', 'He having to write it', 'He owing the writing', '(I) owing him writing'.

31 Idiomatic expression meaning 'at twilight'.

Appendices

Excerpt 1: Jacques Derrida, 'Fourmis', *Lectures de la Différence Sexuelle*

Ant is a brand new word for me. It comes to me from one of Hélène's dreams, a dream she dreamed and that she told me recently without knowing until this instant how this 'ant' would make its way within me, insinuating itself between experiences that resemble song as much as work, like the animals of the fable, one of Hélène's dreams that as far as I know I am the only one to know, of which I will apparently say nothing, nothing direct, but of which I note already, because there was epiphany of an ant [*un fourmi*] in the dream, that it is very hard to see, if not to know, the sexual difference of an ant, and not only because it is imperceptibly black, but because as soon as in a dream, for example Hélène's dream, the word *fourmi* becomes masculine, we see it at once hidden to seeing, doomed to the blackness of blindness, but promised by this very fact to reading.[1]
Une fourmi can be seen, perhaps, but already so as to defy us to identify the sex of this little black living thing. As for *un fourmi*, it is already the adventure of reading and interpretation,[2] it crawls with thousands of meanings, with a thousand and one images, with a thousand and one sexes, it cuts itself in the middle (four/mis) it can lose its two wings or only one (because the ant, Hélène's insect, is a winged insect [*à aile*], an insect that is classed among the winged insects, the hymenoptera), it is put, and it's put in the oven, the he-ant put into motion/the oven turned on [*le fourmis en marche*], in the little oven and the great oven of all the incinerations, it makes, once it's been cut in two, sentences forward and backward, up to the end or halfway, it gives everything, it furnishes drink and food, the fourme, that is to say the form *I*, it goes in the oven or the furnace both the crust and the soft part, it's good like the bread one shares and eats in the family – and families are also anthills – but it's also something to vomit like the inedible itself.

I am not in the process of writing a new fable about *la cigale et le fourmi*,[3] nor of suggesting that sexual difference reads like a fable, as if it were a fable. If I were to say 'sexual difference is a fable', the copula 'is' would permit the proposition to be turned around: a fable, thus every fable, is sexual difference, which can be understood in many ways. We can say that every fabulous narrative recounts sexual difference, stages it, teaches it or offers it for interpretation; or

that 'fable', that is to say, speech or parable, *is* all of sexual difference. Sexual difference, if there were such a thing, would be fabulous. There would be no speech, no word, no talking that would not say and would not be and would not institute or would not translate something like sexual difference, this fabulous sexual difference. And there would be no sexual difference that would not go through speech, thus through the word *fable*.

This fable was given to me, like a word, by Hélène's telephoned dream. And as I asked a few minutes ago the question, 'What is it to give the word [*donner le mot*]?' or, 'What is it to give the thing?', 'What is it to give?', 'What do we mean by "to give"?' before the word or the thing, I will advance the following thesis (in a dogmatic and elliptical fashion, so as not to speak a long time or all the time): if there is giving, it must give itself as a dream, as in a dream. For the unconscious or for pure consciousness there is no gift, nor any forgiving, only exchange and the restricted economy, because there is gratitude, symbolic return, because there is 'thank you', when the consciousness of giving compensates and recompenses itself, when it thanks itself and in its turn remakes the mercenary or mercantile circle of salary (the deadly logic of the 'wait your turn' [*à chacun son tour*]). One can only give without knowing – and if consciousness as well as a certain unconscious are figures of knowledge, then permit me to see in the dream the figure at least of this gift that carries between the two and beyond the two. No longer the gift for gift (gift and counter-gift), but the gift-by-gift, when one must (duty without duty) forgive the gift for interrupting the circle of revenge or breaking the mirror of resentment, where one risks no longer knowing that giving knows how to receive.

It's a dream, of course. And if one can only give while dreaming, one can only dream of giving. Even so one must have the unchangeable and unexchangeable grace of certain dreams. Even so one must know how to dream. Enough to foil, in dream, the avaricious circle of absolute knowledge.

Fourmi, this is not only the figure of the very small, the scale of the minuscule (small as an ant) and the microscopic figure of innumerable multiplicity, of the incalculable of what teems and swarms without counting, without letting itself be counted, without letting itself be taken in (I will return to the tale, the narrative and the fable in a moment).[4] The ant, the swarming of the ant is also the

thing that is *insect*. Hymnenopteran insect, thus winged insect, hymeneal insect, with veiled wings, with wings in the form of veils. It teems and swarms. The word *insect* participates in the teeming anthill of the word *fourmi*. (In parentheses, I note that all words are ants, and in this way insects, we must draw all the conclusions for sexual difference: as soon as words join in, as soon as they are a party to sexual difference or sexual difference has a brush with them, here is my hypothesis, as soon as there is sexual difference, there are words or rather traces *to read*. It begins *in this way*. There can be traces without sexual difference, for example with asexual living things, but there cannot be sexual difference without trace, and this holds not only for 'us', for the living things we call human. But from here on, sexual difference is to be interpreted, to be deciphered, to be decoded, to be read and not to be seen. Readable, thus invisible, the object of testimony and not of proof – and in the same stroke problematic, mobile, not assured – it passes by, it is in passage, it passes from the one to the other, by the one and the other, from *l'une* to the other like *une fourmi, un fourmi* of a dream.) The word *insect*, thus, as we hear it without seeing it, as on the telephone, crawls with meanings and it offers for reading all that can be deciphered on the programme of this conference.

Let us start with the *neuter* (it is also the title of one of Hélène's novels, one of her immense fables). Everything passes by the neuter. First, 'insecta', the Latin word for *insect*, is a *neuter* (always in the plural, as if there were never *one* insect but a collective of insects, an anthill of insects: *insecta, insectorum*). And this plural neuter, *insecta*, does not mean insecable, indivisible, atomic. It is said, on the contrary, to come from *inseco* which means to cut, to dissect, at times to tear with the teeth (*dentibus aliquid insecare*), to put into small pieces. The frequentative *insector* means 'to pursue without respite', to be on the heels, to hasten energetically, to seduce, perhaps to court, to harass, to go after – etc. As '*insecta*', this sort of genus [*genre*], of quasi-genus specified by thousands of species, the ant is a cut invertebrate (the word means *cut*, it names the cutting), that is to say divided into small strangulations by so many annuli.

In the end the ant merits the title of insect: it is an annulated animal. Its body is marked, phrased, strictured by an annular multiplicity of rings, which cut it without cutting it, divide it without slicing, differentiate it without dissociating it – even though the

word *insecta*, from *inseco*, means 'cut'. Thus a word meaning 'cut' comes to signify 'strangulated', but not 'cut', both (but) cut and (but) non-cut, separated but (and) non-separated, no sooner cut than repaired.

Here is what we would like to speak of: of the separation/non-separation, of the cut/non-cut – and of the word 'sex', of sexual difference in its relation to the cut (and) (but) non-cut, to the cut that no longer opposes itself to the non-cut, between the 'separating' and the 'repairing'. Here, to 'parry' between two, to 'adorn' oneself [*se 'parer'*] between 'separate' and 'repair', the one becomes two and then one with the other without ceasing to be *un séparé*,[5] that is to say two beyond all arithmetic, separation *and* reparation, separation *as* reparation. Here [*là*], with *là*, as with the parry of the se-reparation, we are already speaking about [*au titre d'*] Hélène. I will not only cite the magnificent titles that all tell of the hymen and of sexual difference: *La* (republished in 1979) or *Illa* (1980) nor the *Préparatifs de noces* (1978), etc. No, I will cite in passing the appearance of the words 'separation/reparation', the two of them associated in the recent 'Self-portraits of a blind woman' (which are, as you know, a chapter of *FirstDays of the Year* published a few months ago without our ever having passed the word between us,[6] as she wrote her '*Autoportraits d'une aveugle*' at about the same time I was writing *Mémoires d'aveugles, L'autoportrait et autres ruines*).

In the chapter of *FirstDays of the Year* entitled '*Autoportraits d'une aveugle*' ('Self-portraits' in the plural, this time, and 'blind' in the feminine; I have tried to explain why the blind of mythology or of revelation are almost always men; *une aveugle* is almost as strange a word in French as *un fourmi*, but we will return to this, it is more complicated), a certain *Story of Contretemps*[7] (the expression *Story of Contretemps* is in italics as for a title to be read; without our having passed the word between us, I had previously used *contretemps* in the title of an aphoristic text concerning another aphoristic couple that Hélène knows well, Romeo and Juliet), a certain *Histoire de Contretemps* begins with a *bench*. It begins on a bench – and it is also a scene of reading, a reading of sexual difference: between separation and reparation, the in-between between Separation and Reparation.

Each one of the two words, *Reparation* and *Separation*, remains all alone. Each one all alone is a sentence, but that sentence is a

question ('Reparation? Separation?'). Each one stands in its solitude – and, between the two, there is the between. But the between which opens in the instant someone enters, some 'one', Onegin. I'll read a passage, it's better to read, always:

> Because this *Story of Contretemps* begins with *a bench* [. . .]
> What I love: the race, what Marina loves: the bench. Each one reads in her own book. The author: hesitates. In Marina's: a bench.
> A bench. On the bench Tatiana. Enter Onegin. He does not sit down. Everything is already broken off. It's she who gets up. Reparation? They remain standing, the two of them. Separation? All two of them.[8]
>
> *(Jours de l'an, pp. 190–1)*

'All two of them': *tous les deux* is one of the most singular works of French grammar. Hélène has a genius for making the language speak, down to the most familiar idiom, the place where it seems to be crawling with secrets which give way to thought. She knows how to make it say what it keeps in reserve, which in the process also makes it come out of its reserve. Thus: *tous les deux* can always be heard as *all the 'twos'*, all the couples, the duals, the duos, the differences, all the dyads in the world: each time there's two in the world. The singular name of this plural which nonetheless regroups couples and dual unities, '*tous les deux*' thus becomes the subject or the origin of a fable, history and morality included. The fable says everything that can happen *to* sexual difference or *from* sexual difference. Here, in the more narrowly delimited sequence of this *Story of Contretemps*, it remains impossible to decide if this '*tous les deux*', which repeats the earlier '*tous les deux*' (I reread: 'Reparation? They remain standing, the two of them. Separation? All two of them. But it's only he who speaks. He speaks for a long time. All the time. As for her, she does not say a word.'), means *both of them*, him and her, in the most ordinary and obvious sense (when *tous les deux* means the one and the other, both together, in chorus, equally, indissociably, of common accord, all two of them as one, inseparable in this sense) or *all the twos*, 'reparation' and 'separation', the one and the other, the reparation which doesn't separate itself from the separation, that is from the irreparable separation, the irreparable separation of the pair disparate in its very appearance. In this second hearing, what makes *tous les deux* inseparable includes also the

separation which unites them, the experience of distancing or inaccessibility which conjoins them still.

> But it's only he who speaks. He speaks for a long time. All the time. As for her, she does not say a word. Between them, speech does not give the word [*les paroles ne donnent pas le mot*].

Not to give the word, for speech, is strange. This complicates the questions of what it means to *give the floor* [*donner la parole*], to *give one's word* [*donner sa parole*], which gives still something else, to give a thing and to give the word, to give in general, to give the given. So it happens now that wordless speech comes to us, in any case speech which, if it has the word, and maybe the closing word or the password, does not give it. Is speech which does not give the word the same thing as speech which does not give the floor? Not to give the floor to the other, to interdict the other or to deprive the other of the right to respond, and certain people who are also orators or rhetoricians know how: it is always in speaking that this operation takes place. But maybe we need to distinguish here between, *on the one hand*, '*donner le mot*' which can mean to unveil the password or the closing word, to turn over the secret or the key of a reading, for example of sexual difference, and, *on the other hand*, something else entirely, '*se donner le mot*'. (That is, just what we have not done, Hélène and I, today: *se donner le mot* is to agree together as accomplices to stage an operation, to plot, to sketch the 'plot' of an intrigue; unless absolute conspirators, those who haven't had to decide on their conspiracy with a contract, don't even need to pass the word to find themselves at the appointment, with or without contretemps, my other hypothesis being that there are no appointments without the space of the contretemps, without the spacing of the contretemps, and there is no contretemps without sexual difference, as if sexual difference were contretemps itself, a *Story of Contretemps*. One of the effects of Contretemps today is that, among other things, Hélène furnished me *unknowingly* with the word *fourmi*, giving it to me thus. Her dream gave it to me without knowing what it was doing, without knowing what I would do with it, without knowing period, because one can only give without knowing. Her dream gave me the word not only as a term that I would play on today without playing, but as a word, and no doubt a

thing, a living winged being, that I had never before seen in my life. It is an epiphany in my language and in the world that is tuned to it. It is as if, blind, I had never seen '*fourmi*' before, neither '*fourmi*' the noun, nor '*fourmi*' the phrase nor *fourmi* the thing or the animal with or without wings, and even less the *fourmi*, someone named *fourmi*. My God, who is it? Who could be named *fourmi*? And how he's changed!)

All this happened, all this was given in dream, from Hélène's dream. If we have the time, because I am speaking all the time here (whereas when the two of us speak, above all on the telephone, it is Hélène who speaks all the time, more or less), if we have the time, I will say how I see the difference of the dream, between her and me, and why she writes *to* the dream [*au rêve*], if you will, she strides to the dream when she writes, that is, if you follow the premises of my reasoning, she gives in writing, she gives to write, she advances to the dream, she advances on the dream, she nourishes herself with dream but also she strides *on it, towards it*, she goes to, gives herself up [*se rend*] to it, in advance, while as for me, I stride to the interruption of the dream or rather to a certain separation/reparation of the dream: I strangle the dream, the dream strangles itself in me, tightens and compresses itself, represses itself, prevails over itself also, like an ant at work, as an insect strangles, compresses, disciplines itself laboriously in the corset of its annuli. Hélène, as for her, lets the gift of the dream breathe in her writing. It is as if her dream were at home there.

I'll resume my reading of *First Days of the Year* repeating a bit for memory:

> Everything is already broken off. It's she who gets up. Reparation? They remain standing, the two of them. Separation? All two of them. But it's only he who speaks. He speaks for a long time. All the time. As for her, she does not say a word. Between them, speech does not give the word.
> Has entered: Time, long time, distancing: with large strokes between the two of them he digs and digs (. . .)

How can time enter? How can we say of time that he arrives, that he enters in a stroke, 'with large strokes'? One must be two, in two, 'all the twos' for that, maybe, on the verge of giving each other the floor, if not the word.

In the preceding paragraph, a sentence began with this inversion of the subject: 'Enter Onegin'. Onegin speaks 'a long time. All the time'. Hélène says 'all' ['*tout*']. After the singular '*tous*' of '*tous les deux*', we have here the no less singular '*tout*' of '*tout le temps*'. How can one 'all the time'? give, give oneself or take all the time? What then remains? This gives all the more for meditation: from one totality to the other, is not the most common trait precisely the impossibility of totalizing? The two idiomatic occurrences of '*tous*' and '*tout*' have to do with fracture, with infinite separation or interrupting distance: difference itself. So beautiful and so mysterious an invention, so impossible, as beautiful and as impossible as '*tous les deux*', this '*tout le temps*' with no remains is clearly the most enigmatic subject of that difference between him and her. We're going back in time, we're recounting it backwards to precede it with its fable. We hear '*tout le temps*' as for the first time from a poem and as if the internal and intense versification of this '*tout le temps*' came down to saying the time of time, the staggering origin of temporality itself, there where time in a stroke enters on stage. One must be two, 'all two of them', for this anabasis of time to have a chance of happening, 'between the two of them'.

Notes

All notes have been supplied by the translator.

1 While the grammatical gender of *fourmi* is female (*une fourmi*), Cixous's dream involved a grammatically masculine ant (*un fourmi*).

2 This sentence is itself teeming with ants: *fourmiller* (to crawl or teem with), *mille* (one thousand), *milieu* (middle), *four* (oven), *mis* (put), *mi-chemin* (halfway), *fournit* (furnish), *fournil* (furnace), *mie* (soft part of bread), *famille* (family), *fourmillière* (anthill) . . .

3 *La cigale et la fourmi* (The Cicada and the Ant) is a fable by La Fontaine.

4 This comment refers to the idiomatic expression *s'en laisser conter*, translated as to let oneself be taken in, but which turns on the verb *conter*: to tell or rather to recount, for instance an account, a fable or a tale (*un conte*), and not far from *compter*, to count.

5 *One separated*, or *a separate* (person or thing, as if it were a noun), not far phonetically from *unseparated*, and *one – it's just the same*.

6 Derrida returns to this expression (*se donner le mot*, literally *to give oneself* or *one another the word*) a bit further on, where he 'translates' it himself.

7 *Contretemps*: a mishap or a hitch, an anachronous syncopation, 'against-time'.

8 'The two of them', and 'all two of them' both translate the French idiomatic expression *tous les deux*, rendered more literally by 'all the twos'.

Excerpt 2: Hélène Cixous, 'Quelle heure est-il?'
Le Passage des frontières.

'Ah! in three months, I will be fifty; is it possible?' exclaims Stendhal, another unlimited child, to whom the incredible happens, the incredible same –

> It was the morning of 16 October 1832, at San Pietro in Montorio, on Mount Janicule, in Rome; it was magnificently sunny. A light sirocco wind barely perceptible made a few small white clouds float above Mount Albano, a delicious heat reigned in the air; I was happy to be living. I could perfectly well make out Frascati and Castel Gandolfo which are four leagues from here . . . I see perfectly well the white wall that marks the reparations made finally by the prince François Borghèse, . . .
>
> What a magnificent view! So it is here that *The Transfiguration* of Raphaël was admired during two and a half centuries . . . So during two hundred and fifty years that masterpiece was here: two hundred and fifty years![1]

and all of a sudden a cry: Ah! the hour rises, over there, in three months I will be fifty years old. Who would believe it? And he checks on his fingers: 1783, 93 . . .

> . . . Ah! in three months I will be fifty; is it possible? 1783, 93, 1803: I follow the whole count on my fingers . . . and 1833: fifty. Is it possible? Fifty! I am going to be fifty, and I sang the aria of Grétry

> *Quand on a la cinquantaine.*[2]

> This unforeseen discovery did not irritate me, I had just been daydreaming about Hannibal and the Romans? Greater men than I are dead! . . .

When one is fifty – and in fact the song says sixty. I am going to be 'sixty'. Is it the name of a sickness? an honourific decoration? I have become a 'sexagenarian'! a friend of mine says laughing. What a nickname! What an adventure! Is it possible? Perhaps; but not true. So this is what can happen to us: a signifier, full of sound and laughter, and signifying nothing. If not: 'auch einer'. Him too, me too, I am one. Me too, I have it, the mark – the virus – the circumcision continues . . .

Indeed? So, struck with incredulity, we write an Essay on circumfession: an attempt to spit up the most secret blood to try and see with one's own eyes the interior colour – of what? – of one's own mind, the personal juice of life, the interior proof of the existence of oneself,

an attempt to catch the mortal material that irrigates the immortal soul, to *see* the principle. Ah! what a shock, at the sight of this red inhabitant that holds our secret codes. The haematologist-heimatologist apprentices that we are exclaim: And I am the result of this blood and the sum of these decades? Is my life in me, in front of me, behind me, before me, longer than I? Who's in command here? I want it to be me! Who me? We all would like one time to have hands to take ourselves wholly in those hands, arms to embrace ourselves right from the first day including the last.

And Stendhal sets himself writing the 'Life-of-Henry-Brulard-written-by-himself', because of 'this unforeseen discovery'. And better yet, out of his own trousers in a flash, leaping on himself, and capturing himself in full foreignness, ah! I have hold of myself, and I will write my *Life* myself. Let's at it, Life! he cries to this life, his own, which gallops off, stumbles, throws him, he loathes that, this life he mounts and which does not obey him, he is mad about it as about a mare. He called it Life, this stubborn one that travels him over and unseats him – as if he had always sensed it dashing off, taking English leave from its French master.

And J.D. going to see, tracing back the vein to circumvent himself, going so far as to take fifty-nine turns around J., because we know since the Bible that in due time the walls yield. The dream is to be there, at the first hour, to be able to respond, to be witness to one's own birth, to arrive where Esther was, Esther my mother, Wo Esther war soll ich gehen – my mother the proof, my mother who circulates in me, my mother who is in me as I was in her, what a strange bond, strange and red, contained, and which does not collect itself, does not stop, which goes by, escapes, follows its course across generations, carrying our colours well beyond ourselves. Here, in the invisible inside, I no longer know if I am the subject of verbs in the past, in the present, or if already today is the day before yesterday while days of old are part of the future.

In truth, I saw and I see, simultaneously, as Stendhal wrote. I am I was she is me still already she begins to not be [*n'être*], I am

(following) her [*je la suis*] she is not following me, he/she gets ahead of me.

The most surprising is not that I will die, but that I was born, that I am not you, that I am me. I would like to know that one there.

> I sat on the steps of San Pietro and there I dreamed for an hour or two about that idea. I am going to be fifty, it should be high time to get to know myself. What have I been? what am I? I would, in truth, be quite embarrassed to say.[3]

What nostalgia! What jealousy! Everyone will have met him but myself? I would love to love him. What an idea! An idea that comes to us when I leans on my elbows at the edge of me and stretches my neck, pokes my head a little bit outside of time so as to study my self. I would love to confess myself; and the circonfessor is me. That is what circumfession is, confession is inside, it takes place between myself and myself, circumfession is to stick one's head outside of the silk tent, to go beyond one's skin, to go beyond one's death so as to grab one's life by the hair, by the mane. Where are these surprising books written, these books that surprise? To surprise oneself, one must go to the interterritorial places, in the spaces that border me and extend me.

The 'fifty-nine periods and periphrases' of *Circumfession* 'are written in a sort of interior margin, between the book of Geoffrey Bennington and a work in preparation'.[4]

Where to write the words that traverse us taking the footbridge of our body, drawn by an event that we sense and repel, barbed thoughts that transfix us and rush as if mad towards the hated and venerable event, where to write what we can speak to no one, this secret without audible sound that precedes us, of which we are at once the guardian and the celebration?

Where? Between two books, between a book and a work, in a sort of interior margin, between the skin of my belly and the waistband of my trousers,

> Finally, I only came down from the Janicule when the light evening mist came to warn me that soon I would be seized by the sudden and very disagreeable and unhealthy cold that in this country follows immediately the sunset. I hurried back to the Palazzo Conti (Piazza

Minerva); I was exhausted. I was wearing trousers made of white English [—]; I wrote on the waistband inside: *16 octobre 1832. Je vais avoir la cinquantaine*, abbreviated thus so as not to be understood: *J. vaisa voirla5.*[5]

written while still hot, at the extreme, between day and night, just before death,

'abbreviated so as not to be understood',

not understood by whom? the person who will read the message written on the waistband of the trousers? '*J. vaisa voirla5*': You must not say it! No one must know! It is the secret.

Secret proclaimed aloud, but in a book presumed to be posthumous.

But then secret for whom? Secret hidden from whom? Even from myself. I mean: from himself. I mean from myself. Secret announced, but not revealed. Instantaneous. Written to not be read. But to have been written. Who will know? Abbreviated: emergency inscription: must go fast, it's that *J. vaisa voirla5* between one minute and the next. And the first thing that comes into his hand is the trousers.

'I was exhausted – I was wearing trousers' – the harnessing is mad, it gallops.

'I was exhausted – I was wearing trousers, I wrote', this is what I call raw writing.

My waistband murmurs this message to the skin of my belly in a disguised tongue. An utterance that is much closer to the insane truth than the other one, the non-abbreviated one, with its proper air. What is going to happen to J. is incomprehensible in truth.

The scene takes place between these two (hes); he who writes and he-who-reads. The scene takes place with the interior foreigner.[6] The strangeness goes between me and me. Between the skin and the trousers. To write a book in a coded language, a language that is very foreign to me, is the height of writing. And more precisely: to write oneself a book. Because writing does not address first of all the exterior reader, it begins with myself. I write; I write myself, it writes itself. The trousers are the scene of writing in its native clandestineness. Few writers are magic enough, child enough, raw enough, to make this gesture and to transcribe it raw.

Montaigne paints the passage with tamed, subdued, mounted words.

Stendhal formed a single body with writing against the rider he was.

The book escapes him. Like that age, his own, the age of Henry Brulard, unforeseen! those fifties that come up on him. But even so they are his. How to keep and to let run at the same time? To have what one does not have? Try to bring the 'unforeseen discovery' to the interior of the trousers. The waistband will keep the secret.

Without knowing it we have gone into another world. Here, a somewhat mad causality reigns. In this decisive moment everything obeys chance and fantasy. We hear those divinities make the narrative of a musical and capricious genesis lisp with a churreptitious zibboleth.

'I hurried back to the Palazzo Conti [. . .]; I was exhausted. I was wearing trousers made of white English [twill]; I wrote on the waistband inside [. . .]: *J. vaisa voirla5.*' This is the germ of a book that will always be a few necks ahead of its rider.

How old was Stendhal, I mean Henry Brulard, what age did he dare have still or already when he wrote *J. vaisa voirla5*, in three sort of words? The age where magic is law. five years, six years old?

And everything was the fruit of this elusive hour!

*

As soon as it is a question of thinking out a date, of making a notch in the course of blood, of putting a bridle on the wind, we are mad,

A date is mad, that is the truth.

And we are mad about dates.

And how mad we can be when we're alone with our trousers! Mad, that is to say free.

A date is mad: it is never what it is, what it says it is, always more or less than what it is. What it is is either what it is or what it is not. It is not a matter of being, of some meaning of being, this is the condition on which its mad incantation becomes music. It remains without being, by force of music, remains for the song, *Singbarer Rest*, this is the *incipit* or the title of a poem that *begins* by saying the remains. It begins with the remains – which are not and are not being –, letting a wordless (*lautlos*) song be heard, perhaps an inaudible or inarticulated song, yet a song whose turn and whose line, whose sketch, whose contour line (*Umriss*) is undoubtedly due to the cutting, sharpened, concise, but also rounded, circumventing form of a sickle, of a writing still, of a writing.[7]

A date says our human madness. To think that we date God! What liberty!We plant flags in blood.

Notes

1 Stendhal, 'Vie de Henry Brulard', *Oeuvres Intimes II* (La Pléiade, 1982), pp. 529–31.

2 'When one is fifty', or 'when one reaches one's fifties'. According to the note in the volume of *La Pléiade*: 'Aria from *La Fausse Magie* (act I, sc. vi), opéra comique, words by Marmontel, music by Grétry (1775), Stendhal was mistaken by his memory, unless he deliberately wanted to make the words of the aria coincide with his own case, as the text reads: *sixty*. He had known *La Fausse Magie* for a long time.' See the *Journal* of 21 September 1804 (vol. I, pp. 125–6), *Oeuvres Intimes* II, p. 1318.

3 *Oeuvres Intimes* II, p. 532.

4 Jacques Derrida, *Circonfession*, in G. Bennington and J. Derrida, *Jacques Derrida* (Seuil 1991), p. 5.

5 *Oeuvres Intimes* II, p. 533.

6 *A l'étranger intérieur* could also translate as 'abroad interior'. [Trans.]

7 Jacques Derrida, *Schibboleth*, p. 68.

Portrait of the writing

by
Mireille Calle-Gruber

Portrait of writing
Writing-thinking

> One *must* go all the way to beyond
> the possibilities of the instrument. But
> unconsciously.
> We are here to lose
>
> (*L'ange au secret*)

The critical approach here does not go without the *undecidable* which works it in turn. Or rather, without a relation of uncertainty that slips away from what would be an act of taking, that grapples with the work which calls for it – at the price of not saying a word. Mesmerizing reading: in the face of something that interpolates, *puts* everything *into questions*. Namely into these:

Is it a matter of speaking *about*, feigning that the books are objectified according to the established index of ideas, themes, images, and the re-unions with the catalogue of the traits of what is eternally human? In this case it is a takeover by force [*coup de force*] on the part of the topic that attempts to class the unclassable.

Or is it a matter of speaking *with*, maintaining in a mimetic and identifica-tional discourse the illusion that the author of the work and her reader ex-change glances face to face? In this case it is a love at first sight [*coup de cœur*] making one forget that writing discourses *in absentia*, as far as the eye can see, and that the reader blinds herself in the mirror.

Or is it a matter of speaking *on*, the pen running over, covering, pre-text-ing the Cixous text so as to gloss its dreams, to rewrite its cry? In this case it is

a turn of style [*coup de style*] of the tropic discourse that crosses out and deletes, speaks from between the words and the languages.

These are the questions that are asked of the origin and there is no doubt that the writing of Hélène Cixous solicits and stages this triple modality of speaking. Questions of distance that divide the origin, that confer on the gesture of literary criticism a status that is always already divided, shared. A ruinous reading obsessed by this question: at what distance should we talk about it, write about it? A question grafted onto the other's question, the writer's, which echoes it: at what distance does talking occur in her fiction? It talks to me – to me, of me. It talks to itself – to itself of itself, of the other selves, of the others. And at what distance does the flood of writing emerge, interrupt itself, start off again?

So the critical approach undecides itself on the invitation of works that offer the ruinous and ruiniform writing of a text making its way, giving voice all over. The cost is exorbitant: not a single point of view that isn't immediately overwhelmed, not a single role play that is not displaced, not a single narrative that is not eccentric; not a single beginning that is not disjointed between Auctor and Actor, between the she-*author* [*auteur-elle*] eternally dropping ink(er), from book to book, and the I-wing [*je-aile*] pursuing a thousand I(s). This is what can be deciphered in *Jours de l'an* [*FirstDays of the Year*], where the plural s of 'jour [day]' diverts the common meaning (New Year's Day), no longer designates the first day of the newborn year but rather each day as the birthday of a dead and reborn I:

> The person we have been is now an 'I was', the character from our past. She follows us, but at a distance. And sometimes she can even become a character in one of our books.
>
> This is how I have behind me, one, two, three, four deceased women (and maybe others whose bones and dust are all that's left), of whom one is a mummy, and one could be my friend. The other two I hate.
>
> Left today is the one who will have followed us till here. And who passes with me into the present. We cherish this one, the one who has traversed the decades where others fell: she cannot be, we believe, but the strongest and best of ourselves. This is but a belief. Maybe she's the one who in the end will have been us, we think furtively, is it she we will have been? But maybe things will be altogether to the contrary. She will succumb, and all we will feel for her is a distant wonder?
>
> This is how, every fifteen or twenty years, we lose a life and we welcome another. Behold: we are our own oriental bride. And we desire ourselves in fear.

Certain of our familiars know my future before I do. In our own eyes we are at the age of sixty still baby chicks in the limestone. I will reveal myself in my own time. My already tenuous shell will burst into bits. I sense that this birth is imminent. Already a part of me is future: everything I've just thought is what I'm going to think in the next hour.

(*FirstDays; Jours*, pp. 45–6)[1]

In sum, in the domain of the origin, a complex theatre is brought into play: a *theatre of writing* that indeed consists in effect(s) of distance(s) which is to say of passages from the one to the other, at once mechanism and representation, place and game of retractable spaces, where the doing and the being interpolate each other. The representations of writing are what they make of themselves, do what they say, say what they do, make the true and the false – but true or false matters little; it is the question of doing that prevails. And for this, which is always 'on the point, between already and not yet' (*Jours*, p. 47), the staging must also reduce writing to ashes, making the most of all the props and artifices. A single rule, consequently, seems to guide Cixous's pen: to return to the greatest uncertainty, to let speech speak, to phrase the sentence, to make the tongue slip, without the predestination of a previous thought – because, by virtue of the infinite displacement of meanings, 'death is not what we think' (*Jours*, p. 49), 'the crime is not what we think' (*Jours*, p. 105), 'thinking is not what we think' (*Jours*, pp. 51, 53, 54). The rule is to play dispersion, diversion, surprise, to invent a 'state from before God' that is to say 'the secret of Genesis' (*Jours*, p. 59), and this, in order that writing should *return from afar*, from nothing, from before the History of every story, from before the narratives of society, the common language, the references; in order that, *in extremis*, on delivery, it should strike us with the surprise of a book.

Author, have you ever written the book you wanted to write? What is an author? wonders the author. The shipwrecked, the vanquished survivor of a thousand books.

I had only not to want? That's impossible. We want. That's always how it starts. I wanted. I bore the brunt of a thousand tempests and saved some thirty shells.

Have I ever wanted to write a book and believed I was writing it? I've tried. In the end a book is left. And I adopt it.

(*FirstDays; Jours*, p. 55)

The surprise of the book is this: between abandon ('vanquished') and adoption, to give chance back its rightful place. *In the end*, unhoped-for and

disenchanting, desired and undesirable, run aground and saved, what is giv-
en is a book. A book arrives: as a miracle and as an intruder. It is delivered
(like a posted parcel) and does not reveal itself: in the department of lost and
found objects, an unexpected object that does not cor-respond, emerged
against all expectation, unbeknownst, the Cixousian book is mourning and
gift. Mourning for 'one thousand' lost works that it excludes. A gift without
destination: that was not wanted, not believed, not owed. A left-over. – I will
take it, thank you. – Think nothing of it. Gift of nothing if not the insatiable
desire to write the book that is not written.

> [. . .] for thirty years I have been writing, borne by writing, this book
> that book; and now, suddenly, I sense it: among all these books is the
> book I haven't written; haven't ceased not to write. And it is now I
> sense it, today, one day after February twelfth I learn this and not
> before: here is the book I've missed. [. . .]
> See what can happen to us: for thirty years we never think about
> the book we do not write.
>
> (*FirstDays; Jours*, pp. 7–8)

What asserts itself here is writing in the negative, writing that endeavours
to make the inaudible heard, the unthinkable thought, to induce reading and
writing where there is no writing, with regard to negative constructions that
come into existence in Cixous's texts, that ek-sist, and give a (re)boundary to
the meanings.

A disruption of the concepts and values that ordinarily organize the rela-
tionship to literature follows. Namely, the concept of author. *The author*,
who is inscribed in her books in the foreign body of italics, like a citation, or
else finds herself mentioned incidentally in the recess of the parenthetical
'asks/thinks/says the author', the author is a *so-called*, a *self-calling*, a way
of calling forth a relative authority – an instance forced into relations with I
[*je-aile*] who escape, the book-wreckage that arrives, all the I(s), all the dead
and the characters of the library who pass through. In short, the book is not
proper to the author, it gives itself where by definition there is no property –
but rather expropriation, dispossession without end. Consequently, the
author constantly has her eye on her author's character, who effectively
takes on a dubious, equivocal gender: 'the shipwrecked man, the surviving
woman'; and a double voice, the one as contra-band of the other.

As for the book: it's an unidentifiable object; not a product but *the trace*,
the deposit of something that happened, that is past: the place of a passage,
a place of passages. It is not even an object because it cannot be reified: not

a programme but a jet, pro-ject, tra-jectories; unfinishing; always a book-desire book; a time and space slot opened to/by writing. It is the *scene of writing*: the stage on which it goes, grows, shows itself. It is also *the* scene of writing: primitive, first, fundamental and thus, by definition, *unsupportable* – which nothing prior supports.[2] Hélène Cixous does not write the 'book about nothing', but the book *of nothing*. Exposed.

Writing thus becomes a place of the sublime: exasperating tensions and contrasts, it works frontwards and backwards, reversibility and meaning, adoption and option, tacking stitch and straight thread of narrative, twisted thread and chain of logic. The writing takes meanings obliquely, by tangents. Of wanting, it retains the volition; of ability, the potential; of power, the possibility. In short, it is a writing of the faculties and of the optional – not at all a writing of laws or of prerogatives.[3] To the latter, Hélène Cixous opposes a writing that is a *weak force*: that does not exercise mastery; that at most exercises itself in attempts.

At the beginning of this enterprise are the fault and the fallible – not the Verb. The writing of the feeble force: what is poised to falter and which goes together with the thought of failure. Declension and decline of meanings: the book falls to my lot, the book runs aground, the book founders.

> The tempest passes. We are run aground, swirled around, having wrested a few atoms from the wind, and that's already immense. And yet it was *I* who unleashed it. I press a button and lo, the world's explained, but all *I* command is the button. To think?: to founder. To founder: to think.
>
> (*FirstDays; Jours*, pp. 54–5)

'To think?: to founder. To founder: to think'. Here, the turn of the aphorism is exemplary of what happens *in the course* of the sentence, pen in hand, now on the page: writing always does and says more; repetition, inversion, overflow the pure reciprocity of the round trip, the symmetry is dissymmetry, changing the place of two elements goes together with invention. In sum, every intervention in the text leads to a significant displacement; in this case, something that is not only the bias of a writer but an ethics of writing: preposited, the thinking is destined to founder, to failure; consented at the origin, the failing induces thought. Even more: failing *is* thinking (the failure). Because, in deploying the triple construction (active, passive, reflexive) of the French verb *échouer*, Hélène Cixous emphasizes with acuity that thinking overflows all finality, that thought never arrives (thinks) where it believed it was going (thinking). And in the same breath, the origin is also undone:

writing is end without end, beginning without beginning. The opposite extreme of divine creation: without alpha or omega. In the beginning, it's always already in the middle:

> It is always thus when it comes to beginning a book. We are in the middle. [. . .] God begins – we, no. We: is in the middle. Thus we have begun to exist, thus we write: begun, and by the middle. And: unbeknownst to us.
>
> (*L'ange*, p. 11)[4]

In other words, Hélène Cixous's aim is to not lock up meaning, to give it/oneself over to the chance of linguistic and textual crossings, to work a nonform. Less to say this or that than to listen to language speak. To write not a novel but *fiction* – and the term takes on all its consequences here, making the book into a vast scene of invention. The aim is also to disarm thought; to work with the consciousness that all writing is a factor of disruption, that one must lose the meaning for more to be discovered, spend [*dépenser*] to think [*penser*], go blind for the thought to arise in 'the page to page of a book' (*Jours*, p. 55), according to its weight in the words it flexes.[5]

Such is what I would call the writing-thinking of Hélène Cixous: nothing is conceived outside of the process of writing, but all the same neither is there textual diktat; it is always a writing that almost did not succeed and that fails at its task.

> [. . .] only the impossibility of ever painting Fuji-Yama authorized the painter to paint and to attempt to paint his entire life. For if it ever came to pass that one succeeded in painting what one had dreamed of painting since the very first paint-brush, everything would perish on the spot: art, nature, the painter, hope, everything would have come to pass, the mountain would fade into a picture, the picture would lose the trembling desperation that delicately tore at its canvas. A stony completion would seize the universe.
>
> (*FirstDays; Jours*, p. 17)

This comparison with the 'mad truth' of painting irresistibly recalls the Oval Portrait of Edgar Allan Poe – where reality, that is to say the young woman model from whom the very *Life* of the portrait is *drawn*, literally dies from the metaphor[6] – and speaks of the heartrending contradiction that constitutes art. The writing-thinking of Cixous is the unworking at work which takes hold of the self-flexing writing. Or the writing reflecting itself in the mirror of its others: Hokusai, Rembrandt, Clarice Lispector, Tsvetaeva, Thomas Bernhard.

In sum, with the books of Hélène Cixous comes the end of the world: of the world we imagine – which is thinkable, presentable, representable.

The writing-thinking, under the sign of its name of 'axe and knife' (*L'ange*, p. 37),[7] inaugurates a space that is *combat*;[8] that is *beating* with the play of rupture-suture (*Jours*, p. 191) detaching the writing from the fable; that is a place of rocking because this end of the world cannot put an end to finishing in the successive scenes of its 'remakes'.

There remains, of course, the question of how: how does writing proceed when it is looking to undermine its supposedly proper terrain? What manœuvres, what know-how or what scuttling of art allow one to regulate 'the magic progression of writing' (*L'ange*, pp. 236–7)? to tell the untenable tale that dreams of being *natural*, of speaking *like* the wind, the storm, the sea? What mechanisms allow one to invent a writing from before the invention of writing, from before Thot, when the *tree spoke*,[9] as Plato's *Phaedrus* says? In short, how does this frenzied writing of the book without destination proceed, this writing that tells it straight to one's face?

I will only consider one aspect, to my eyes primordial: the wager-in-I [*l'en-je*] of the writing. The writing of Hélène Cixous necessarily goes by a putting into *I*: the pronoun. I am not saying the first person; because in her books, there is not one but a thousand people, and not a first among them. No order. Everything is cardinal. Or rather, what is cardinal is this putting into pronoun – there for the name, in its place – this infinite and indefinite displacing of what belongs in proper, of the subject. Active/passive from then on, subject *of*, subject *to* slippage. Less possessor than possessed – with the demon of writing.

The in-I is the opposite of the in-itself. Where the in-itself designates a density of substance and a coincidence, the in-I is accident, phenomenon, alteration, other. It is a mobile, a non-presence to oneself, a non-figure. The in-I is a place of intuitions, of roles, of representations as the only possibility of knowledge: it leads to a writing of interruption and separation; it leads the writer to make the 'self-portraits of a blind woman' – title of one of the sections of *FirstDays of the Year*. Here is how it begins:

> Meanwhile the author . . . the author doesn't return. She is all given over to her drama, always.
> Why do I speak of the author as if she were not me? Because she isn't me. She departs from me and goes where I don't want to go. [. . .] Whereas I, since 12 February of this year, have been trying

with all my might to seize some brief glimmers of truth, or at least I do all I can to lie as little as possible, the author is occupied only with this story. To tell. An ideal story. She goes at it . . . So slowly that in the meantime I could tell ten stories. I write under the ground, she says, like a beast, burrowing into the silence of my breast. [. . .]

One difference between the author and me: the author is the daughter of the dead-fathers. *I*'m on the side of my living mother. Between us everything is different, unequal, rending.

(*FirstDays; Jours*, pp. 153–4)

The putting into I, the wager is inherent to the course of the writing it founds, which is necessarily dis-course; a revealer of the double demand that puts writing under extreme tension: between scription and diction; between fiction (coherent, finished, a story) and fractioning; between textual effects and affects whose violence makes the writer into 'a reading body with the head cut off' (*L'ange*, p. 91); tension also between the slowness of the calligraphy organizing the page and the telegraphic surprise of the meaning 'in flashes' (*Jours*, p. 155), illumination. The work being born and nourishing itself from a handicap that is the essence of the writer's gesture: 'we toil for months to copy down the flash of lightning', we who 'are made of a star on the end of a stick' (*L'ange*, p. 70).

To write, consequently, is to proceed with the necessary connection of opposites, a connection internal to the text, which constitutes its presupposition (writing-nonwriting), its essential structure; because here – and as Walter Benjamin points out in Hölderlin – 'one cannot grasp the elements in the pure state, but only the rational structure where the identity of the singular essence is the function of an infinite chain of series'.[10] In other words, an order of writing takes shape where the plurality of relations is not without an affective and lyric capture, and where the thought has textual space, is at one with the letter, happens 'right in the earth of the text' (*Jours*, p. 156). This is how one must hear the 'truth' of the text: as an *æsthethics* where the two h's make æsthetics be read with ethics. In this way, the contradictory knot where meanings stumble is reinscribed, in infinite constellations.

This narrative is not a novel, is not searching to create illusion; it is a place of confrontations where 'I' never stop(s) making scenes. In these fictions, it's a question of life or of death; a vital question – that is to say suicidal because the 'playing with fire' is Promethean: 'To write a book is a suicide that one can begin again. A book has everything of a suicide, except for the end' (*L'ange*, p. 254).

Everything will be played out on the page: to a word, an error, a surprise. The work will be gripping or will not be. Nothing evacuated from the field. It over-

flows before my bulging eyes, and not in a hidden or allusive elsewhere. Fiction founds reality, invention-truth, theatricality-life. Without literary, moral, ideological escape. As always in the books of Hélène Cixous, language is with and opposed to thought: which it prevents from settling in, but which finds derivative consequences and unexpected rebounds. The putting *into-I* which points out the fundamental disagreement, the drama of the subject, is the combat with the angel and the very wager of literature, keeping an eye on the win-lose of its non-mastery which permits, at this price, to 'mutate literally'.

> I read: 'There was nothing more on earth save nothing,' Cello said. I read Celan. [. . .] A God had provided for her need to weep by inventing Celan, the poet with the name in reverse, the poet who started out being called Ancel, then stopped being called Ancel, then called himself: Celan, and thus had emerged from the forgetting into which we had slipped him, *by calling himself contrarily*, and behold him standing on the silent soil, his chest full of cello boughs. Only so are we able to advance, by beginning at the end, death first, life next, chancy, secret life next, so celative, so elative, so celantive,
> Mused she, the author, trembling.
> *(FirstDays; Jours*, p. 14)

Here, in this writing that makes thought divisible and then multiplies the intersections, one can already read it: the stakes of literature sketch a decisive division between novel and poem. Hélène Cixous rejects the novel which 'forgets its rubble' (*L'ange*, p. 225), and 'the people of passions' (*L'ange*, p. 226) one finds in Dostoevsky:

> We are pray to angels, but since our angels are always our preventers, we never know what kind of good they inflict upon us. They preach for the heights, we lean for the depths. I want what is neither given, nor ready, nor finished, I want the lavas, I want the boiling era before the work of art, with the innumerable seeds, the irritations, the angers, [. . .] nothing has been decided, no one has won, I want life before the deluge and before the ark, because afterwards, everything will be put in order [. . .]. Hundreds of people will be chased from the work. The novel forgets its rubble.
> *(L'ange*, p. 225)

At the horizon of the work of art there is on the one hand the novel-foil, on the other the poem-paradigm, which is the name of 'the distant existence of the book, its star's wandering' (*Jours*, p. 9),[11] the 'latent' book, which is not written, 'kept lost' (*Jours*, p. 10) because guarantor *of desire*: desire to write, to

modify the line. The poem gives body to the writing: it is a question of 'physical sensation', of 'cardiac certainty' (*Jours*, p. 9), rhythms, rhymes, passages – that come under another temporality, that of the plural of Days of the year for example. Yet even so, 'with words, music, images, with desire and pain, one does not have enough to make a whole book all the same' (*Jours*, p. 10). Between two impossibilities, between two cross-outs: this is where Cixousian writing elaborates: neither novel nor poem, but holding the untenable division; the position of the interval. Giving poetic body back to the narrative; making the book a delay with respect to the fable – as Marcel Duchamp made the painting a '*retard sur verre*' – reflecting its process of loss.

This writing-thinking has no measure except its errors (writes 'by error: by definition' [*Jours*, p. 59]), and no progression except its *repentirs* (corrections). The book works at maintaining the interval: which is announced by *L'ange au secret* in its title, coming back to the etymology of *secretus* – separate, off to the side, and promising an obstacle to saying, to communicating. In sum, there is no grounds for stopping, nor for concluding. Without end, rather: passing over the line.

<p style="text-align:center">*</p>

In *FirstDays of the Year*, Hélène Cixous writes:

> [. . .] the most loving thing one could give to a person, that is to say the most giving thing, I imagine it would be his or her portrait *in truth*.
>
> (*Jours*, p. 113)

Passing rapidly back over what I have just said, I would like to attempt to sketch this portrait *in truth* of the writer, that is to say the portrait of writing *in difficulty*, here, on the page. And for this to reconsider Picasso's drawing *La Repasseuse [The Woman Ironing]*, which Hélène herself chose in the collection of the Picasso Museum (Paris) to comment on it in a collective volume of the Louvre Museum entitled *Repentirs*.[12]

It seems to me that this drawing inscribes precisely 'the truth' of the writer as woman ironing. A figure with two heads, it is not Janus bifrons facing up, but torn between low and high, bent in the minuteness of her task, leaning back in the imprecation of the heavens or the apostrophe; she who does, she who thinks; head of the body, head of the soul.

There is more, and to the meaning of the figure there is in addition the meaning of the emotion. Because the *repentirs* of the lines also say this: the body does not cling to the head. *Between* the two heads, there is the

space of a *no head*. A going back over, an ironing, a writing 'with the head cut off'. With emotion. Between writing and thinking, the affective beating – syncopation. ('I prefer keeping my head cut off', *L'ange*, p. 92.)

> I do not want to draw the idea, I do not want to write the being, I want what passes in the *Repasseuse*, I want the nerve, I want the revelation of the broken *Repasseuse*.
>
> (*Repentirs*, p. 60)

However, this is not exactly the portrait of a decapitation of the writer as Woman Ironing. Writing-thinking, admittedly, does not happen without breakage. Without losing: one's head. But there is more. In the rubble of the line, the work of *repentirs*. The writing-thinking of Hélène Cixous is rather: in all cases, to stand up to the head.

Notes

1 All citations attributed to *FirstDays; Jours* are taken, slightly modified, from a manuscript version of Catherine A.F. MacGillivray's forthcoming translation of *Jours de l'an*. The page numbers refer to the French edition. [Trans.]

2 Jean-Luc Nancy, *Le discours de la syncope I. Logodaedalus* (Paris, Flammarion, 1976), p. 13: 'What founds, what supports – should it not be, 'itself', *unsupportable?*'

3 '[. . .] one can want, and approach and remain on the point of without will. It's the most difficult: to want without will' (*L'ange*, p. 16).

4 We find Derridian accents here concerning the origin-ruin, *the question of* the origin: 'It's like a ruin that does not come *after* the work but remains, *right from the origin*, produced by the advent and the structure of the work. At the origin there was the ruin. At the origin the ruin happens, it is what happens first, to the origin.' Jacques Derrida, *Mémoires d'aveugle, L'autoportrait et autres ruines* (Paris, Louvre, Éditions de la réunion des musées nationaux, 1990), p. 69. ['At the origin' and 'to the origin' both translate *à l'origine* here. – Trans.]

5 Jean-Luc Nancy, *Le poids d'une pensée* (Grenoble and Québec, Presses Universitaires de Grenoble, Le Griffon d'argile, Collection Trait d'union, 1991).

6 Edgar Allan Poe, *The Oval Portrait*: 'And he *would* not see that the tints which he spread upon the canvas were drawn from the cheeks of her who sat beside him. And when many weeks had passed, and but little

remained to do [. . .] he grew tremulous and very pallid, and aghast, and crying with a loud voice, "This is indeed *Life* itself!" turned suddenly to regard his beloved: – *she was dead!* in *The Complete Stories* (London, David Campbell Publishers, Everyman's Library, 1992), pp. 612–13.

7 The way I fight against myself is that of the matador and the bull.
 In the arena, am I the matador who deep down doesn't dare charge unreservedly at the bull [. . .] or else am I the bull who doesn't respond [. . .]
 There was between the matador and the bull such a mysterious mix of peace and resignation.
 Nothing is served by struggling in love. One of us must lose her head. Whoever we may be and whatever we may do, in the arena it is written that the beast will die. [. . .]
 As bull and matador *I* am condemned to death.

 (*FirstDays; Jours*, pp. 25–30)

8 '[. . .] the book of the angel is possessed by the book of the devil, the book of reason is shaken by the book of madness, everything is double, the idea of a character opens the window and throws itself into the other text' (*L'ange*, p. 69).

9 To the story of the myth of Thot and the critique of writing, Socrates opposes the words of nature: '[. . .] words of the oak were the first prophetic utterances. So the men of those days, because they were not wise like you moderns, were content because of their simplicity to listen to oak and rock, provided only that they said what was true [. . .]' *Phaedrus*, 275b, c, in *Plato: Phaedrus*, with translation and commentary by C.J. Rowe, Warminster (Aris & Phillips, 1986), p. 123.

10 Walter Benjamin, 'Zwei Gedichte von Friedrich Hölderlin', in *Gesammelte Schriften*, ed. Tiedemann von Kolf and Hermann Schweppenhäuser (Frankfurt/M., Suhrkamp, 1977), vol. II, p. 112.

11 She had tried to figure out how to call this unwritten book. This restrained thing – this unripened expectation – and, lacking a name for designating a thing that was not of this world, our own, the visible, had proposed to herself the word "poem". This was not entirely unfitting – : – the distant existence of the book, its starry wandering about which we sense, without ever seeing it, the presence of an order other than our own [. . .]. Poems too are of this astral nature, sparks that they are of a dead or distantly imminent fire.

 (*FirstDays; Jours*, pp. 8–9).

12 '*Sans Arrêt non État de Dessination non, plutôt: Le Décollage du Bourreau,*' in *Repentirs* (Paris, Louvre, Éditions de la réunion des musées nationaux, 1991), pp. 55–64.

Cixous *Genre* Outlaw

What's the *genre*[1] in Hélène Cixous's books? The question comes up in the same way one asks: what's the weather?

It's sunny, it's rainy, it's all *genres* in Cixous's works. And then some. Because the text is always making more. And she-the-author, and I-the-voices of the writing.

What's the *genre?*

To question her works in this way is to tear them from the having and the qualification of being. What *genre* do they *have?* What *is* their *genre?* To tear them away, that is to say, from appropriation and from the attribution of quality/ies: from what allows owning, the turn of the owner, the my-own that is not your-own, and that excludes the possibility of our-own.

Y:[2] this is the place Hélène Cixous's writing attempts to compose-invent. An indefinite and infinite place (whose limits are not marked); sign of the crossroads, the opening; bursting, fragment, star; crow's-foot, crossing (-out) (*biffur(es)* as Leiris would say); fork (in the road and the tongue); symmetrical dissymmetry, neither one nor two, neither the one nor the other but more: a growing, an effervescence. The one and the other, which Hélène plays with by writing 'moon [*lune*] and the other' – which is then the earth, reversing in this way the points of view:[3] place of dis-location, of displacement, of departure and of parting, it is also the place of being-without-qualities, free from the scale of pre-established magnitudes, from the value system that regularly puts the world under house arrest, in the enclosures of referentiality and psychology.

On the contrary, the *genre* in Hélène Cixous's texts expresses being as it

arises, in the 'it happens', even before knowing what, who. Emergence in the very place of the verb – and not arranged in categories of attribution. Emergence in the imperson: before any dictat of the person, of the personal, of the human. And in this regard the *Y*, a verbal adjunct that neither joins nor patches, is symbolically the only possible signature: that of the being that does not avoid the blind task which constitutes it, and activates the impersonal:

> (*Me*: Clarice is innocent; and at the same time she doesn't let herself be had; by anything.
> N.B.: The expression: *to not let oneself be had*. And all the expressions with *to let [laisser]*, this is the signature (of Clarice). She's a person who most often *lets herself go*. And she goes.)[4]
>
> (*Déluge*, p. 216)

If one listens to these lines with a literal ear, they say that the question of being does not come under the domain of having: it is not a question of letting oneself 'possess'; that is, to be mistaken but also to be defined by one's having, by what one has. Or else: not letting oneself be mistaken by the fact of possessing. Not stopping. Because, having is entirely the opposite: it's *to be had*. To be taken. Prisoner. And the only grace, the only safe-guard – how this word is eloquent and precise, designating at once tearing and gain, the gain *of* tearing – the only safe-guard is: loss. To let oneself go. 'And she goes'.

It is to designate loss as necessary; to accept that it is necessary for a dynamic process. Never for a finality: goal, aim, end. Terminus. So that it should go. And it goes – absolutely. There is no object, no circumstance, no place, no destination. Loss opens the door, it is sufficient. The being is the being-en-route. Hence the importance of the *Y* in its unlimit, which cannot be traded for anything at all, neither beacon nor enclosure.

> Thank God, there is not only the world. Beyond the world there is the Other side. One can pass over, it's open or it opens. Thank God one can go there. Where? There [*Y*].[5]

Y – breach in the void, crack, catapult. That signifies, cries out. But not a sentence; not meaning. Not yet. Prepares the passage. Says at least this: the back (the other side) is also a front, space.

When Maurice Roche writes: 'I am not going well but I must go there', with a neighbouring twist, the text opens onto the destinal gaping of being, that is to say its negative, its annihilation. With Hélène, on the contrary, all the signifying energy of being-en-route is found to be at work: by which loss is beneficial; the sign of the Other, the unknown person, life vector.

Hélène Cixous 'treats' *genre* under the sign of this line of force of other-ness. Treats, that is to say transforms, exchanges, trades, negotiates. Leaves nothing of the pre-established classifications intact. And firstly: the work en-deavours to play all the meanings of the word *genre* – which has meaning in French within at least three domains: biological (genetic and sexual), gram-matical, literary. Now the novelty of Hélène's approach is born precisely of this articulation which considers them together, and the triple practice con-jugating questions of various orders. Does this amount to saying that the Cixous *genre* is to not have any? To borrow them all? Clearly, it is not so simple. This triple approach to the question of *genre* in the Cixousian per-spective gives a specific turn to the problematic in so far as it is indissociable from those of: (1) the beyond (2) art.

As for the beyond

The question of *genre* is . . . a question. The act of keeping it as a *question*, that one can only attempt to put to work, to relaunch. Because it's in unre-solution. There is no repertory, no catalogue, no classification that's worth-while. Neither is there any claim put on one *genre* rather than another; no law of one *genre* over the other: of the human 'reign' over the animal 'reign' and over the vegetable and mineral 'reigns'. Or else of the masculine over the feminine – or vice versa.

Such that the question of identity, of 'Who I?' is accompanied by a 'Where I?' More exactly: *how far* I, you, the other? The questioning, in other words, does not refer to a file, a label: it is related to thresholds and to the between. Where does the edge overflow? Where does the border con-front? Where is the porosity of limits, the uncertainty of sharing, the fragility of regulations?

How far can I go with it still being *I*? asks Cixous. Or with it still being hu-man? Or comedy? And how far (no)-more-I? And: playing out-law?

The other at my side, who marks my sides, the other is the besides, the beyond. Overstepping. Besides-self, besides-world, besides-my-own.

Such is the room for manœuvre in which the differential of *genres* is in-scribed: a between where what's at stake is reaching the limits, playing with them, establishing passages. The writing works at measuring relationships: at grasping the point where the minuscule difference makes a great separa-tion; where meaning goes backwards, where the human becomes non-hu-man; where the extremes of major-minor, masculine-feminine, prose-poem touch each other, have a reciprocal need, form the two moments (forces,

movements) of a dynamic. In short, this way of keeping to the question of *genre* postulates: 'One' (individual, unique) does not exist. 'One *genre*' does not exist either. Nor a hierarchy of *genres*.

I take this overstepping as the emblem of *l'Outre*[6] which is the title of a short story in *Prénom de Dieu* and which designates, at once noun and adverb, the skin container that vibrates or empties according to the wind, and the desire for elevation. A nice metaphor of our body full of emotions and the fundamental duplicity that tears us apart: between greatness and familiarity, aspiration and vacuity – *un* and *une outre*.

As for art

It is not a banal affair and yet we often forget to mention it: it's in fictional writing, in the novel, the poem, lyricism, theatre, that Hélène Cixous puts *genre* to work and into question. In fiction and not in the exercise of theory, or of the essay, or of the thesis, or of philosophy. Take, in this respect, the cover of the novel published in 1972: *Neutre. roman* where the title and the subtitle put each other into erasure, with the announced conceptualization revealing a fictional base while the novelistic expresses an aspiration for abstraction. The genres connoted in this way by the two words cross each other out, the one weakening the other.

In fact, to choose fiction is to lever (meaning) by finding support where the test, the notch, the forge of difference and polymorphism arise, that is to say, language. A language of invention.

> It's so dark here where I am searching for a language that makes no noise to whisper what is neither living nor dead. All words are too loud, too rapid, too sure, I'm searching for the names of the shadows *between the words*.
>
> (*Déluge*, p. 111; my emphasis)

These lines act: word [*mot*] and death [*mort*] are consonant. One must work at moving in language at the risk of being a dead letter – of arrest (death sentence).

To choose fiction and not theory as a place of intervention is also to prefer the terrain of imagination to that of feminist ideology; art to demonstration, emotion to abstraction. To look for a language of flesh and of blood which is a language of poetry instead of a conceptually, terminologically set language.

One must be able to carve a language out for oneself in the fatty part of the flesh in the place where the cipher is woven in the thickness, so that *it speaks by/of itself.*

(*Déluge*, p. 129; my emphasis)

Speaking by/of oneself speaks for itself, goes without saying: this can only be the task of the flesh-language in its living networks and movements that form a body-in-itself. That is to say, the task of art. Loss which forms a door, brings one to art, carries art: writing, painting, music. And what Hélène Cixous calls, taking Rembrandt as an emblem this time: '*peindre à l'étranger*,'[7] '*hinaus in die Fremde der Heimat* going off through the door of the picture' (*Jours*, p. 97).

In this image, the passage opened by art connects the secret of creation to the Other: feminine, homeland, Oriental – the bride; the Jewish bride. It's 'the other origin', 'the foreign origin' towards which 'certain people bend their life like a bow'. It's 'the unknown source'; 'the foreigner who plants the heartrending desire of the next picture in the breast like a knife' (*Jours*, p. 97). And just as Rembrandt, behind the door, finds the Jewish bride 'who is not afraid' (*Jours*, p. 28), in the same way and conversely, Clarice Lispector has the courage, Hélène Cixous notes, of the extraordinary transgression in the *beyond-sex*: it is as Rodrigo that she finds the entrance of her book, 'as a man that she ends up becoming at the price of a going without return' (*Jours*, p. 28). Hélène Cixous notes the trace of this total 'foreignization' in the writing of Clarice: 'I am not me. I am so foreign to myself that I seem to belong to a distant galaxy' (*Jours*, p. 29).

Such is the Cixousian syndrome that presides over the question of *genre;* gives it a stellar direction; this constellation of the other, the beyond, art.

I will follow several branches and branchings, while keeping this in mind: that the tongue is a living organ in the mouth *and* a body of signs. That every subject affects the text: narcissistically, it *paonne;* thinking, it *paonse* (*Neutre*, p. 193; my emphasis).[8] That the subject that loses its head, with Hélène, is an *Ubject* (*Neutre*, p. 193) (decapitated of its first letter) – an Ubject that frightens the writing up to the *beyond-text*: where the text ex-cites itself. Literally. Expropriates itself in generating citations, references, signatures, texts that are foreign to it. Do not reproduce it.

The text, seized with desire, with mirth, with resemblance, vaginates, laughs, covers itself with spots, different sexes and century effects, and unfolds itself, Nile, neither the one nor the other, nor Oneself, but crossed over, running, extraordinary, natural, neither Achilles,

nor Amazon nor Hamlet father or Hamlet son, but the child of all:
his mother is unlimited, and he rejoices [*en jouit*] . . .

(*Neutre*, p. 193)

These last lines of *Neutre*, which speak indissociably of loss and rebirth, expose a 'denatured' nature of writing. Which is less inscribing than *ex-cribing*: excribing the fact (the facts) of a foreign subject, *genre*, species. More precisely: *excribe* the inscription. That is to say, according to Jean-Luc Nancy, to make 'inscription be the being-inscribed, or rather the true being-inscribing of inscription itself'. Such is the only modality of existing-writing which allows one to '*weigh* at the heart of thought and in spite of thought: to be the breast, the belly, the entrails of thought. The charge of meaning in excess of the meaning itself'.[9]

The writing work of Hélène Cixous, her concern for writingness, arises precisely in this impossible place (of the impossible): a thought in spite of thought. A thought that forms (into) a body, blood, meaning, without, upside-down (meaning). A thought that exceeds with all its weight – of flesh. Mental and scriptural species of spaces are opened in this way, spaces that radically confront the question of the norm and the ab-norm.

The unnamable filiation or the crisis of grammar

Neutre asks the question of the threshold. With acuteness, it puts the threshold par excellence into question: the engendering, the passage to life, the reproduction of the species, the generation of the same, or of what is supposed to be, the immutable. As well as the birth of the impossible, of the monster – ab-norm, unnamable. This: that 'without sin, without hereditary stain, without psychic or hormonal disorder' a young woman 'gives birth in normal conditions, without medical, magic or superstitious intervention, to a . . . (being)' (*Neutre*, p. 62). Here, already, the text stammers while attempting to speak the unspeakable, it suspends, shows reserve. Because it is the unthinkable genetic accident, the failure of the law of nature; by chance, the non-human that arises *in the place* of the human, and manifests the inexplicable 'dislocation of components at the most secret level, a bursting of the most ancient and the most venerable alliances' (*Neutre*, p. 63). The paradox, the madness is indeed that there is a solution of continuity, *but in* the line, *in* the straight line, the lineage itself. There is a solution of continuity and not.

Because there is a son: even if the mimetic reproduction of the human, the reassuring *mise en abyme*, mirror, Russian doll, human miniature in the human belly has failed. In this absolute passage from the one (given) to some other, there is bond and abyss: where language becomes abyssal, grammar is in crisis, deprived of antecedents, of matrix, womb, of Literature-mother or grandmother, of name, *genre*, subject, complement according to the rules.

> [. . .] by what tortuous and cruel taxonomy could she then regain the immemorial ground, where women are made mothers, and mothers are women, and sons are singular masculine subjects and natural complements of the noun mother [. . .]
>
> (*Neutre*, p. 63)

And the most moving, undoubtedly, in the scraps of Literature that in the shock burst into pieces and (de)compose *Neutre*, the most moving is to note that in order to invent a designation for this unnamable son – the *letter being [l'être lettre]*, henceforth mentioned in the work by '*le f*', which is heard in French as 'the fire',[10] and soon inflames the writing, scuttles it (at the far edge of meaning), turns it into ashes – Hélène Cixous's text returns to the accents Shakespeare gives to the description of senescence. For the generation of the non-human, she echoes the text of the other extreme, life on the point of death, the *second childishness* that is at the heart of Jaques' monologue in *As you like it*. And occasionally *As you like it* can suddenly be heard as: '*You* like *it*': like *it*, 'this sans-arm, sans-leg, sans-member', writes Hélène Cixous, 'sans teeth, sans eyes, sans taste, sans everything',[11] says Shakespeare's character, in a writing that allows this monstrous *short-circuit* of the human to be put to work. Life-death together and neither the one nor the other. Short-circuited human, less and less human, with which Cixous's text applies itself to saying: that we cannot say. That there is: nothing. Lack. Loss. Infinitely minute. Because what is without name is, obviously, *the passage* from the human to the non-human: the bond, the *cord* of skin from the one to the other.

A recent text of a different style – lyric theatre – takes back up the investigation of denatured human nature, 'this stammering of the species'. With *On ne part pas, on ne revient pas*, the Russian doll of reproduction has become a Down's syndrome patient; and comparative approximations abound: 'flayed rabbit', 'clandestine dog' (p. 83), 'rather a puppy' (p. 88), 'failed pottery' (p. 83), 'monster' (p. 83), 'failed Homunculus' (p. 84), 'innocent vampires' (p. 91), 'larva' (p. 84),

> [. . .] sans age, sans speech, sans light,
> Who are these Chinamen I asked myself
>
> <div align="right">(On ne part pas, p 81)</div>

In the taxonomic erasures of language, in the nervous, syncopated rhythm of a prose moulded in the poetic measure, and in a Logos outstripped by diction, we find constants that it is time to recapitulate:

1) The extremes touch, in an untenable-incredible passage. The nearest (flesh of my flesh) is the most foreign; the most familiar, the most monstrous; the most private the most exterior. The highest the lowest because 'with pride, with innocence [. . .] we give birth in the name of a Shakespeare' – and Lucie named the Down's syndrome child William:

> Poor William, my poor fool, my designated [*dénommé*] son,
> Neither human nor non human.
>
> <div align="right">(On ne part pas, p. 83)</div>

2) The short-circuit is the fate of the human being destined for the derisory, for tragedy and for comedy. An accident – a 'larva fallen from the tree by chance into my bed' – and here *I* is 'Chased without knowing it from human nature' (*On ne part pas*, p. 84). The Down's syndrome child 'uproots us and denatures us' (*On ne part pas*, p. 86).

3) The lesson of all this is that one must challenge anthropomorphism and psychology. The possessive is without object: mine is not mine. The categorical has no hold. The pretension to mimetism, to the perpetuation of the species, to the fable of man in the image of God and the earth in the image of the human – is out-dated.

4) There is more: another point of view, urgently, is introduced. Or rather, the point of view of the other: vegetable, animal – 'A vegetable, or at best an animal/This is what William will succeed in being' (*On ne part pas*, p. 82) – or astral. That is to say the point of view of the non-earth, of the stars, of disaster. It is truly a question here of deconstructing the power relations, of disarming the relationships of the human to the world. What Hélène Cixous calls: 'dehierarchizing-everything' (*supra*, p. 10). A whole philosophy of life is searching, in this way, to invent (itself).

Beyond-sex, beyond-text

Hélène Cixous's approach takes the problematic of sexual difference and of the masculine-feminine from above: in the vaster perspective of human *genre*. To envisage a hegemony of one sex over the other is consequently out of the question. Her text arranges masculine and feminine in a mirrored, facing perspective.

> And suddenly, it's reality [*la réalité*]. Right in the middle of the dream [*du rêve*], an isle [*une île*] in an ocean [*un océan*] of dreams, and it's the earth [*la terre*]. It is *she*. It is *he*. It's reality. But reality with perfect features, like in dreams. Good fortune is like that. Fortune arrives. Looks at us. We see each other. The absolute simplicity of the mirror is produced: the two people are suddenly the same.
>
> (*Déluge*, p. 148; my emphasis)

In these lines, the feminine and the masculine regularly alternate. They express an alternative: otherness and equivalence, equivalence *in* the otherness. These lines also express the resemblance: the inversion and the resemblance of the two genders. And, as a corollary, they denounce division, when 'we are the mournful personal individual instead of being humanity' (*Déluge*, p. 128). This perspective on a humanity truly realized by a complementarity of the two genders echoes the vision of German romanticism – of Schlegel, in particular, in *Lucinde*:

> [. . .] when we exchange roles and in childish high spirits compete to see who can mimic the other more convincingly, whether you are better at imitating the protective intensity of the man, or I the appealing devotion of the woman. [. . .] I see here a wonderful, deeply meaningful allegory of the development of man and woman to full and complete humanity.[12]

Consequently, it is clear that Hélène Cixous's writing makes an effort to play on the alternatives in a text that carries the traces of these alterations and that makes a motivating force of the heterogeneity that constitutes it:

> This book could be called *Pierre Vole*, no one would know what this title means. *Pierre Vole* would fly and reach his/its secret goal, every one would receive one pierre or another, what is important is that '*Pierre*' should fly, he or she, coming from a he [*il*] or from a she [*elle*], or from an isle [*île*] or from an el'.
>
> (*Déluge*, p. 196)

Here, the audaciousness of the writing stems from the all-out application of a logic of gender alternation that imposes its law on language: postulating that a masculine always responds to a feminine and vice versa, the writing (a) plays all the possibilities: and *la pierre* becomes *un Pierre*, the proper name; and the pun proposes the echo: *'un il'*, *'une île'*; (b) makes the impossible intervene: which writes, with all the consequences, *'une île, un el'*. All of this, inside/outside the system of meaning, is perfectly readable.

This mechanism is extremely exciting in Hélène Cixous's writing because, far from being an arbitrary and gratuitous game, it systematically, logically opens the door onto 'the Other side' of the text. One ought to conduct a meticulous analysis in this domain. I will only sketch out a few directions.

1) Masculine and feminine are not only in a mirroring relationship, but also in indecision, participating thus in the *intertwining* which is the person. Even more: they intersect, as one says of mathematical groups. Which is to say that there is not, in a clear-cut manner, on one side the masculine, on the other the feminine, but the one with the other, approximately and weighing the alternatives, the masculine *of* the feminine and the feminine *of* the masculine. Which a whole metaphorical lexicon in Hélène Cixous's writing aims to suggest. The text puts into play **un** *fourmi*, **une** *météorite*, **une** *aigle*, **la** *rêve*. The indefinite pronoun *tout* has its feminine double which upsets the agreements: *'Tout est vérifié [. . .]. Toute est parfumée'* (*Déluge*, pp. 136–7).[13] In short, once again here, what is important is to form a door; to open, to find, to show *the passage* from the masculine to the feminine – and back. And forth.

2) We are therefore better able to measure the importance of choosing the *writing* of *fiction*, and the specific role that the one plays in the other.

3) First, writing. In *Déluge*, for the first time, strangely, Hélène Cixous gives a name, a proper name, to 'writing'. Or more exactly, a pre-name. A person's name which is also a biblical name, *a name of the Book*: and it's Isaac.

> I love. 'Isaac': it is the name I have given my love, so he can have a name. Because if I say simply I love 'To write', that's not it. It's such a mystery. It's the other. It is not I.
>
> (*Déluge*, p. 134)

Now, by a play on the name, which de-names and re-names writing, Hélène Cixous plays again on the Bride, but in the masculine: Isaac, the Groom, Jewish, who is not afraid. Who is 'a case of a high-pitched creature, high-pitched but human, but hardly of the *genre*' (*Déluge*, p. 207).

And with whom she forms a couple, capable of establishing – contrary to Clarice's experiment – a there *and* back that increases her forces tenfold, that places her, writing writer, in a state of overcapacity, of surpassing, in a limit case: 'Neither man nor woman more, more strong, more girl but no, eagle, but of human incarnation' (*Déluge*, p. 208). To convoke Isaac, Hélène Cixous conjugates the tropes of approximating: of inexistence, of retreat, of the superlative, of excess in all ways. Man and woman, place of feminine and of masculine, of singular and of plural, place of imperson, of impatience, of insistence, Isaac 'figures' – or rather prefigures, without a face – the non-anthropomorphic, non-psychologizing, non-representing growth of the text. Prefigures *what happens: pathos*. Setting the imagination's clocks to the time zone of the written form: the present. Names this: that 'writing' is to give passage to the *pathos of the present*. To what happens in/to the present: what happens to it, to this present, from the overflowing of writing, from the love of writing. Advent-event: of passage and of love. In which saying 'I love. Isaac' is to make heard the event of love as well as *the love of the event*: that is to say the advent of writing. To make it heard in (the) place of the writer-medium subject, in the reversal of all priorities, forwards and backwards.

4) And then, *fiction*. It is the privileged terrain for making the love-event of writing happen. The barriers in fiction are there to be crossed; reality is there to lead to the dream; prosaic significations are there for the extravagances of the letter; meaning for sound, for tone, for the bridge of down and upstrokes. These are elements which demand that fiction become the melting pot of literary genres: that it not accept the exterior law of established conventions but forge its constraints to its own making. Which is polyvalence, showing of traces, corrections, deletions, resumptions. This explains the mistrust of a certain novel that orders-classifies for a teleology of narrative.

Neither does Hélène Cixous's fiction accept the omnipotence of rules masking the possibilities of language. This explains the trust in poetry and the exportation of poetic techniques into the tissue of prose. Language takes on body there; and if communication is found to be indebted, it nonetheless sketches narrative vectors: the Narrative comes to the rescue (*Déluge*, p. 82), 'the Narrative warns us' (*Déluge*, pp. 14, 95), the Narrative allows us or does not allow us to think that, to know that (*Déluge*, pp. 191, 197), the Narrative as a cord, the cord of 'a mute interior telephone [. . .] from the part of me that is outside to me inside' (*Déluge*, p. 71), a call on the line from David (p. 63), 'a stroke of D dur' (p. 226)

'D-minishing' (p. 227), in short, 'the Narrative, as universal desire' (*Neutre*, p. 27). The desire of meaning.

This narrative indicates a line that is subject to caution: that is to say to infinite branching and derivations. It is a Shakespearean narrative: '[. . .] mad north-northwest: when the wind is southerly [it knows] a hawk from a handsaw';[14] a comedy in the literal smallness of the games of writing, a tragedy in the scale of the upheavals of meaning that they entail. The writer is in effect searching for the unrealized, unprecedented work: *with two contradictory genres*.

> I have searched in the novels on my shelves, for a similar story, with two contradictory *genres*. I did not find any.
> One body and two bloods that drive in opposite directions.
>
> (*Déluge*, p. 37)

This writing eludes all generic codification, marks the spaces, the silences, the rhythms and only retains as truth the palpitation that produces a sort of cardiac necessity in the narrative, this writing tries to respond to the demands of a torn-away-literature, that grasps everything together, mixes up and spells out: '[does not write] goodness' but tears 'sombre texts' from 'the interior rocks', from the 'magma' (*Déluge*, p. 216).

*

Hélène Cixous says that she carries an image, vaguely, perhaps from Blake, of a couple, standing at the edge of the line of the earth, facing the stars (*supra*, p. 21).

I take it as the emblem of Cixous's work: it indicates the configuration of her work perfectly. That is: I-earth always at the far limit because facing *toi* [you] who are in *étoile* [star], you who are the other, the aster and disaster (for me). Such is the metaphor that drives the writing of asters/writing-disaster of Hélène Cixous. This is not the writing of clear-cut truths nor of representations in majesty: it's the writing of preservation, risen to the edge of the abyss; of watchfulness; of mourning and of the hope of beginnings.

> [. . .] the deluge is our condition, but it is not our end, while it streams in torrents over our plumage, in the interior the dream lights a candle.
>
> (*Déluge*, p. 177)

With each book-deluge, Hélène Cixous's writing – plumage in the rain, with the dream at the plume – lights a candle.

Notes

1 *Genre* is at once 'gender', 'genus' and 'genre' (literary genre for example), as well as looks, type or style in more idiomatic usages. [Trans.]

2 French adverbial pronoun derived from the Latin *hic*, meaning generally 'there', and appearing in various colloquial expressions. [Trans.]

3 Cf. *supra*, p.10

4 Part of this same passage appears above (p.37) with the word *laisser* translated as 'to leave' rather than 'to let'. [Trans.]

5 Hélène Cixous, 'Quelle heure est-il?', in *Le Passage des frontières* (Paris, Galilée, 1994), p. 83.

6 *Outre* is a feminine noun (a leather pouch or container for water or wine), as well as an adverb and a preposition (from the Latin *ultra*) used in many expressions and generally meaning: besides, moreover, beyond, above and beyond . . . In this sense it can be nominalized to give a masculine noun much like the beyond. [Trans.]

7 See p. 92 and note 30, p. 115

8 The *paonne* and the *paon* are the peahen and the peacock. The Cixousian verb *paonser* is a homonym of *penser*, to think. [Trans.]

9 Jean-Luc Nancy, *Le poids d'une pensée*, p. 11.

10 In learning the alphabet the letter *f* is sometimes pronounced *feu*. [Trans.]

11 *As You Like It*, II, vii.

12 Schlegel, *Lucinde*, in *Friedrich Schlegel's Lucinde and the Fragments*, translated with an introduction by Peter Firchow, (Minneapolis, University of Minnesota Press 1971), p. 49.

13 'All is verified [. . .]. All is perfumed', but *tout* does not as a rule take the feminine form *toute* in this type of construction where it is considered to be an invariant or collective pronoun. [Trans.]

14 *Hamlet*, II, ii, cited in translation in *Neutre*, pp. 20–1.

Hélène Cixous's Book of Hours, Book of Fortune[1]

> An hour passes, they do not see it pass, the clocks notice nothing, it passes through their mesh. What is there to say about the hour? It was in the process of becoming pearls, the presentiment of the future was in the process of coating it and isolating it from all mortality. The hour was a foreign body in the clock-work time.
>
> It goes on, stretches out.
> – God, they said to themselves –
> – Is it that way?
> – They will not be long to touch themselves but I no longer know when.
> Because they did not hear each other say the things that were said between the words: it is that way, come, what is it?
>
> *Beethoven à jamais* (pp. 47–8)

To make one's way: *Le livre d'Heurs* (the Book of Fortune)

We set off. We are already there: advancing. At the junction of the paths and the languages which branch.

We are in times which take time – hostage. In the passage. Remove it, skip it. Stasis. 'An hour passes, they do not see it pass, the clocks notice nothing.' Ecstasy. With the passing time, with the passing styles, narratives are brought together, deferred, made to dialogue, to differ. And their neighbourhood forms concretions (*cum crescere*): pushed together they acquire body; they speak; they pearl. They weigh. They deposit. And never has a deposit better signalled the *movement* of the work towards which it carries.

Between has been and future, 'between the words', writing shows what the clock does not show. Note: that what marks is non-remarked, non remarkable. If not passed-passing. Immediately. Within the hour – that passes without making a ruffle. And yet unclocked time arises on the circuit of the clock, and the narrative has absences. Feature by feature, the writing of Hélène Cixous gives the portrait of the arising. By which the work is: *straight-away*. Awandering. Always already on the way: 'A way that presented itself, took hold of me, carried me away' (*Angst*, p. 17); and right in the middle: 'It is always so when one sets out to begin a book. We are in the middle [. . .] Thus we have begun to exist, thus we write: begun, and by the middle' (*L'ange*, p. 11). And to write is: to make: that *it happens* – surprises, discoveries, following the lines of language which writes itself, blurs over, opens up: 'questions have come, bitten me right down to the marrow [. . .] Answer! They questioned me *right down to the meaning*. Stricken' (*Angst*, p. 16; emphasis added).

The narratives, the books, the readings that mark off pieces, differences, differential, absence-to-be-read and written, compose a rhapsody-work: like an immense Book of Fortune: Hélène Cixous's *Book of Fortune*.

Inscribing the joys of writing, as they say – Hélène Cixous's texts are time gone to seed, set in necklaces, precious stones for memory – but also, as is less often said, the fortune of writing – by which writing becomes an augury, of that towards which it tends: lends an ear, captures resonances and rhythms, this Book of Fortune is symptomatic of making (one's way towards) the work. It presents a *moment* (as the term is used in physics) of the driving forces that constitute the Cixousian text. Moreover: it does not simply give texts to read. It *gives the gift* of texts: the thrust of language, the happening of meaning.

When I set out to write, friends ask me 'about what?' What is the subject? I, of course, never know . . . It is a mystery: there where it grabs, where it bursts forth, where it gathers like rain.[2]

It is the gift of the heuristic, of writing as heuristic, where words speak and make marvels.

This gift of telescopy which, at every moment, makes the pen a telegraph – flash, lightning, a stroke of writing – disrupts, as we know, the structure of space-time in this fiction. The result is a narrative without *reason;* a temporality without chronology; 'from one minute to the next no bridge' (*Angst*, p. 14). And the question, emblematic, from *Beethoven à jamais*, remains, 'How they got from coffee to eternity, one will never know' (p. 43).

In other words, the only time which *holds* (which exists, and ties the scenes together) is that of narration, of writing and of reading themselves: their going, their passing makes Time. Marks the Hours. The work formed of gaps, syncopation, the collisions of eras, also arranges, in its journey, Hélène Cixous's *Book of Hours*. If, in being read, they scan the unfolding of time, Hélène Cixous's narratives, through the symbolic tenor of the scenes they arouse, also propose a poetical-philosophical understanding of our daily life, of our gestures, of everything we do not know that we know. The Book of Hours thus constitutes the place of the quest that summons the writer: quest of the secret; of the mystery of the Real. And so, working on the letters' body, it is into the heart of things that the writer strives to carry the reading.

From inside to outside, from the Angst outside the secret to the Angel within it, from the Letter to the Being, from the portrait to the boundary of (her) unknown, what is coming into play is the *displacement*: incalculable, unequal; brief hours or time downcast. Sometimes by leaps and bounds, sometimes by cardiac arrest, the style signals the dial of the imaginary. And as on the clock face, returning is not repetition but *always* another passing; twelve is double, one two, day and night on balance. Every minute in the book is firstday(s) of the year: anniversary of the birth where meaning is born; where the being makes its way: 'every morning, I am a little girl' (*Dedans*, p. 77).

> It was 5 June 1937. Someone was being called. 'Well?' The tongue grumbled. 'It'll soon be time,' said the mother. So it was not a dream. Imagination had started working [. . .] If you were being called, it must then be because one had some ground on which to place oneself. It was time! [. . .] The mother was preparing the first nappy, she was folding it in a triangle, she was announcing me. So I was about to be born! Myself my mother, my child. Bashful. First I had heard of it.
>
> (*Angst*, pp. 24–5)

Scenes of the human

It is the scene of laughter and tears: good times, bad times blended. Hélène Cixous takes us along to the theatre of the everyday, to our theatre, comedy and tragedy together. That is to say: dream, contemplation of reality, revealing existence. There, unremittingly, under the signature of Shakespeare (but also Verdi, Schönberg, Sophocles, Rossini), of this theatre which knows how to tell stories 'legendarily and yet straight in the eye',[3] she attempts to seize, painting with strokes and lively scenes, our tensions, our paradoxes, our contradictions. To give to the human a form entirely of contrast.

Let us make no mistake: it is not a question, with Hélène Cixous, of psychologism or of moralism. At the pole of categorisation and the simplistic recourse to models, the writer applies herself to dis-concealing complexity and singularity, to describing the irrepressible conflict of which we are the ground. Dwarf-giants, noble-and-poor, scene, accordingly, of Great Suffering, Flood(s), Apocalypse just as much as of Joy, we never know very well 'what costume we are wearing, or with what handkerchief we blow our nose. If it is a kleenex or if we will look for a fine cloth'.[4] Riveted on our images, untiring spectators of ourselves, up to 'the edge of the tomb, we live, we blow our nose, a mirror watches us'.[5]

In short, it is she herself (the author), it is we ourselves (we who 'are made from a star on a piece of stick', *L'ange*, p. 70), it is the dis-aster of the human condition that the writing passes through the crucible of the text: giving the analysis of an existential dynamic to be read.

The human which Hélène Cixous explores has nothing to do with 'humanism' nor with any anthropocentrism. What she places on the scene are the perspectives of a 'better human'[6] by which all borders crossed, the human being enters in floods and expands from its others, vegetal, mineral, animal: knows itself to be dust, convolvulus (*Dedans*), butter (ibid.), air (*L'ange*), body-fruit (*Vivre l'orange*); recognizes its arch-vegetal kinship (*La*), its wound of terrible meat (*Déluge*), and that it is necessary to have brushes to clean shoes. The souls too (*Beethoven à jamais*).

So it is, doubtless, that the reader has the feeling of emerging strengthened by the crossing of these texts: we are strengthened by our weaknesses, by our dichotomies, by our censures. By our lacerations. Hélène Cixous gives us these. Let us make no mistake: she does not reconcile us. She gives us the gift of the irreconcilable. Gives us *'unversöhnt'*.

The gift of languages

The principle of duality, the calling into question of labels and categories of thoughts, the naming un-naming that is at work, constitute the foundation of the Cixousian approach. It is a systematic game-playing capable of dynamiting (and of dynamizing) the conventions, the clichés, the expressions that suit the ready-to-think.

It is a kind of explosion machine by which the writer 'tries [the] names in all the tongues her tongue moves' (*La*, p. 137).

Her task, in other words, consists in restoring to language its fabulous disposition, and all its vocal cords; carefully handling the echo chamber, the sound boxes, the metaphorical journeys; burrowing between words, between-letters, between-strokes in order to deconstruct our dead language habits.

The envoy of *Vivre l'orange* is in this respect exemplary: giving voice and flight (from the 'windows', the last word in the book), it makes us hear through Clarice Lispector's name, the other in language, the language of the other, the other languages which pass – near, far, aslant.

> If one takes her name in delicate hands and if one unfolds it and unpeels it following attentively the directions of the shells, in accordance with its intimate nature, there are dozens of small glittering crystals, which reflect each other in all the tongues where women pass. Claricelispector. Clar. Ricelis. Celis. Lisp. Clasp. Clarisp. Clarilisp. – Clar – Spec – Tor – Lis – Icelis – Isp – Larice – Ricepector – clarispector – claror – listor – rire – clarire – respect – rispect – clarispect – Ice – Clarici – O Clarice you are yourself the voices of the light, the iris, the glance, the flash [*éclair*] the orange *éclaris* around our window.
>
> (*Vivre l'orange*, p. 113)

By metaphors of fructification, a whole poetics announces itself: where the text is crystallisation; celebration and cerebration. On the tracks of the lexicon, a whole poetics shows itself at work: where, truly, it makes meaning. The idioms weave and blend; foreign bodies decouple my tongue, forming veins, opening seams.

As for the stakes, the priorities are reversed: it is the magi voice which forms the image. One can 'call forth claricely' the meaning (*Vivre l'orange*, p. 104), or according to the word 'Celante' (Paul Celan) (*Jours*, p. 14), or following Kafka: *Limonade es war alles so grenzenlos* ('Lemonade Everything Was So Infinite').

The eternal making surges from the breath of the letters. The writing is even in language.

Floribunda writing

The writing of Hélène Cixous abounds in flowers: those of the art of tropes – above all, of the metaphor. 'A woman immortal' (*La*) becomes immediately flower, immediately bouquet, arranging itself, like the parts of a text.

But metaphor alone would not suffice for the arts' élan: for it is on the back of phrases that it rides. It is a matter then of *touching* the things *by name*; and the true touch is touching (within) language. Therefore, no effervescent figure without a literal and a syntactical deflagration. In other words, without these varied geometrical phrases of which Hélène Cixous holds the secret. *Limonade tout était si infini:*

> – I would like to write in French *because of the word swallow* [*hirondelle*].
> [. . .]
> I will write a free phrase. All the questions will go from it [*iront d'elle*] to their answers, without detours.
> (*Limonade*, pp. 304–5, emphasis added)

By playing on words (clashes of signifiers and signified), the analogy, making syntax come off its hinges, sets up another principle of cause(s) and effect(s). There is no allegorical figure of liberty here except through the cracks: where un-connecting connects. And a swallow heralds the spring (contrary to the saying). But it is not just a stroke of writing (nor a stroke of the wing). Or rather, the Cixousian stroke is always *portentous:* through configuration (textual rhizome), it shows the metatextual process. The flowers of these books are not embellishments but essences. They bear fruit: beauty and *intelligence* (of the text). It is this that Joyce calls: epiphanies.

The spectre of the work

The efflorescence, however, must not hide the bereavement. Writing weaves itself from loss; the book written from that which has not been written: 'on the edges of each newborn chapter lie the pages which have passed away' (*Jours*, p. 155).

Death nourishes art as it nourishes life. And it is necessary pain. For only

the incompletion encourages pursuit. To write, to paint is: never to see the end; attempt after attempt, to begin again, to begin *oneself* again. By which the work is infinite desire. The desire to work.

Writing, for Hélène Cixous, also tells mourning through the traces left by others – books, writers, whose reading has excited an emotional and scriptural journeying. Writing is making (the journey) *with*. In honour of. In memory. Clarice Lispector, Rembrandt, Tsvetaeva, Franz Kafka, Paul Celan, Ingeborg Bachmann, Thomas Bernhard. 'All these people in me have lived their lives. They have written. They die. They continue, never ceasing to live, never ceasing to die, never ceasing to write' (*Jours*, p. 162).

The book writes itself at the confluence of two lines of perspective. On the horizon, the writing-to-come sketches, behind the leaf (of paper), a forest. It designs the roots of the work. Bereavement takes on debt.

The keystone: Ankh

The keystone in Hélène Cixous's work is the key to life: Ankh. The Egyptian cross marks out the crossing: convergence–rupture, but also encirclement: infinite rebeginning. It is the sign that there is breath passing out from the teeth. And breath between the letters, that give themselves voice, take on body and come to life with all the '*animots* of a tongue' (*La*, p. 93).[7] For if we follow Hélène Cixous to the letter, until we are short of breath, 'we no longer have *reason* to live, we are wrong' (*Angst*, p. 20; emphasis added) – 'Live for nothing [. . .] If an answer occurs to you, save yourself, save your life' (ibid.) – there is nothing but *rhyme*. And rhyme is what constitutes '*Lettre-Là*' (*La*, p. 21), the 'Letter-There', the 'Being-There', which carries along a game of forms and of metamorphoses. Which gives life for what life is: passage – *form(s) of the movement*.

The key of the Being-there – which is also key to the lies [*mensonges*], key to the dreams [*songes*], the key to her I [*son je*] – finds itself between the hands of Isis, goddess of the same and of the other, sister lover, with the name that rings. She watches over the rites of passage through the gates, from Death to Life, from the Book of the Dead [*mort(e)s*] to the Book of Words [*mots*]. For it is she who reunites the pieces of Osiris's dismemberment, re-forms the body from all parts, and from each part draws, shapes, invents an entire body.

She is the goddess of recollection, of difference, of multiplication. It is the principle of the Osiriac text (she says 'osirisk'): 'Her art of arriving from all parts' (*La*, p. 92). From all lives. From 'Allangue' (*La*, p. 82).

Redemption, for Hélène-Isis, comes down to evoking the germinating image recognizable/unrecognizable. 'It is to speak [to eat] languages [dandelions] by the roots' (*La*, p. 86).[8] 'In a language, one cannot die' (*Jours*, p. 120).

Giving the feminine, giving the music

One must guard against obliterating this germination which ferments the writer's text under the cover of 'feminism'.

Cixousian writing does not name a he without a she: never *un il* without '*une île*' (a he-she-isle), nor without '*un el*' (a she-he-el) (*La*, p. 185; *Déluge*, p. 196). In other words, this writing is informed by the differential of sexual difference, the strange truths that it conveys.

Hélène Cixous's books give precisely the feminine, the music [*donne le la*]: other entries to meaning; the between at work which escapes classification; a between-two, which makes three and more; a between-time which exceeds time. They multiply the differences (for example: 'son who is a daughter', *La*, p. 132; 'the man who is your mother', *Angst*, p. 72), even the smallest: *Jours; Promethea*; an ant transposed, in French, from the feminine to the masculine (*un fourmi*). They inscribe the overturning, differentiating activity: especially the mute 'e' (used to designate the feminine) which at the same time changes and mutates the meanings. There is the she-child [*enfante*], the female falcon [*fauconne*], the sky as feminine or sky as feminine blue [*cielle* or *ciel bleue*]; there is a she-brother [*la frère*], there is in-itself-(feminine)/silk [*en soie*], for in-itself-(masculine) [*en soi*], and that masculinized ant which is the linguistic *happening* par excellence; which happens. Which passes. Vector. Mark of an accident, cause of trouble, in the circulation of meaning.

This trouble is beneficial: it awakens, it softens the hard of hearing – makes them receptive. Opens the eyes, awakens the heart.

Giving the feminine, giving the music, is giving the fertile separation (she says: 'sacred'), the 'separation with great desirable arms in which we make our beds and our fusions' (*Beethoven à jamais*, p. 211).

She. It is the other which is called with the feminine pronoun: the title of Hélène Cixous's book, *La*, plays on the definite and on the infinite. On every possible designation: all is *terra incognita*. Designating the gesture of designation.

There is more. When *La* takes an accent, it takes on the accent of the

beyond (beyond, over there), and co-responding to the *It* [*Ça*], crosses the limit: gives to the body 'the desire to run through overflowing regions, the desire to invent transports, carriages to draw oneself within reach of the Unknown, the art of going *Là* [there/here] . . .' (*La*, p. 83).

Reach of the unknown

Art creates a conduit from the inside to the outside, leads abroad, to the unknown. It is always there that I know nothing about *it*. Hélène Cixous writes 'abroad', 'to the stranger', in the same way Rembrandt painted '*hinaus in die Fremde der Heimat*, leaving by the painting's door' (*Jours*, p. 129). There gestures are needed for an address with no addressee. Or rather, whose addressee is: Nothing. No One. An address whose nature is that of a promise. Of the star being followed.

Art is the arch thrown over the void, carried by its own momentum, its advance on the abyss. There one needs courage, confidence. Faith. And humility. The humility of the labourer's technique: there one must grasp with both hands – to tomorrow returned with both hands [*demain à deux mains*]. 'In the hand, invisible dice, invisible tomorrows' (*Beethoven à jamais*).

Art is door and loss. Window ('An unknown woman at the window of infinity', *La*, p. 55). Opening from all sides. Art clears the way for an inside-outside. It puts within reach that which is unknown to me. Unknown *in* me. The constitutive strangeness 'which vertigos my life' (*La*, p. 58): not to know knowing, not to think thinking.

There fear is necessary, instability: setting foot right in the text's earth, so as to be able to let oneself go there, blindly. Doing the splits. *Le Livre de Promethea*: 'I am a little afraid for this book [. . .] It would be better to throw oneself in' (p. 20).

The reach of the unknown (woman) is incommensurable. She gives (to) me. Discovery that we are much more than ourselves. She stretches us, lays us down. Somewhere, she *becomes* (she *makes us*) earth [*elle (nous) fait terre*]:

> She sees herself stretched out upon the earth as if it were the familiar pose [. . .] in relation to the earth which bears her, which does not disturb her, which receives her and stretches her out, she sees herself in all *her/its* length.
>
> (*La*, p. 156)

(Emphasis added to the amphibological possessive where 'she' and 'earth' melt together: Her length and/is the earth's length.)

A subject at risk

The Cixousian subject presents itself in practice. In the present: from the theatre of writing. It is the application point of existential phenomena and, as such, may fall to pieces. A being of intermittencies, not ceasing to disconnect: lives a thousand lives, lives a thousand deaths. Does not recognize itself there. Does not recognize its defunct faces. 'We carry within us the speechless dead. My mummies' (*La*, p. 20).

> [. . .] time our painter is slow. It needs twenty years to assemble a portrait that is our result [. . .] Time pursues its work, taking note of and retaining our elements in transformation, until the person we have ended up being comes to our consciousness, and everything has changed. And everything will change again.
>
> (*Jours de l'an*, p. 45)

This is what the books strive to tell: a subject that *does not have time*, is atomised. And how time smashes it to pieces, holds it, in suffering, on the point of: 'between already and not yet' (*Jours*, p. 47); 'Between nothing-more and nothing-yet' (*Beethoven à jamais*, p. 33). At every instant, they (the Book and the subject) risk a short-circuit – breakdown or bursting into flames.

It is a subject at risk. Tied to the instant, it can only be *instance* ('Isay') – of enunciation, of fabulation: 'The yesterday is travelled. Between Ihadto [*jedus*] and Isay [*jedis*]' (*La*, p. 20) – and not proprietor of the proper name. Nor of identity. Nor of an entity. It lives on (narrative) credit and wears borrowed skins.

The subject must be risked. That is even what the subject is: by definition: risk. 'At risk of losing oneself. The risk is necessary' (*Jours de l'an*, p. 53). That is why the Cixousian subject does not stop running: it races against itself and against its narratives. Its truth is in this race: since the only safeguard for this subject so *subject to*, so much of a *taken* course, is to multiply the points of view, the points. The blind spots.

It is thus a singularly subjective subject which is at work: summoned, assigned, affected. Affected with common scaling [*commun*]. *Comme-un*, like David/a david, Clarice/a clarice, Ascension/an ascension, pierre [stone]/

Pierre, Thomas Bernhard/*mention T.B.*,[9] the almond [*Mandel*] in Mandela and Mandelstam, and so many other de-nominations, other running, ordinary subjects (like an ordinary, common title, rendered banal) swarm in the text, constituting semantic force fields, sectors of magnetisation. Where *meaning is magnet*.

For the subjective subject has a tendency to lose its head: it thus becomes 'Ubject' (*Neutre*), thinks with the heart, reads 'with its head cut off' (*L'ange*, p. 91), becomes capable of apprehending the sentences' cardiac truth. Of the subject, it is above all je(c)t: pro-ject, tra-jectory, variable of a geometry which creates narrative economy. In the unflagging combat the subject wages with the angel, the heart stands up to the head and the soul takes on the body.

The subject at risk is the unparalleled *subject of writing*, in the double sense of the genitive, passive-active: writing matter, producer of the text. There, it makes a scene, scenes are made for it. As in these lines: 'We guess that we are guessed, we are crafty, *we are crafted* [*on est rusé*], we slip' (*La*, p. 21; emphasis added), where, through the mechanism of the double tracks in the first proposition, the third – 'we are crafted' – crosses the boundaries of grammaticality and becomes laden with a passive (mis)interpretation: to be crafty = to deceive; to be crafted = to be deceived. While the slippage names straight away what the text has just done.

On the scene of writing, the subject thus exhibits itself as palimpsest, memory, parchment, receives inked impressions, can lose 'too much sense' ('I had lost too much sense. I saw things dimly', *Angst*, p. 35), can sign and bleed letters, can be faulty, can give itself over to madness. And to the splitting of the narrative instance, which is never one without the other: The Author-she and I-Me ('The author that I am can say: I am not me', *L'ange*, p. 29) instance which most often does not hesitate with one or two and proliferates, refining proximities. It is thus that appears, between 'the makers' H and Promethea, an 'I of the author': 'It is a thin character' whose purpose is to 'slip as closely as possible to the being of the two real makers, to the point of being able to follow the contour of their souls with mine, without, however, causing confusion' (*Le Livre de Promethea*, p. 12).

The subject? They are the voices-ways of the text. It is the book. The book of hours is the book of instants, delivers instants.

The oxymoric narrative

'To what do our lives cling? Our lives cling to their narrative' (*Beethoven à jamais*, p. 19). And in order that this narrative should in turn *hold*, it must be like 'all that lives [which] is oxymoric' (p. 172). Such is the principle of equational drift which organizes the texts: it shows that there is no tautology and that *nothing is equal*. Each inscription counts.

The oxymoron permits antipodes to be brought together, allows the gap to be rendered infinitely sensitive. It is the principle of the minuscule abyss, which fissures significations and risks extraordinary footbridges – principle all the more effective in that it plays on points, to within a comma. In a breath.

'The Secret – we do not have it. It is us/For us it is.[10] Faith' (*Beethoven à jamais*, p. 18). The semantic commotion arises here from the punctuation. The expected 'For us it is faith' would make the text smooth. The caesura, unexpected, drives the reading upstream where all the attention (the tension) is brought to bear on the verb 'to have'. Thus confronted, to have and to be establish a non-symmetrical symmetry: 'we do not have it' calls up 'it *has* us', but leads to 'it *is* us'. The reading falters, halted before a difficulty in thinking (aporia, unthought-of) then, rebounding downstream, echoes the parallel deciphering to be/to have onto 'faith' (to have, to be held by faith).

The broken line of this trajectory offers an exemplary process of Cixousian writing where it is a matter of giving greater importance to the rhyme a – not-a (as opposed to the rhyme a – a). This figure of thought informs all the works and confers on the narrative a parabolic function. Mixing literary genres and discursive genres, the oxymoric mechanism allows it to be said: 'the trial for us to be human. The Pain' (*L'Indiade ou l'Inde de leurs rêves*, p. 253). The difficulty in hearing: the Suffering of Joy, the Truth of Error, the relation Reason/non-reason/Madness ('Madness! I lost my non-reason', *Angst*, p. 21) which are some of the narrative's major articulations.

An unusual writing is thus elaborated: a tale with two bloods, with opposite directions and doubly without: Story without plot; event without character – in other words *with* (No/Some) One. The heterogeneity which shapes this unbridled narrative, completely dislocated in appearance, reveals itself as everything but anything: in fact, a dynamic of compensation organises the equilibria of the de-construction at work. That is what the song says, in such a beautiful manner, at the centre of *Beethoven à jamais* (pp. 112–13):

– O that we are not of the same blood [. . .]
– But then we would lose [. . .] these flights by which we struggle to
prevent the cleft from broadening [. . .]
It is because we are not of the same blood
That I have such breathless love
Between us no bond, no knot
Only the musicality –
O that we are not of the same blood . . .
 (each time *one tone higher*)

From coffee to eternity: the philtre of the text

Strength does not come from preservation (of the same) but from the irrup-
tion of alterity. My life comes to me from the other, love is the mainspring of
writing: such is the axiom at the heart of the workings of Hélène Cixous's
narrative, the secret of her art's vitality. A magnetic sense – attraction and
difference – organizes what the writer calls '*séparéunion*' and which is: the
work of passion.

From this point onwards, there is no worthy literature but that which
strives towards the writing of passion: under the regime of lightning, fire,
blaze, of the oxymoron, of the dative. Of All-Nothing, coffee-eternity.

It is, in fact, the parable of creation which Hélène Cixous's narratives tell;
of the magical force which trans-figures but whose passing happens word by
word, drop by drop, through the filter of the text – which purifies, balances.
With the 'fear of writing on too low a flame' (*Beethoven*, p. 42), that lan-
guage neither sees nor hears far enough, that the coffee-filter is not fine
enough, the interstices not sufficiently small. Nietzsche, exemplar, gives a
lesson of mad love by homophony: where naming is burning.

> *Die Liebe ist's die mich mitgehen heißt*
> *Die heiß ersehnte!*
> *Heiß* and *heißt*, same letter same fire, the call burns me, the fire calls
> me. All the names of love pass through me.
>
> (*La*, p. 67)

The text must be like a good, strong coffee, as they say – so that it may
become magical philtre. That the gaps in meaning break through, the fire
ashes where meaning is reborn, the scorched earth of the text sends forth

narrative shoots. Like *Le Livre de Promethea* which, at the end (p. 248), stops with these words:

> – Oh I forgot! Promethea falls in love.
> – Falls?
> – Is.

The falling cadence [*chute*] of the sentence, of the book, makes earth; the text rebounds to the point where it finishes, thanks to the oxymoric force of this ultimate device: which, by explosion of the cliché, reinscribes everyday banality at the centre of what is vitally at stake: Death, Life, Resurrection. For 'Fall' [*Tombe*] also names 'the tomb' [*la tombe*], summons the opposition under/on the earth, makes an ascent of this fall of the fire thief. Promethea liable to fall and taking flight is, like the writer, Phoenix – bird of fire.

Or the existence of God[11]

From book to book, Hélène Cixous has constructed for herself an entire collection of registers and keys. An entire scale: to play, to climb and to descend. Scale of what is possible, musical scale. Do re mi fa sol la ti. It is a Jacob's ladder, a ladder of vocal chords, always resumed ever higher, which leads to the ascension to heaven. Degree by degree:

do – madness, abyss; it is the note *do* in Schumann's ear (*On ne part pas, on ne revient pas*).

re – recollection from loss, the awakening.

mi – by the middle, always already begun.

fa – nymphs' voices, the new year, the new sap: 'the nymphs speak in fa, the dead are forgiven and forgive us, writing arises' (*Beethoven à jamais*, p. 234).

sol – where the soul makes earth in language: 'the *sol*/Of the soul which is language' (p. 160).

la – gift, difference.

ti – the infinite: 'each mouthful was *too*, was *ti*, and what she was in the process of understanding then, was the infinite' (*Limonade tout était si infini*, p. 300).

It is in this way that the rigorous economy of the text has brought order to the laws of ascensional and gravitational forces; and succeeded in making (the) work: in other words, in creating an expanding universe. Held out

towards. Between Madness and Infinity. Madness and Faith ('I see it, the word Faith [*Foi*] in the word Madness [*Folie*]', *Beethoven à jamais*, p. 43). Eternity at the moment.

This is probably why, in the work of Hélène Cixous, the greatest risk is not without the greatest serenity. At the end, on the edge of the abyss, of the emptiness of the blank page and of the earth, in an exemplary acceptance where 'living the moment' is finding force in precariousness ('for the moment'), *Limonade* inscribes this portent of a writing infinitely begun anew:

> – When I will have paid. Afterwards.
> But *for the moment, there are enough flowers.*
> <div align="right">(*Limonade*, p. 306, emphasis added)</div>

Enough flowers to breathe, to write.

Notes

1 Translated by Agnes Conacher and Catherine McGann in *The Hélène Cixous Reader*. Translation modified by Eric Prenowitz.

2 Hélène Cixous, 'En octobre 1991 . . .', in *Du féminin*, ed. Mireille Calle, (Grenoble and Quebec, Presses Universitaires de Grenoble, le Griffon d'argile, 1992), p. 135.

3 '*Le lieu du Crime, le lieu du Pardon*,' in *L'indiade ou l'Inde de leurs rêves*, p. 253.

4 Hélène Cixous, *supra*, 'Inter view', this vol., p. 20.

5 Ibid.

6 Ibid, pp. 30–2.

7 *Animots:* a created and animated word (*mot*) homophonic with *animaux* (animals). [Trans.]

8 I am including the words of the French saying *manger les pissenlits par la racine* (to be pushing up daisies) in order to show the displacement at work in Cixous's text. [Calle-Gruber.]

9 *Mention T. B. (Très Bien)* is the approximate equivalent of an 'A' at school. [Trans.]

10 These are two readings of the sentence *Il nous est* that will come into play here. [Trans.]

11 Subtitle of *Beethoven à jamais*.

Albums and legends

All biographies like all autobiographies
like all narratives tell one story in place of another story.

Hélène Cixous:

They have always been there.
 I do not look at them. I have never looked at them. I 'know' they are there. Their presence. Roots. Mine? My so strange roots.

 Old tattered album. Respect the tatteredness. The tatteredness is the secret: portrait of the family memory. Album, memory, cemetery, abandoned. One goes forward, sowing the stones of grief behind oneself. Album of abandonment. Faithful to the abandonment. Respect the abandonment. To the question: how have these frail objects survived, how have they resisted, will they resist the teeth of time? not to respond.
 And each time in thirty, forty, fifty years, when one comes to the album of dust, each rare time of attention, there is a slight trembling of the flicker of fear that the photo which holds only by a worn torn gold corner, by a spot of old old glue, should fall. Some have fallen, inside. Photos of people fallen one after the other, crumbling of years, time has slowed so brutally, a city falls into another, a grandmother of a mother meets an unknown cousin by a stroke of memory without law.

 Album in ruins to be respected. It is memory itself. A place I do not return to. If we leaf through, we do it absent-mindedly, going by the open photos, that fade to let me pass. I was born so far from my beginnings. I follow the bed of the blood. My distant blood, my foreigner, what a way we have come . . .

'Les Deux Mondes' [The Two Worlds] – Oran

What constitutes the originary earth, the native country of my writing is a vast expanse of time and lands where my long, my double childhood unfolds. I have a childhood with two memories. My own childhood was accompanied and illustrated by the childhood of my mother. The German childhood of my mother came to recount and resuscitate itself in my childhood like an immense North in my South. With Omi my grandmother the North went back even further. Consequently, although I am profoundly Mediterranean of body, of appearance, of *jouissances*, all my imaginary affinities are Nordic.

Reine and Samuel Cixous, my Oranian grandparents

Geography of my genealogical memory: I stand at the edge of North Africa. On its beach. To my left, that is, to the West, my paternal family – which followed the classic trajectory of the Jews chased from Spain to Morocco. My father's grandparents are from Tetuán or Tangier. They travelled on donkey-back. No doubt following the French army – as peddlers and interpreters – they arrive at the western edge of Algeria: Oran. My native city. A very Spanish city. In my father's family, French and Spanish are spoken. The father, Samuel, also speaks Arabic. The father becomes a 'business man' at the age of eleven. An 'out of the ordinary' man. He plays the violin. A handsome imposing man. Capable. He opens boutiques. A hat and tobacco boutique on the *Place d'Armes* in Oran called 'The Two Worlds'. When I was little I lived in a city full of neighbourhoods, of peoples, of languages.

Hélène Meyer and her husband Abraham Jonas
My German great-grandparents

There were the Spanish, who were Catholic; the Arabs; the Jews. And the French. There were the French French from France. And in the French there were also the Jews and the Spanish. That was my West.

My East, my right, my North: it was the landscape of my mother. It is a very tall tree with many branches. On the one hand the German branch, of Omi my grandmother (born Rosalie Jonas in

**My German grandparents
Rosi and Michael Klein**

Eve my mother and her sister Erika

1882 in Osnabrück, Hanover, old German family, very German).
Omi traversed my whole life. She is a bit m,o,i.[1] Omi is the eighth
child, the youngest of her mother Hélène Meyer (there's my
name). On the other hand, there is the branch of my mother's
father, Michael Klein, who belonged to a family originating from a
small village on the border of the Austro-Hungarian Empire, not
far from Trnava which is not far from Vienna. The border moves.
I thought my grandfather was Hungarian, then Czech, until I
discover that this village was Slovak.

(N.B.: but today I discover that he was *born* in a small Hungarian
village.)

My childhood was spent in large part in the landscape of a
recounted Europe. It was the legend of Europe told by those who

My grandfathers in 1915

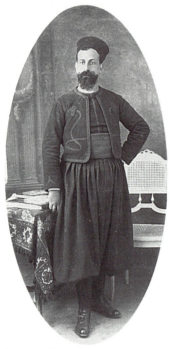

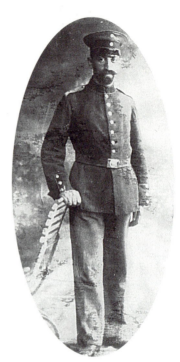

Samuel Cixous **Michael Klein**

travelled it over. I sense that the French are firmly rooted. The Jews were the travellers of Europe. Not because they were expelled, but because they were searching: they went from one community to another across countries and kingdoms, searching either for the Rabbi, for knowledge, or for the wife from a suitable family.

In fact, these Jews were destinally European. All those Jews, so different from each other, who were Hungarian, Austrian, Czechoslovakian, Romanian, Polish, etc. . . . all – like Kafka – had a general common language, which was German, to which they added the language of the country in which they lived. My grandfather knew Hungarian though he was German-speaking. The Kleins had twenty children. The family ran a farm. The mother managed the land which she crossed on horseback. On horseback. And on her head, the wig of the Orthodox woman. The father spent his nights studying the Talmud.

The landscape that unfolded for me in all these countries of the

Telegraph the German Empire
The soldier Michael Klein died on 27.7 at the military hospital of
Baranovici as a result of his wounds. Written message already sent.
Lieutenant Billenstein 11th Company of the Light Infantry Regiment.

East took a sort of mortal leap in 1915 towards the most north of
the North, the uncertain Russian North. And it is from this furthest
North point that all my personal narrative was crystallized: from
the story of Michael Klein.

Michael Klein, who was then of Hungarian nationality, took
German nationality in 1909 so as to marry my grandmother
Rosalie Jonas. Which got him enrolled in the German army in the
First World War. Omi still dated her childhood stories from the
Kaiser. For her, the Kaiser still existed.

My grandfather died on the Russian front as a German soldier.
There is an account: he received a piece of shrapnel in the leg and
died of a haemorrhage. There is a star. When I was small, what I
saw as a star, in the North of my history, was my grandfather's grave
in an unknown Russian forest.

My Jewish German soldier grandfather was buried in 1916 in
Russia and on the grave they put up a true little monument
carrying an inscription in German and in Hebrew and a star of
David. The grave is among other German graves adorned with
crosses. That was the Europe of the beginning of this century . . .
Star and cross together.

Photos: portals, porticos. I enter the forest. I have already seen trees. But neither I nor anyone has ever seen this grave. It is dead. Wooden letter, no one has come to hear you breathe. Standing, I copy the address onto the envelope: Hier ruht in Gott – Landstm. – Michael Klein – 11 KOMP.L.I.R.6 – GEST. 27.7.16

I copy and I cry.

The soldier with lilacs and his grave in Baranovici (Byelorussia)

Why these tears? Because I am dead. I am so dead. Because I have become this raised wooden stone that repeats my name and my date of death to the air where I never lived. The wooden page informs the empty wood that henceforth it is here that I live, become foreign earth and wood. Oh! I need God so as not to forget myself.

My name is Michael Klein. I am resting. I have lost my birth. How can one be so dead? The passer-by would teach me more than my death about myself. This is where I begin. The last day. But there are no passers-by. The entire forest has no address. Everything is interrupted.

The grass in disorder on my foot. To my left a Fritz, behind me a Paul behind Paul a . . . illegible behind Fritz a . . . illegible.

It happened thus:

Stopped short, cut, first the leg then the root. I am planted in a forest where no one I know has ever come to see me. All of a

Nicolaïplatz, Osnabrück in 1915: the family building

sudden, in July, I became Russian and dead. The shafts of the pine trees rise very straight among our crosses and our simple wooden stories. God is an unknown pine forest.

On the right, the standing soldier. To his left, preceding him in our reading which goes from left to right, his grave. But read from right to left according to the Hebrew mode, first him then his grave.

The soldier's glance goes off towards his left to infinity. At infinity, what does he see, the soldier whose glance goes off, goes off?

And just next door, hard by, his grave.

Life-size grave. I mean of the same nature: both of them, the soldier and it, the same size. So these are two portraits of the same person, before and after. A resemblance unites them.

On the left, an abstract portrait. Encircled, smooth brow, on which wooden veins run. In the middle of the chest, the face: a six-pointed star.

To the right, the infinite soldier. A true soldier. Widowed. Widowed of himself. Above: the helmet with a spike. What remains of the face remembers, it seems, that the day before he was a man with a family, a living being, a lover. It seems. If not, why in front of the lilacs this face that remembers to infinity? A true soldier is always already a memory.

Such is the strange heart of the family album. The implausible origin with a spike. It pierces my chest.

The synagogue destroyed by the Germans

Am I born of this man who goes off? I myself do not believe it. Or rather: I unbelieve it.

My grandfather also earned a cross. We still have the German war cross.

A wonderful thing: how my grandmother, a German war widow, became a French war widow. Just before the war, my grandfather moved to Strasbourg in German Alsace where he had opened a little jute factory. Widowed, Omi returned to Germany proper, with her daughters, to Osnabrück, where my mother went to school.

My parents

Alsace became French: because of the Alsatian address, Omi then had the right to a double nationality passport. When she left Nazi Germany in November 1938 thanks to this passport, she went keeping her status as war widow. This is how she became a war widow in France where she received a small pension until the end. These little things, these ties, are very strong weavings. I have vestiges in myself of a History that still had a pre-inhuman mask.

One year old

I was born in an opposite age: an age of nationalisms, of re-nationalisms.

My life begins with graves. They go beyond the individual, the singularity.

I see a sort of genealogy of graves. When I was little, it seemed to me that the grave of my father came out of that grave of the North. My father's grave is also a lost grave. It is in Algeria. No one ever goes there any more or will ever go.

When I speak today in terms of genealogy, it is no longer only Europe that I see, but, in an astral way, the totality of the universe. The families of my mother, very large as Jewish families often are, had two fates: the concentration camps on the one hand; on the other, the scattering across the earth. This gives me a sort of world-wide resonance. I have always felt it because the echoes always came from the whole earth. From all the survivors.

My Slovak great-grandfather Abraham Klein studies the Talmud

1941: The deportation train leaves Osnabrück

Klein from Tyrnau (Slovakia) Family tree

Abraham Meir KLEIN 1844 Smolenitz (Slovakia) – 1924 Tyrnau
Rosa (Rivka) EHRENSTEIN: 1846 (about) Skalitze – 1925 Tyrnau

Children:
1. Charlotte
2. Riesa
3. Sidi
4. Moritz
5. Michael
6. Salmi
7. Sigmund
8. Selma
9. Sara
10. Marcus
11. Shamshi
12. Leah
13. Elsa
14. Norbert

1. Charlotte KLEIN: 1871–1923, Tyrnau
 Jacob EHRLICH: 1869, Pressburg – 1901, Tyrnau
 a. Hilda Ehrlich
 —— Freund
 5 children: 4 died in concentration camp.
 The 5th, Eliezer Freund, Jerusalem, 3 children: Nathan,
 married, 1 boy; Ilana, married, 1 boy; Ronit, single.
 b. Yolan Ehrlich
 —— Friedlander
 Both died in c. c., had a few children.
 c. Shandor Ehrlich (died in Israel)
 Bella Ungar
 Lived in Tyrnau, 3 children:
 Walter Orli, Judith Orli (famous officer in the Israeli Army
 Ramat Gan), 4 children: 3 daughters, 1 boy;
 Edith Mattalon and husband, Tel Aviv, 2 daughters: 1
 daughter married with 1 child;
 Benno Ehrlich, Penina Ehrlich, 3 sons.
 d. Jacob Ehrlich
 Frieda Fleischman
 Lived in Tyrnau, no children, live in Jerusalem.

2. Riesa KLEIN: 1894–1975, Tyrnau, Watz, Strasbourg
 Samuel BUCHINGER: 1877–1936, Watz, Hungary
 7 children, all born in Watz
 a. Nandor Buchinger
 Marie Weinberg
 Lived in Colmar, France, 3 children: Paul, André, Claude.
 b. Shandor Buchinger
 Anna
 Lived in Strasbourg, Shandor died in c. c., Anna lives in
 Strasbourg, no children.
 c. Boeschke Buchinger, born 1901
 Frederic Buchinger, died 1968
 4 children:
 Chaya (Lazzi), 10 children;
 Nandi, – children;
 Robert, – children;
 1 daughter (Evi) died in c. c.

d. Yennoe Buchinger and his wife died in c. c. with their seven children.

e. Margit Buchinger, born 1904
Samuel Rosenberg, born 1903
3 children: 2 daughters, 1 son, all married, all live in Tel Aviv.

f. Fritz Buchinger
Liesel Klein
Have a few children, all live in Strasbourg and Israel.

g. Imre Buchinger
Magda Schnitzer
Live in New York.

3. Sidonie (Sidi) KLEIN: died 1950 in Nesher, Israel
Adolf REICHENTHAL: died 1948 in Nesher, Israel
They lived before the war in Pystian, where he was a teacher.

a. Shandor Reichenthal
—— Roth
Live in Nesher near Haifa
2 sons married in Israel.

b. Yennoe Reichenthal, died 1945
—— Honig
They had no children.

4. Moritz (Maurice) KLEIN: 4.08.1875 in Tyrnau–Elul 1, 1958
Selma LEWY: 24.04.1882 in Berlin–Adar 21, 1935,
Lived in Strasbourg, France, 6 children

a. Albert Klein, 16.07.1909, Strasbourg – Iyar 25, 1976
Roberte Kahn, born 1924, Strasbourg, where she lives
2 daughters:
Eliane married George Weill, 5 children;
Joelle married Bernard Amsalem, 3 daughters.

b. Rachel (Hella) Klein, born 26.02.1912, Strasbourg
Hugo Stransky (Rabbi), 1905, Prague, CSR – 1983
She lives in Israel. 2 children:
Michael and wife live in Australia with 2 children: Nicole, Raoul;
Judith and Otta Schnepp, no children.

c. Berthe Klein, 27.04.1913, Strasbourg
Pierre Bernheim, Colmar, France, died in the 1960s
2 children:

Marc and Rivka Sibony live in Grenoble with 3 daughters;
Gilles and Joelle Bollack, live in Paris.

d. Ruth Klein, born 19.01.1915, Strasbourg, USA, Israel
Fritz Blank 29.09.1914, Horn, Germany – Iyar 4, 1977
3 children:
David and Gladys Barg, live in Toronto, Canada, 3 children:
Robin, Mark and Jeffrey;
Eve (Chava Eshel), lives in New Mexico, USA;
Jacob and Dinah Hazzan (Hezi Zurishaddai) live in Beer
Shevah, Israel.

e. Jeanne Klein, 19.01.1915, Strasbourg
Emmanuel Rais, 1909 – January 1981, Paris
She lives in Paris, no children.

5. Michael KLEIN: Tyrnau – died W.W.I., 1916
Rosy JONAS: Osnabrück – died in the seventies
2 daughters
a. Eve Klein
Georges (passed away)
1 daughter, 1 son, live in Paris.
b. Erica Klein, lives in Manchester
Bertold Barme (passed away)
1 son, 1 daughter, both married, have children.

6. Salmi KLEIN: Tyrnau–died in c. c.
Louisa WAHRKANY: Gyoer–died in c. c.
4 children
a. Walter Klein, died in c. c.
b. Michael Klein
Leah Levin
2 children: 1 daughter, 1 son, married, children.
c. Edith Klein, born 1920
Yennoe Deutsch, born 1916
Live in Tel Aviv, 2 sons, married, children.
d. Alice Klein, born 1910
Leopold Buchinger, born 1910, Hungary, Los Angeles
2 children:
Tami, married with 2 daughters;
1 daughter.

7. Sigmund KLEIN: Wounded a few times in W.W.I, single,
 died in c. c.

8. Selma KLEIN: Died in c. c.
 —— COHEN: Liska, Rumania – died in c. c.
 1 son, David, died in c. c.

9. Sarah KLEIN: Died in c. c.
 —— COHEN: Liska, Rumania – died in c. c.
 1 son, Isidore, married, daughter in Tel Aviv.

10. Marcus KLEIN: 8 years in South Africa, died in c. c.
 Married and lived in Velky-Meder, 4–5 children, all died in c. c.

11. Schamschi KLEIN: Died in c. c.
 Olga SCHLESINGER: Died in c. c.
 Lived in Tyrnau, 5 daughters, all died in c. c.

12. Leah KLEIN: 1888, Tyrnau – 1944, (c. c.) Theresienstadt
 Sigmund UNGER: 1883 Frauenkirchen, Austria – 1944, c. c.
 6 children
 a. Alfred Unger, born 1909 Zielenrig, Germany
 Ester Beigel, born 1922 Frankfurt
 4 children:
 Judah, 1945–1964, died in military service;
 Leah and Jossi Bamberger, 4 children: 2 boys and 2 girls,
 Hafetz H.;
 Yeshayahu and Sh. Freyhan live in Arad, 3 children; Sarah
 and Argamon Beigel live in Mevocheron, 3 children.
 b. Kurt Unger, 1913, Frankfurt/Oder – died in c. c.
 c. Ruth Unger, 1915, Frankfurt/Oder
 Kurt Singer, 1907, Berlin
 Live in Los Angeles, 2 children:
 Joel and Bluete;
 Linda, single, North Carolina.
 d. Manfred Unger, 1921, Chemnitz, single, lives in New York.
 e. Margot Unger, 1923, Chemnitz
 Hans Manasse, 1918, Berlin
 All live in Los Angeles, 2 children:
 Diana and M. Mechnick (2 children);
 Jerry, single.

 f. Charlotte Unger, 1924, Chemnitz
 Ernst Vulkan, 1918, Vienna
 Live in Los Angeles, 2 children: Dennis and Mike, both single.

13. Elsa KLEIN: Born 1889, Tyrnau
 Aron WEISS (Rabbi): 1945, Strasbourg, formerly Vienna
 4 children
 a. Lily Weiss, born 1915
 Naftali Friedman
 They live in Haifa, 2 children, all in Israel:
 Deborah is married, has married children;
 Ginki is married, has one son.
 b. Michael Weiss, single, lives in Israel.
 c. Pauli Weiss, born 1921, divorced, remarried, lives in Arad,
 1 son in USA, 1 daughter in Israel.
 d. Herta Weiss, born 1923
 Zeev Yitshaki, born 1918
 Live in Tel Aviv, 2 children:
 Noah Elsheva;
 Aharon (Roni), married, 2 children.

14. Norbert KLEIN: Tyrnau – 1979, Strasbourg
 Celine BLOCH: Zurich – she died before him
 No children.

**At the Clos Salembier, with my cousin
Gisèle (on the right) in the wistaria**

The landscape of my childhood was double. On one hand there was North Africa, a powerfully sensual body, that I shared, bread, fruit, odours, spices, with my brother. On the other hand existed a landscape with the snow of my mother. And above the countries, the always present History of wars. I had the sense that humanity advanced from war to war. I was born to return to war. During the war my house resonated with the magic words used by my mother: 'before-the-war'.

Rue Philippe in Oran
on my father's knees

In Oran, I had a very strong feeling of paradise, even while it was the war and my family was hit from all sides: by the concentration camps in the North, by Vichy in Algeria. My father was forbidden to practise medicine, we lost French nationality, we were excluded from the public school.

But in spite of the difficulties of living, in spite of the first experiences of anti-Semitism, in spite of the bombing and the threats, it was paradise. The family was full of dreams and creation. My father and my mother were naturally poetic and deft with their hands. My mother and Omi spoke and sang in German. My father loved music, drawing, words, books. The family played word games. We were happy.

First beach with my father

I had such a violent sense of happiness that I spent my young childhood in secret fears. Because on earth there cannot be paradise, I thought I was going to pay. The price is that surely my mother is going to die. It is my father who died. Hell began: it is not only because we had lost everything; but also because with great urgency I had to carry out a mutilating mutation of identity. As the eldest of the family, I was obliged in many circumstances to become my father, for reasons of survival, of the honour of my mother or of my family. (On one hand I lost the right to childhood. On the other, I had an exacerbated taste for childhood.)

I associate my father with four figures I know to be undeniable.

The dominant figure was that of the just or the saint. Strangely, while he was youthful and he died very young, he had such a strong ethical nature that he was seen as being a model.

My father was non-religious. He was not a believer, in the family that maintained a Jewish tradition. There are innumerable scenes of my father behaving as a hospitable man, a generous man, a fraternal man. He was saluted by the Arabs whom he treated with love because my father

Poppies at the Petit Vichy in Oran

placed himself beyond all racism. He was a human being who preached by example. In his profession and in the family.

The second figure is what he was for us, Hélène-and-Pierre: the law. Moral, absolute law. He was extremely severe. We committed many 'crimes', my brother and I, transgressions of all sorts, probably in response to the power of the law in the family. Because we were punished. This engendered a vision of the world. It was as if my father the non-believer were the incarnation of the Tablets of the Law.

That law was accompanied by a vivid trait in my father: the laugh. Humour was a second language for him. He played on everything, members of the family, situations, and above all signifiers. He was

the enchanter. The universe was slightly translated. He had married a German woman and he had a house where we spoke German because my grandmother Omi had arrived and spoke almost no French. So my father had forged, in a Joycian way, an entire system of jokes on the German language that became part of the family idiom. We all juggled.

Perhaps the verbal virtuosity or versatility that there is in my writing comes to me from my father: as if he had made me a gift of keys or of linguistics.

The third figure goes with the fourth: he was a doctor and he was a sick person. He carried his profession in himself in the most noble form (I continue to idealize medicine-seen-by-my-father). I only understood that he was a sick person belatedly because it was something hidden and that must have been inscribed insidiously in our life.

Eve and Georges, wedding day

My father died of tuberculosis, he was not thirty-nine years old.

There is a series of fateful themes. My father does his thesis of medicine on tuberculosis. At the time he was to be engaged to my mother, he has a spontaneous pneumothorax. He writes saying that if he is tubercular he will not get married. It was his sense of responsibility. His senior medical director says that it is only the flu. He gets married. Everything is fateful: the appearance of the sickness, the denial of the sickness, the fact that we could have not

existed. I was born in '37, my brother in '38, my father was engaged in the war in '39, as a lieutenant-doctor in Tunisia. He is discharged for TB.

From then on, he leads the life of a clandestine tuberculosis patient. There is a sort of veiled death in the house, the effects of which we receive only because my father reserves himself, physically, in his relations with us. He avoids holding us in his arms. This produces uninterpretable effects of distance for us.

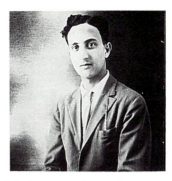

My father at the Lycèe Lamoricière, Oran

He seemed like a beautiful being. He was beautiful. With a beauty that is all the more striking no doubt in that it was a very interior beauty and threatened by death.

Twice my father appeared to me as an unknown person. Twice I did not recognize him. The first time is in '39 when he was mobilized – the word 'mobilization' enters into my life. Someone rang the bell, the door was opened and I see someone enter, someone foreign, strange. And richly trimmed. I pause. I remember the static shot

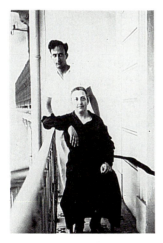

1935: my father thinks about my mother standing behind his mother

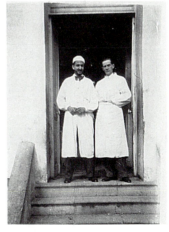

Intern at Mustapha Hospital in Algiers

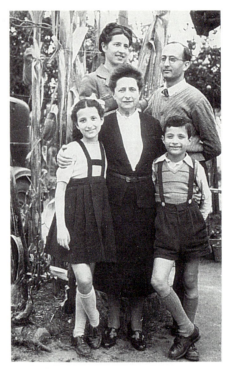

**1948: in the garden with Omi, just before
my father's death**

My father in 1939

perfectly. And then my father makes himself known. My father in uniform, with a blue kepi. I learn the word 'kepi'. I have the feeling of an abduction, of a transformation. Nothing tragic. Something fantastic.

The second time it is something else altogether. It is terrible. It was just before his death. Brutally a withdrawal then hospital. The last times of his life are violently brief. (Marked without my knowing it by 1, 2 – and the last hemoptysis.)

Last images: he is in a narrow room, in his own radiological clinic, lying on a small divan. I was allowed to go and see him. He no longer speaks. (He spoke no more – cf. Kafka.) I do not want to put a name on my anguish. He addresses me with signs. I respond abundantly, overabundantly. I sense I am playing 'completely natural'. I put on an act for myself. I saw my father enter into silence while he was alive. Everything held back: smile, held back, breath, held back, life, held back. No doubt he was trying to hold on to the last breath.

I was the child of two cities. Oran my native city which I adored. Osnabrück, city of the childhood of my mother, native city of Omi. I imagine Osnabrück. And I have a memory problem: I do not know if I went to Osnabrück or if I did not go.

When I was fifteen, I went to Germany for the first time in my life, with Omi. It was the first time Omi returned

'Christian Christmas – Jewish profit' anti-Semitic propaganda in Osnabrück

to Germany. It was a mad gesture, a solemn, light gesture, divided between love and resentment.

I have the feeling I went to Osnabrück with Omi. I seem to see the streets. But I do not know if I dreamed it. Everything seems to me. And no one to tell me if we went there, since Omi is dead. Osnabrück – if I went – remains dreamed. I cannot know.

The children

Esther and Ahasuerus (Purim)

Hélène and Pierre

The childhoods; the children. Infancy, a major term – rather in-fance than in France, and rather in-fiant: virtue, poetry, alliance, advance.

In fance I was not without my other. My other, my brother. We have a small difference in age. We were a couple: Hélène-and-Pierre. Sharing everything. Accomplices in the face of the adults; allies against the surrounding violence.

All the time I lived my life with the life of a small boy. I lived with the possibilities: I had a female possibility (that was me) and the masculine possibility with all its episodes. We were united and disunited. We fought. Together. In private, we said everything to each other (I think). I went through the stages of the development of a little boy. It was fortunate.

The brother is very strongly in me. He appears little in my texts, but he is certainly a constituent of my masculine universes.

We made childhood. We were explorers. We went on expeditions. We invented the theatre and the cinema.

This couple reappears with my own children. A stroke of genetic luck. The sister–brother couple returns. The older girl; later the olderness is displaced.

When we are together, we are four children. We are a single group. Composed of four possibilities. Who associate and disassociate – also by sexual attraction, repulsion, identification.

At Paradis Plage, Oran

Anne and Pierre-François at Arcachon

Children: with time they catch up with us. Luckily I admire them. Half children half friends. Half disciples half masters. 'Anne-Emmanuelle, Pierre-François'. Both of them teach and teach me.

What I am recounting here (including what is forgotten and omitted) is what for me is indissociable from writing. There is a

Pierre, Hélène, Anne, Pierre-François 1968 Alger-Plage

continuity between my childhoods, my children, and the world of writing – or of the narrative.

Then I arrive in France, in 1955. It is the first time. My first European city was London where my mother sent me (1950) alone to learn English.

In 1955, in *khâgne* at the Lycée Lakanal – that is where I felt the true torments of exile. Not before. Neither with the Germanys, nor with the Englands, nor with the Africas, I did not have such an absolute feeling of exclusion, of interdiction, of deportation. I was deported right inside the class.

In Algeria I never thought I was at home, nor that Algeria was my country, nor that I was French. This was part of the exercise of my life: I had to play with the question of French nationality which was aberrant, extravagant. I had French nationality when I was born. But no one ever took themselves for French in my family. Perhaps, on my father's side, they refrained from not being French. We were deprived of French nationality during the war: I don't know how they gave it back to us.

Image: I am three years old. I have followed in the streets of Oran the Pétain Youth parade. Dazzled, I go home singing 'Maréchal here we are'. My father takes my brother (two years old) and me solemnly on his knees. He solemnly tears the photo of Maréchal Pétain that I brought back, and he explains it to us.

That logic of nationality was accompanied by behaviours that have always been unbearable for me. The French nation was colonial. How could I be from a France that colonized an Algerian country when I knew that we ourselves, German Czechoslovak Hungarian Jews, were other Arabs. I could do nothing in this country. But neither did I know where I had something to do. It was the French language that brought me to Paris.

In France, what fell from me first was the obligation of the Jewish identity. On one hand, the anti-Semitism was incomparably weaker in Paris than in Algiers. On the other hand, I abruptly learned that my unacceptable truth in this world was my being a woman. Right away, it was war. I felt the explosion, the odour of misogyny. Up until then, living in a world of women, I had not felt it, I was Jewess, I was Jew.

From 1955 on, I adopted an imaginary nationality which is literary nationality.

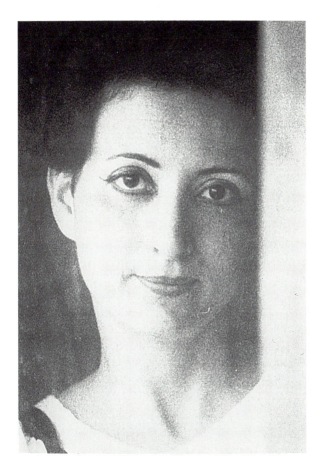

Photo by my friend D.L. Mohror

Note

1 *Moi*: me in French. [Trans.]

Chronicle

composed by
Mireille Calle-Gruber

12 February	
1948:	Hélène's father dies at the age of 39.
1947 to 1953:	Secondary school education at Lycée Fromentin in Algiers. The registers bear the traces of a restricted quota for Jews. In spite of a large community, there are few Jews at the Lycée. Hélène is the only Jew in her class for years.
1950:	Her mother Eve begins studies to become a mid-wife. Years of apprenticeship: her brother helps Hélène recite her lessons, Hélène helps her mother recite hers.
1952:	Having obtained her diploma, Eve practises in the nearby shanty-town: she is the 'Arabs' midwife'. At 14, Hélène accompanies her mother to the hospital where she sees women giving birth.
1954:	Hélène enters *hypokhâgne* (a class for the preparation of difficult university entrance exams) at the Lycée Bugeaud in Algiers, a boys' school.
1955:	Marriage to Guy Berger and departure for Paris where she enters *khâgne* (second preparatory year) at Lycée Lakanal, also a boys' school.
1956:	Guy Berger, who has obtained the CAPES (secondary school teaching diploma) in philosophy, is assigned a post in Bordeaux. Hélène prepares the *agrégation* (highest level teachers' exam) in English there.
1958:	Hélène's first child, Anne-Emmanuelle, is born. Hélène obtains the CAPES in English.
1959:	After having passed the *agrégation*, she decides to take a job at the lycée of Arcachon during the absence of her husband who is drafted for military service. It is the Algerian war: the length of service is extended to two years.
1960:	Hélène meets Jean-Jacques Mayoux with whom she begins a thesis on Joyce. Stephane is born.
1956 to 1962:	Her mother and her brother Pierre, a medical student, stay in Algeria during the war.
1961:	Stephane dies. Pierre-François is born.
	Her brother, who supports Algerian independence, is condemned to death by the OAS (*Organisation de l'armée secrète*, supporting French rule in Algeria). He joins Hélène in Bordeaux to finish his studies, and plans to return and take Algerian nationality.
1962:	Independence of Algeria. Eve is arrested by the Algerians. Pierre returns hastily and is arrested in turn. Hélène obtains their release with the help of Ben Bella's lawyer. Her brother moves to Bordeaux where he practises paediatrics. Her mother stays in Algeria, until she is finally expelled with the last French doctors and midwives. She loses everything. In France, where she does not have the status of a repatriate, she moves with Omi close to Hélène in 1971.
1962–63:	*Assistante* at the University of Bordeaux.

End of 1962:	Meets Jacques Derrida in Paris. They talk about Joyce.
1963:	First trip to the United States where Hélène does research on Joyce's manuscripts. She works in Buffalo, at Yale, and prepares a secondary thesis on Robinson Jeffers in California.
	Jean-Jacques Mayoux introduces her to Jacques Lacan who is looking for an introduction to Joyce's work. For approximately two years she works regularly with Lacan.
End of 1964:	Divorce.
1965:	*Maître-Assistante* at the Sorbonne. Period of friendship with poets and writers, in particular Piotr Rawicz and Julio Cortazar. Hélène has close ties with the Latin-American scene.
1967:	Raymond Las Vergnas, Vice-Dean of the Sorbonne and director of the Institute of English, obtains a chair in English Literature for Hélène at the University of Nanterre near Paris.
1967–68:	In an ambiguous situation at Nanterre, since she is a full professor without having a doctorate, Hélène sees the explosion of '68 coming. Witness to excess and dysfunction in the university system, she very quickly becomes conscious of the existence of an 'ancien régime' that must be abolished.
May 1968:	Hélène is closely involved in the events taking place at Nanterre and at the Sorbonne.
	At the suggestion of Las Vergnas, she is charged by Edgar Faure, Minister of Education, with creating an experimental university in the Bois de Vincennes. The adventure of the Université de Paris VIII begins: aided by an advisory council, Hélène is responsible for recruiting professors to establish viable departments. In the extremely conservative French university context, she calls on people sharing a modern view of the arts and the social sciences. Conscious of the fragility of the student movement and the urgency of the situation, they must wrest some lasting cultural progress from the turbulence of the moment. Through Hélène's impetus, the University is formed in close contact with the world of writing. Chairs are given to Latin-American writers as well as to innovators such as Michel Butor, Michel Deguy, Lucette Finas, Gérard Genette, Jean-Pierre Richard, Tzvetan Todorov. Michel Foucault, Gilles Deleuze and Michel Serres come to the Philosophy Department; the first department of psychoanalysis in France is set up by Serge Leclaire.
1968:	Creation of the journal *Poétique* with Genette and Todorov. Hélène defends her two theses (the principal and the secondary theses required for the *Doctorat d'Etat*). Receives summa cum laude. She is the youngest 'Doctor' in France.
1969:	Chair in English Literature at Paris VIII where she has taught ever since. Prix Médicis for *Dedans*.
1971:	Participates actively in the GIP (Groupe Information Prison) with Foucault.

Until the expulsion of her mother in 1971, Hélène returns regularly to Algeria with her children. Afterwards, never again.

1972: Discovers the work of Ariane Mnouchkine: Hélène proposes to Foucault to associate the *Théâtre du Soleil* with the GIP. Together they put on blitz performances in front of prisons, regularly dispersed by the police. Hélène is beaten at a demonstration in Nancy.

1974: Hélène creates the first doctoral program in women's studies in Europe: the DEA in *Etudes Féminines* at Paris VIII. Why *'études féminines'*? On the one hand, she has reservations about the political connotations of the word 'feminist' in France, where, unlike in the English-speaking world, it has inherited an extremely limiting acceptation. On the other hand, for the Ministry of Education, it was necessary to make explicit reference to questions concerning women. Had it been up to her, the title of the doctorate would have alluded to sexual differences instead.

Since 1974: Thanks to the friendly agreement of her colleagues in English Literature, she devotes most of her teaching to the interdisciplinary development of *Etudes Féminines*. She directs the doctoral programmes in both English Literature and *Etudes Féminines*.

1975: Writes her first major theatrical work: *Portrait de Dora*. It is a great success, and runs for a year at the *Théâtre d'Orsay*, directed by Simone Benmussa.

Antoinette Fouque, founder of the MLF (*Mouvement de Libération des Femmes*) in '68 and of the *Editions des Femmes* publishing house in '73, proposes to publish a book by Hélène: it will be *Souffles*. Discovers Antoinette Fouque's political-psychoanalytical approach. Hélène becomes involved with the complicated scene of the Women's Movement at this time, and is engaged in many actions lead by Antoinette. From now on, by political choice, Hélène publishes with *Editions des Femmes*.

1977: Joins AIDA (*Association Internationale pour la Défense des Artistes*, founded by Ariane Mnouchkine) and participates in numerous campaigns, notably for Vaclav Havel and for Wei Jingsheng.

She discovers Clarice Lispector through the publication by *Editions des Femmes* of a translation of *The Passion According to GH*. Clarice dies in December.

Omi dies at the age of 95.

1978: Her opera *Le nom d'Œdipe* is played at the Avignon theatre festival in the *Cour d'Honneur*. Libretto by Hélène, music by André Boucourechliev, directed by Claude Régy.

1980: The conservative Barre government abolishes the doctorate in *Etudes Féminines*. General outcry in the world of culture: an international protest campaign is launched. Hélène responds to the elimination by creating the *Centre de Recherches en Etudes*

Féminines at Paris VIII, a symbolic space for teaching and research though not a degree programme.

1981–82: The doctorate in *Etudes Féminines* is re-established by the new Socialist government.

With her friends Derrida, Foucault and Cortazar, Hélène is part of the first *Commission Nationale des Lettres* of the Socialist government. They resign in 1982.

1982–83: Ariane Mnouchkine asks her to write for the *Théâtre du Soleil.* The result will be: *L'histoire terrible mais inachevée de Norodom Sihanouk, roi du Cambodge.*

1984 (Dec.): Goes with Ariane Mnouchkine to the Khmer refugee camps on the Cambodian-Thai border.

1985–86: Several trips to India. Does research for *L'Indiade.*

1987–88: *L'Indiade* at the *Théâtre du Soleil.* Enormous public success.

1987: Death of Jean-Jacques Mayoux.

1989: Screenplay of *La Nuit Miraculeuse,* film by Ariane Mnouchkine commissioned by the French National Assembly for the bicentennial of the Declaration of Human Rights.

Receives the Southern Cross of Brazil for her contribution to the international understanding of Brazilian literature.

1990: Wellek Library Lectures at the University of California, Irvine.

Lectures with Jacques Derrida at conference entitled *Lectures de la Différence Sexuelle* organised by the *Centre.*

1991: Visiting Professor at the University of Virginia, Charlottesville.

Receives Honorary Doctorate from Queen's University, Ontario, Canada, during its 150th anniversary celebrations.

1992: Honorary Doctorate from Edmonton University, Alberta, Canada. Oxford University: Amnesty International Lectures.

1993: Honorary Doctorate from York University, England.

Keynote speaker at the Tate Gallery for the plenary Assembly of English Museum Curators.

1994: Receives the *Légion d'Honneur* from François Mitterrand.

La Ville parjure opens at the Théâtre du Soleil.

1995: The Balladur government threatens to eliminate the doctoral programme in *Etudes Féminines,* still the only one in France. Thousands of protests are received from the world over; the programme is accredited for one year.

Honorary Doctorate from Georgetown University, Washington D.C.

Avalon Distinguished Professor, Northwestern University, Chicago, IL (intensive fall seminar).

1996: Doctorate again refused accreditation. Another international campaign; another massive response; victory: the programme is accredited for the standard three years.

Honorary Doctorate from Northwestern University, where she again teaches.

1997	Film about Hélène inspired by *Photos de Racines: Moire Mémoire des Souvenirs/Remembering Memory* by Lara Fitzgerald (Les Films au bord de Sabine, Toronto, Canada).
1984–:	Hélène's doctoral seminars take place at the *Collège International de Philosophie* which is associated with the *Centre*. The *Centre* collaborates with Women's Studies programmes in Europe, America, Asia.
1994–:	Works closely with Mnouchkine and AIDA on Bosnia, to assist Algerian artists forced underground or into exile, to oppose increasingly restrictive immigration measures in France. Member of the board of the International Parliament of Writers, primarily defending writers faced with censorship and repression.
	In addition to her on-going seminar, she gives numerous conferences and public lectures each year, regularly publishes major works of fiction and theatre as well as shorter pieces and critical essays in various journals and collective works.
June 1998:	Colloquium at Cerisy-la-Salle on Hélène's works, '*Hélène Cixous: Croisées d'une ,uvre*'.

Hélène Cixous,
Bibliography

compiled by
M. Sandré and E. Prenowitz

French publications

Fiction

(1967) *Le Prénom de Dieu*, Nouvelles, Grasset.
(1969) *Dedans*, Roman, Prix Médicis 1969 (jury included Michel Butor, Marguerite Duras, Claude Mauriac, Alain Robbe-Grillet and Claude Simon), Grasset; second edn, Des femmes, 1986.
(1970) *Le Troisième corps*, Roman, Grasset.
—— *Les Commencements*, Roman, Grasset.
(1971) *Un vrai jardin*, Nouvelle poétique, L'Herne.
(1972) *Neutre*, Roman, Grasset.
(1973) *Tombe*, Roman, Le Seuil.
—— *Portrait du soleil*, Roman, Denoël.
(1975) *Révolutions pour plus d'un Faust*, Roman, Seuil.
—— *Souffles*, Fiction, Des femmes.
(1976) *La*, Fiction, Gallimard; second edn, Des femmes, 1979.
—— *Partie*, Fiction, Des femmes.
(1977) *Angst*, Fiction, Des femmes.
(1978) *Préparatifs de noces au-delà de l'abîme*, Fiction, Des femmes. Excerpts read by Hélène Cixous, La Bibliothèque des voix, Des femmes, 1981.
(1979) *Vivre l'orange*, Fiction, Des femmes; second edn. in *L'heure de Clarice Lispector*, 1989.
—— *Anankè*, Fiction, Des femmes.
(1980) *Illa*, Fiction, Des femmes.
(1981) *With ou l'art de l'innocence*, Fiction, Des femmes.
(1982) *Limonade tout était si infini*, Des femmes.
(1983) *Le Livre de Promethea*, Fiction, Gallimard.
(1986) *La bataille d'Arcachon*, Un conte, Laval, Quebec: Trois, collection Topaze.

(1988) *Manne aux Mandelstams aux Mandelas*, Des femmes.
(1990) *Jours de l'an*, Des femmes.
(1991) *L'ange au secret*, Des femmes.
(1992) *Déluge*, Des femmes.
(1993) *Beethoven à jamais*, Des femmes.
(1995) *La fiancée juive*, Des femmes.
(1996) *Messie*, Des femmes.
(1997) *Or les lehres de man père*, Des Femmes.

Theatre

(1972) *La Pupille, Cahiers Renaud-Barrault* 78, Gallimard.
(1976) *Portrait de Dora*, Des femmes; reprinted in *Théâtre*, 1986. Opened 26 February 1976 at the Théâtre d'Orsay, directed by Simone Benmussa; a radio version was broadcast on France Culture, 'Atelier de Création Radiophonique' in 1972.
(1977) *L'Arrivante*, unpublished (adaptation of *La*). Directed by Viviane Théophilidès, Théâtre Ouvert, Festival d'Avignon, July.
(1978) *Le nom d'Œdipe: Chant du corps interdit*, libretto, Des femmes. Music by André Boucourechliev, directed by Claude Régy, Festival d'Avignon, 1978.
(1982) *Je me suis arrêtée à un mètre de Jerusalem et c'était le paradis*, unpublished. Reading at the Théâtre Ouvert with Hélène Cixous, Michelle Marquais and Bérangère Bonvoisin, 7 June.
—— *Amour d'une délicatesse*, radio play, unpublished. Radio Suisse Romande, Lausanne, 28 August.
(1984) *La prise de l'école de Madhubaï, Avant-Scène du Théâtre* 745 (March): 6–22; reprinted in *Théâtre*, 1986. Opened 13 December 1983 at the Petit Odéon directed by Michelle Marquais.
—— *Celui qui ne parle pas*, unpublished. Théâtre Tsaï, Grenoble, T.E.P., Paris, June.
(1985) *L'Histoire terrible mais inachevée de Norodom Sihanouk, roi du Cambodge*, Théâtre du Soleil; new, corrected edn, 1987. Opened 11 September 1985 at the Théâtre du Soleil, directed by Ariane Mnouchkine.
(1986) *Théâtre*, Des femmes.
(1987) *L'Indiade, ou l'Inde de leurs rêves, et quelques écrits sur le théâtre*, Théâtre du Soleil. Opened 30 September 1987 at the Théâtre du Soleil, directed by Ariane Mnouchkine.
(1989) *La nuit miraculeuse*, television screenplay with Ariane Mnouchkine, Théâtre du Soleil. Broadcast on FR3, La Sept, December.
(1991) *On ne part pas, on ne revient pas*, Des femmes. First reading 24 November 1991 at (La Métaphore), directed by Daniel Mesguich and André Guittier.
(1992) *Les Euménides* by Aeschylus, translation, Théâtre du Soleil. Opened

26 May 1992 at the Théâtre du Soleil, directed by Ariane Mnouchkine.

(1994) *L'Histoire (qu'on ne connaîtra jamais)*, Des femmes. Directed by Daniel Mesguich at the Théâtre de la Ville and (La Métaphore).

—— *Voile Noire Voile Blanche/Black Sail White Sail*, bilingual, translation by Catherine A.F. MacGillivray, *New Literary History* 25, 2 (Spring), Minnesota University Press: 219–354.

—— *La Ville parjure ou le réveil des Erinyes*, Théâtre du Soleil. Opened at the Théâtre du Soleil, 18 May 1994, directed by Ariane Mnouchkine.

Books of criticism

(1969) *L'exil de James Joyce ou l'art du remplacement*, thesis for Doctorat d'État, Publications de la Faculté des lettres et sciences de Paris-Sorbonne, Grasset; second edn, 1985.

(1974) *Prénoms de personne*, Seuil.

(1975) *Un K. incompréhensible: Pierre Goldman*, Christian Bourgois.

—— *La jeune née*, with Catherine Clément, U.G.E., Collection 10/18.

(1977) *La venue à l'écriture*, with Madeleine Gagnon and Annie Leclerc, U.G.E., 10/18 (title essay reprinted in *Entre l'écriture*, 1986: 9–69).

(1986) *Entre l'écriture*, Des femmes.

(1989) *L'heure de Clarice Lispector, précédé de Vivre l'Orange*, Des femmes.

(1994) *Hélène Cixous, Photos de Racines*, with Mireille Calle-Gruber, Des femmes.

Short texts, lectures, articles

(1964) 'Conrad Aiken', on Jay Martins, *Conrad Aiken: A Life of His Art*, *Les Langues Modernes* 58, 3 (May–June): 271–3.

—— 'Une Farce tragique', on Leslie A. Fiedler, *The Second Stone*, *Les Langues Modernes* 58, 3 (May–June): 303.

—— On Stanley Edgar Hyman, *Nathaniel West*, *Les Langues Modernes*, 58, 3 (May–June): 312–13.

—— On Margaret Church, *Time and Reality: Studies in Contemporary Fiction*, *Études Anglaises* 17, 3 (July–September): 301–2.

—— 'Stephen, Hamlet, Will: Joyce par-delà Shakespeare', *Études Anglaises* 17, 4 (October–December): 571–85.

(1965) On Maurice Beebe, *Ivory Towers and Sacred Founts: The Artist as Hero in Fiction from Goethe to Joyce*, *Études Anglaises*, 18, 2 (April–June): 201–2.

—— 'Un Paritéméraire', on Pierre Dommergue, *Les Ecrivains américains d'aujourd'hui*, *Les Langues Modernes* 59, 3 (May–June): 396–7.

—— 'Une Chronique vériste', on John Clellon Holmes, *Get Home Free*, *Les Langues Modernes* 59, 3 (May–June): 376–7.

—— 'Un Voyage inachevé de la conscience', on Frederick J. Hoffman, *Conrad Aiken, Les Langues Modernes* 59, 4 (July–August): 513.

—— 'L'Avant-portrait ou la bifurcation d'une vocation'. *Tel Quel* 22 (Summer): 69–76.

(1966) 'Portrait de sa femme par l'artiste', *Les Lettres Nouvelles* 15 (March–April): 41–67.

—— 'L'Allégorie du Mal dans l'œuvre de William Golding', *Critique* 22, 227 (April): 309–20.

—— 'William Golding: Mode allégorique et symbolisme ironique d'une éthique des ténèbres', *Les Langues Modernes* 60, 5 (September–October): 528–41.

—— 'Vers une lecture détachée du Prometheus Unbound', *Les Langues Modernes* 60, 5 (September–October): 582–94.

(1967) 'La Leçon d'Ezra Pound: *Un art de lire*', *Le Monde* 6856 (27 January): 17a.

—— '*Jules César*: Un repas sacré: Discours autour d'un meurtre rituel', *Les Langues Modernes* 61, 1 (January–February): 53–5.

—— 'La Présence permanente du tragique', on George Steiner, *La mort de la Tragédie* (R. Celli, tr.), *Les Langues Modernes* 61, 1 (January–February): 109–10.

—— 'La Correspondance de Joyce: Publiée à Londres', *Le Monde* 6860 (1 February): ia, viia, 'Le Monde des Livres'.

—— '*Camp retranché* de J.-C. Powys: Un univers fantastique', *Le Monde* 6908 (29 March): id, iiid, 'Le Monde des Livres'.

—— 'Situation de Saul Bellow', *Les Lettres Nouvelles* 58 (March–April): 130–45.

—— On Joyce, *Letters*, vols II–III, Richard Ellmann (ed., 1966), *Les Lettres Nouvelles* 58 (March–April): 173–83.

—— 'James Joyce et la mort de Parnell', *Les Langues Modernes* 61, 2 (March–April): 142–47.

—— 'Survivances d'un mythe: Le gentleman', *Le Monde* 6914 (5 April): viid, 'Le Monde des Livres'.

—— 'La langue de Kipling et la Renaissance hindoue', *Le Monde* 6937 (3 May): viia, 'Le Monde des Livres'.

—— 'Les Deux voies du catholicisme anglais', *Le Monde* 6943 (10 May): iva, 'Le Monde des Livres'.

—— 'Langage et regard dans le roman expérimental: Grande-Bretagne', *Le Monde* 6949 (18 May): viia, 'Le Monde des Livres'.

—— 'Le Nouveau fantastique dans le roman d'aujourd'hui: Grande-Bretagne', *Le Monde* 6984 (28 June): viia, 'Le Monde des Livres'.

—— '*À Jérusalem*, par Paul Bailey: Jeunes romanciers et vieilles folles', *Le Monde* 6996 (12 July): ve, 'Le Monde des Livres'.

—— '*La Pyramide*, par William Golding: Fables internales', *Le Monde* 7008 (26 July): ia, iia, 'Le Monde des Livres'.

—— 'Nigel Dennis: Une solitude bien ordonnée: L'héritage de Swift', *Le Monde* 7068 (7 October): viic, 'Le Monde des Livres'.

—— 'Une science de la littérature', on Northrop Frye, *Le Monde* 7086 (25 October): ivc, 'Le Monde des Livres'.

—— '*Le Journal de Dublin*, par Stanislaus Joyce: Le frère de l'artiste', *Le Monde* 7110 (22 November): ia, 'Le Monde des Livres'.

—— 'Iris Murdoch et *La Gouvernante italienne*: L'art "dans le filet" des idées', *Le Monde* 7133 (20 December): iiia, 'Le Monde des Livres'.

(1968) 'Thoth et l'écriture: De Dedalus à Finnegans Wake', *L'Arc* 36 ('Joyce et le Roman moderne'): 73–79 (see appendix in *L'Exil de James Joyce ou l'Art du remplacement*, 1969).

—— 'La farce macabre de Muriel Spark: Un catholicisme grimaçant', *Le Monde* 7157 (17 January): viia, 'Le Monde des Livres'.

—— 'Le Retour de Beardsley ou les dentelles du péché', *Le Monde* 7193 (28 February): viic, 'Le Monde des Livres'.

—— 'Le Génie excentrique d'Ivy Compton Burnett', *Le Monde* 7202 (9 March): id, iiid, 'Le Monde des Livres'.

—— 'Les conversations cruelles d'Ivy Compton-Burnett', *Les Lettres Nouvelles* (May–June): 157–67.

—— 'Hors chat', *Nouveaux Cahiers* 18: 17–20.

—— 'Iris Murdoch: l'art poétique d'aimer bien', on Iris Murdoch, *The Nice and the Good*, *Le Monde* 7290 (22 June): viia, 'Le Monde des Livres'.

—— 'Nicholas Mosley et ses accidents: Un dissident du roman anglais', on Nicholas Mosley, *Accident* (J. Le Béquée and Henri Thomas, trs.), *Le Monde* 7296 (29 June): iiic, 'Le Monde des Livres'.

—— 'Relecture d'*Alice au pays des merveilles*: A l'occasion d'une nouvelle traduction', on *Les Aventures d'Alice au Pays des Merveilles* (H. Parisot, tr.), *Le Monde* 7326 (3 August): ic, iic, 'Le Monde des Livres'.

—— 'Giacomo Joyce: Les sanglots ironiques d'Éros', on James Joyce, *Giacomo Joyce*, *Le Monde* 7338 (17 August): ivc, 'Le Monde des Livres'.

—— 'Le Dernier roman de Muriel Spark: "L'Image publique"', on Muriel Spark, *The Public Image*, *Le Monde* 7410 (9 November): viiia, 'Le Monde des Livres'.

—— 'L'Œuvre mystificatrice d'Anthony Burgess: Tendre le miroir à la culture', on Anthony Burgess, *Inside Mr. Enderby* and *Mr. Enderby Outside*, *Le Monde* 7422 (23 November): viia, 'Le Monde des Livres'.

—— 'Christine Brooke-Rose: Le langage du dépaysement', on C. Brooke-Rose, *Between*, *Le Monde* 7452 (28 December): viid, 'Le Monde des Livres'.

(1969) Edited (with Marianne Debouzy and Pierre Dommergues), *Les Etats-Unis d'aujourd'hui par les textes* (introduction in French and texts in English), Série Études anglo-américaines, Colin.

—— 'Le Prix Nobel est attribué à Samuel Beckett: Le Maître du texte

pour rien', *Le Monde* 7707 (24 October): 1, 10; reprinted in *Le Monde (hebdomadaire)* (23–29 October 1969): 13.

(1970) 'Présentation', with Gérard Genette and Tzvetan Todorov, *Poétique* 1: 1–2.

—— 'Henry James: l'Écriture comme placement ou De l'ambiguïté de l'intérêt', *Poétique* 1: 35–50. (See 'l'Écriture comme placement', 1978.)

—— 'Joyce, la ruse de l'écriture', *Poétique* 4: 419–32.

—— 'La Réponse de Hélène Cixous', in 'Enquête: La Crise de la Littérature?' *Les Lettres Françaises* 1361 (25 November–1 December): 4.

(1971) 'Au sujet de Humpty Dumpty toujours déjà tombé', in Henri Parisot, (ed.), *Lewis Carroll, Cahiers de l'Herne* 17, l'Herne: 11–16.

—— 'Préface: "D'une lecture qui joue à travailler"', in Lewis Carroll, *De l'Autre côté du Miroir et de ce que Alice y trouva suivi de La Chasse au Snark*, translation of *Through the Looking Glass and what Alice found there; The Hunting of the Snark*, translated by Henri Parisot, revised and corrected edn, Aubier-Flammarion: 42.

—— 'La déroute du sujet, ou le voyage imaginaire de Dora', excerpt from *Portrait du Soleil*, *Littérature* 1, 3 (October, 'Littérature et Psychanalyse'): 79–85.

—— 'Une lecture imprudente', (on 'Lévi-Strauss et les 'Mythologiques") *Le Monde* 8339 (5 November): 21, 'Le Monde des Livres'.

(1972) 'La fiction et ses fantômes: Une lecture de l'*Unheimliche* de Freud', *Poétique* 10: 199–216. (See *Prénoms de personne*, 1974: 13–38.)

—— 'Poe re-lu: Une poétique du revenir', on Edgar Poe, *Œuvres en prose*, (tr. by Ch. Baudelaire, Gallimard, 1969), *Critique* 299 (April): 299–327. (See *Prénoms de personne*, 1974: 155–82.)

—— 'Un modèle de modernité: La puissante machine d'écriture' ('L'*Ulysse* de Joyce a cinquante ans'), *Le Monde* (23 June): 16.

(1973) 'L'essort de Plus-je', *L'Arc* 54 ('Jacques Derrida'): 46–52.

—— 'La Textrémité', *Nouvelle Revue de Psychanalyse* 5 (Spring): 335–50.

—— 'L'affiche décolle', (on Audrey Beardsley's dramaturgy) *Cahiers Renault-Barrault* 83: 27–37.

—— 'Le Prix Nobel de Littérature est décerné à l'écrivain australien Patrick White: L'épopée d'un continent', *Le Monde* 8948 (20 October): 16.

—— 'Electre. L'après Médée', in *Le travail d'Andreï Serban, Medea, Elektra*, Festival d'automne de Paris and Gallimard: 55–65.

—— 'Le Crépuscule des mères', in *Le travail d'Andreï Serban, Medea, Elektra*, Festival d'automne de Paris and Gallimard: 66–72.

—— '"Le Non-nom', 'Elles volent', Réponse à six questions à Hélène Cixous', *Gramma* (April): 18–26.

—— Excerpt from *Partie* ('Plus-Je' pp. 37–62), *Nouvelle Revue de Psychanalyse* 8 (Spring, 'Bisexualité et différence des sexes'): 336–50.

(1974) 'D'un œil en coin', in Louis Bonnerot, Jacques Aubert, Claude

Jaquet (eds), '*Ulysses': Cinquante ans après: Témoignages Franco-Anglais sur le Chef-d'Oeuvre de James Joyce,*' Études Anglaises 53, Didier: 161–67.

—— 'Les morts contreparties', preface to James Joyce, *Dubliners/Dublinois: Les Morts, Contreparties*, Aubier-Flammarion. (See *Prénoms de personne*, 1974: 287–311.)

—— 'Le bon pied, le bon œil', *Cahiers Renaud-Barrault* 87: 47–75.

(1975) 'Le Livre des Mortes', *Cahiers Renaud-Barrault* 89: 92–109.

—— 'Le paradire (extraits)' (excerpts from *Portrait de Dora*) *Cahiers Renaud-Barrault* 89: 110–27.

—— 'La Noire vole', *La Nouvelle Critique* 82 (March): 47–53.

—— 'L'ordre mental', preface to Phyllis Chesler, *Les Femmes et la folie*, (tr. by J.-P. Cottereau of *Women and Madness*), Payot: 7–8.

—— 'Les Femmes-écrivains et leur colloque', letter with A. Leclerc, C. Chawaf, C. Clément, V. Forrester, S. Kofman, X. Gauthier, V. Therame and F. d'Eaubonne, *Le Monde* 9422 (3 May): 15.

—— 'Le Rire de la Méduse', *L'Arc* 61 ('Simone de Beauvoir et la lutte Des femmes'): 39–54; reprinted in Maïté Albistur et Daniel Armogathe (eds), *Le grief Des femmes*, vol. 2: *Anthologie de textes féministes du Second Empire à nos jours*, Hier & Demain, 1978: 307–13.

(1976) 'Un morceau de Dieu', *Sorcières* 1, (January): 14–17.

—— 'Fort-Sein', *Poétique* 26 ('Finnegans Wake'): 131.

—— 'La Missexualité, où jouis-je?' *Poétique* 26 ('Finnegans Wake'): 240–9; reprinted in *Entre l'écriture*, 1986: 73–95.

—— 'La mode', *Vingt ans*, (June).

—— 'Etre femme-juive', *Les nouveaux cahiers* 46, (Fall).

—— 'Une passion: l'un peu moins que rien', in Tom Bishop and Raymond Federman (eds), *Samuel Beckett: Cahier*, Cahiers de l'Herne 31, l'Herne: 396–413.

(1977) 'Aller à la mer', on the theatre and *Portrait de Dora*, *Le Monde* 1029 (28 April): 19, 'Le Monde des Arts et des Spectacles'.

—— 'La Préméditerranée', *L'Humanité* (8 September): 2.

—— 'Détacher le Hamlet de William Shakespeare', programme for *Le Hamlet de Shakespeare*, directed by D. Mesguich, Centre Dramatique National des Alpes.

—— 'La venue à l'écriture', in *La venue à l'écriture* (1977): 9–62; reprinted in *Entre l'écriture* (1986): 6–69.

(1978) 'Vincennes, héritière de 68, dans le vertige de la scène avec le Père', *Des Femmes en Mouvements* 11 (November).

—— 'L'Ecriture comme placement', in Michel Zéraffa (ed.), '*L'art de la fiction' Henry James . . .: Neuf études*, Collection d'esthétique 30, Klincksieck: 203–22. (See 'Henry James: l'Ecriture comme placement ou De l'ambiguïté de l'intérêt', 1970.)

(1979) 'L'Approche de Clarice Lispector: Se laisser lire (par) Clarice Lispector: A Paixao Segundo C.L.', *Poétique* 40 (November): 408–19; reprinted in *Entre l'écriture*, 1986: 114–38.

—— '"O grand-mère que vous avez de beaux concepts! C'est pour mieux vous arrièrer, mon enfant!"': Un colloque féministe à New York "Le second sexe trente ans après"', *Des Femmes en Mouvements Hebdo* 1 (9–16 November): 11–12.

—— 'Poésie e(s)t Politique', *Des Femmes en Mouvements Hebdo* 4 (30 November–7 December): 29–32.

—— 'Quant à la pomme de texte . . .', *Études littéraires* 12, 3 (December), Quebec: 411–23.

—— 'Commence par a', *Des Femmes en Mouvements Hebdo* 7–8 (21 December–4 January 1980): 15–17.

(1980) 'Extrait de *Illa*', *Revue Nouvelle* 72, 11 (November): 504.

(1981) 'La grâce d'une autre politique', *Le Quotidien de Paris* (April).

—— 'La poésie comme contrepoison', *Le Nouvel Observateur* (May).

—— 'Dossier Jean Genet', *Masques* (Winter 1981–82): 59–63.

(1982) 'La dernière phrase', excerpt from *Limonade tout était si infini* (pp. 252–66), *Corps Écrit* 3: 93–104.

—— 'Une virginité de mémoire', in *Mon Algérie, 62 personnes témoignent*, Acropole.

(1983) 'Cahier de métamorphoses', excerpt from *Le Livre de Promethea*, *Corps écrit* 6: 65–76.

—— 'Suitée de Jérusalem', *Land* (5 June): 36–42.

—— 'Freincipe de plaisir ou Paradoxe perdu' on James Joyce, *Finnegans Wake*, translated by Ph. Lavergne (Gallimard, 1982), *Le temps de la réflexion* 4 (October): 427–33; reprinted in *Entre l'écriture*: 97–112.

—— 'Tancrède continue', *Études freudiennes* 21–22 (March, 'Figurations du féminin'): 115–131; reprinted in *Entre l'écriture*: 139–68.

—— 'Allant vers Jérusalem, Jérusalem à l'envers', *La Nouvelle Barre du Jour* 132 (November), Outremont, Québec: 113–26.

(1984) 'Le droit de légende', *L'Avant-Scène du Théâtre* 745 (March): 4–5. (See 'Le chemin de légende', 1986.)

(1985) 'Sonia Rykiel en traduction', in Hélène Cixous, Madeleine Chapsal and Sonia Rykiel, *Sonia Rykiel*, Herscher: 7–12.

—— 'Les gardiens de notre grandeur', *Le Monde* 1254 (26–27 May): vi.

—— 'C'est l'histoire d'une étoile', *Roméo et Juliette*, Papiers: 20–3.

(1986) 'Le dernier tableau ou le portrait de Dieu', in *Entre l'écriture*, 1986: 169–201.

—— 'Le chemin de légende', in *Théâtre* (*La prise de l'école de Madhubaï*), 1986: 7–11.

—— 'Généalogie', in *Théâtre*: back cover.

—— 'L'Incarnation . . .' *L'Art du Théâtre* 5 (Fall), Actes Sud/Théâtre National de Chaillot: 95–8; a second version published in *L'Indiade ou l'Inde de leurs rêves* (1987): 260–66.

—— 'Un Fils', *Hamlet*, Papiers: 9–15.

—— 'Cela n'a pas de nom, ce qui se passait' (on Michel Foucault), *Le Débat* 41 (September–November): 153–8.

——— 'La Séparation du gâteau', in Jacques Derrida, et al., *Pour Nelson Mandela*, Gallimard: 75–96.

——— 'Le pays des autres', *Réouverture de la Monnaie*, numéro spécial, Théâtre Royal de la Monnaie, Brussels: Gérard Mortier, (November); also in *Revue Opéra*; a second version published as 'Le lieu du Crime, le lieu du Pardon', in *L'Indiade ou l'Inde de leurs rêves* (1987): 253–9.

——— 'Portrait de l'Artiste', *Les Cahiers de l'Herne* ('Joyce'); reprinted in *Joyce*, L'Herne Poche Biblio, 1990.

(1987) 'Extrême Fidélité', *Travessia* 14, Florianopolis, Brazil: 11–45; second version as 'L'auteur en vérité' (1989).

——— 'Clarice Lispector, titane délicate', *La Quinzaine Littéraire* 484, (April 16–30): 10.

——— 'Écrits sur le Théâtre' ('L'Ourse, la Tombe, les Étoiles', 'Le lieu du Crime, le lieu du Pardon', 'L'Incarnation' 'Qui es-tu?') in *L'Indiade ou l'Inde de leurs rêves* (1987): 247–78.

——— 'Invisible visible, Visible invisible' (see 'Qui es-tu?', in *L'Indiade ou l'Inde de leurs rêves* (1987): 267–71), *Double Page* 49.

(1988) 'Jean-Jacques Mayoux', *La Quinzaine Littéraire* 501 (16–31 January): 7.

——— 'Noir émoi', *Corps Écrit* 26 (June): 37–41.

——— 'Comment arriver au théâtre?' *Lettre Internationale* 17 (Summer): 55–6.

——— 'Marina Tsvetaeva – Le feu éteint celle . . .' *Les Cahiers du GRIF* 39, (Fall): 87–96.

——— Text in *Rencontres écrites de Mehdi Qotbi*, Institut du Monde arabe, (October): 9.

——— 'Cercles de la connaissance, cercle militaire', in Jérôme Garcin (ed.), *Le Dictionnaire de Littérature Française contemporaine*, F. Bourin.

(1989) 'Le sens de la forêt', in Jean-Philippe de Tonnac (ed.), *Qui vive?: Autour de Julien Gracq*, José Corti: 49–51.

——— 'Théâtre enfoui', *Europe* 67, 726 (October): 72–7.

——— 'Je me souviens', 'Je me souviens des années 80', *Globe* (November).

——— 'L'auteur en vérité' (see 'Extrême Fidélité', 1987) in *l'Heure de Clarice Lispector* (1989): 123–68.

(1990) 'Photographies de racines', *La Recherche Photographique* (février), Paris Audiovisuel and PUV: 32–3.

——— 'Des pieds et des mains', *Corps Écrit* 34 (June): 105–10.

——— '1190 moïses', *Revue du Comité 89 en 93*, Bobigny.

——— 'L'arrêt du train, ou Résurrections d'Anna', preface to *Karine Saporta*, Armand Colin: 14–20.

——— 'Clarice Lispector – Marina Tsvetaeva – Autoportraits', *Avant Garde* 4, Rodopi, Amsterdam: 147–55.

——— 'De la scène de l'Inconscient à la scène de l'Histoire: Chemin d'une écriture', in Françoise Van Rossum-Guyon and Myriam Díaz-Diocaretz (eds), *Hélène Cixous, chemins d'une écriture*, PUV/Rodopi: 15–34.

—— 'Ecoute avec la main', in *1989 États Généraux Des Femmes*, Des femmes.

(1991) 'Sans Arrêt, non, Etat de Dessination, non, plutôt: Le Décollage du Bourreau', in *Repentirs*, Réunion des musées nationaux: 55–64.

—— 'A quoi bon le théâtre?' *Théâtre Ouvert, 20 ans.*

(1992) 'En octobre 1991', in *Du féminin*, Grenoble: Presses Universitaires de Grenoble: 115–138.

(1993) 'Bethsabée ou la Bible intérieure', *FMR* 43 (April): 14–18.

(1994) 'Contes de la Différence Sexuelle', in Mara Negrón (ed.), *Lectures de la Différence Sexuelle*, Des femmes: 31–68.

—— 'Quelle heure est-il? ou La porte (celle qu'on ne passe pas)', in *Le passage des frontières*, Galilée, 1994: 83–98 (an edited version appeared as '*Quelle heure est-il?* What Is It O'Clock?', in Thomas Bishop (ed.), *The Florence Gould Lectures 1990–1992*, NYU, 1993: 49–78).

—— 'L'amour du Loup', in *La Métaphore (Revue)* 2 (Spring), La Différence: 13–37.

—— 'Nos mauvais sangs', in *La ville parjure ou le réveil des Erinyes* (1994): 5–7.

(1995) 'Démasqués!', in Michel de Manessein (ed.), *De l'égalité des sexes*, Centre National de Documentation Pédagogique: 73–80.

—— 'Respiration de la hache', *Contretemps* 1 (winter): 104–11.

—— 'La Vérité?', with Etienne Balibar, Jacques Derrida, Philippe Lacove-Labarth and Jean-Luc Nancy, *Le Monde* (13–14 August): 10.

—— 'Lettre élue', *Horizons philosophiques* 6, 1 (Fall, 'Annie Leclerc, philosophe'), Longueuil, Quebec: 49–57.

—— 'Noté (en réponse à une question de journaliste), en passant devant moi sans m'arrêter . . .' *Trois* 11, 1–2, Laval, Quebec: 205–12.

—— 'Hélène Cixous', page of manuscript, in *L'écriture et la vie . . .*, exhibit catalogue, NEGOCIA.

(1996) 'Wei Jingsheng, veilleur de l'âme chinoise', *Le Monde* 16037 (18–19 August 1996): 8.

(1997) 'Lettre sur *La Division de l'intérieur* de Mireille Calle-Gruber', *Trois* 12, 1: 199–203.

—— 'Pieds nus', in Leïla Sebbar (ed.), *Une enfance Algérienne*, Paris: Gallimard: 53–63.

Interviews

(1969) 'L'exil de Joyce: Entretien', with Gilles Lapouge on *L'Exil de James Joyce ou l'art du remplacement* (1968), *La Quinzaine Littéraire* 68 (1–15 March): 6–8.

—— 'Hélène Cixous, une grande fille pas simple: Le Prix Médicis', with Ginette Guitard-Auviste, *Les Nouvelles Littéraires* 47, 2201 (27 November): 1, 7.

—— 'Hélène Cixous ou l'illusion cosmique', with Guy Le Clec'h, *Le Figaro Littéraire* (1–7 December): 19.

(1973) 'Dans *Tombe* de Cixous c'est la culture qui est enfouie', with Claudine Jardin, *Le Figaro* 1411 (2 June): 16, II, 'Le Figaro Littéraire'.

—— 'Littérasophie et Philosofiture', with Gilles Deleuze, Emission Dialogues n° 30, by Roger Pillaudin, France Culture (13 November).

(1975) '"À propos de Marguerite Duras", par Michel Foucault et Hélène Cixous', *Cahiers Renaud-Barrault* 89: 8–22.

(1976) 'Hélène Cixous et le *Portrait de Dora*', with Claire Devarrieux, *Le Monde* 9671 (26 February): 15.

—— 'Hélène Cixous: voyage autour du mythe de Dora', with Anne Surgers and Nicole Casanova, *Le Quotidien de Paris* 591 (9 March): 12.

—— 'Le Grand JE au féminin: Un entretien avec Hélène Cixous', with Nicole Casanova on *La*, *Les Nouvelles Littéraires* 54, 2527 (8 April): 6.

—— 'Hélène Cixous: Lorsque je n'écris pas, c'est comme si j'étais morte', with Jean-Louis de Rambures, *Le Monde* 9708 (9 April): 20, 'Le Monde des Livres'; reprinted with additions made in October 1977 in Jean-Louis de Rambures, *Comment travaillent les écrivains*, Flammarion, 1978: 56–63.

—— 'Hélène Cixous: Je me souviens très bien de mon corps d'enfant', with Jean-Louis de Rambures, *Le Monde* (24–25 April): 12.

—— 'Entretien avec Alain Clerval sur *Souffles*', *Infoartitudes* (April).

—— 'Textes de l'imprévisible: Grâce à la différence', *Les Nouvelles Littéraires* 54, 2534 (26 May), (in 'Le Dossier 'Des femmes en écriture"): 18–19.

—— 'Le Sexe ou la tête?' from conversation with editors (Brussels, 1975), *Cahiers du GRIF* 13, (October): 5–15.

—— '"Quelques questions posées à Hélène Cixous': Entretien avec Françoise Collin', *Les Cahiers du GRIF* 13, (October): 16–21.

—— 'Avec Hélène Cixous' with Jacqueline Sudaka, *Les Nouveaux Cahiers* 46 (Fall): 92–5.

(1977) 'Entretien avec Madeleine Gagnon, Philippe Haeck et Patrick Straramn, sur *Le Portrait de Dora*', *Chroniques* 1, Montreal.

—— 'L'étrange traversée d'Hélène Cixous', with Lucette Finas on *Angst*, *Le Monde* 10042 (13 May): 21, 'Le Monde des Livres'.

—— 'Le quitte ou double de la pensée féminine: Un entretien avec Hélène Cixous', with Nicole Casanova on *Angst*, *Les Nouvelles Littéraires* 55, 2603 (22–29 September): 8.

—— 'Entretien avec Françoise Van Rossum-Guyon', *Revue des Sciences Humaines* 44, 168 (October–December), Lille: 479–93.

(1978) 'Entretien avec Hélène Cixous: Un destin révolu', with Colette Godard on *Le Nom d'Œdipe*, *Le Monde* 10417 (28 July): 16.

(1980) 'Entretien avec Salim Jay sur *Illa*', *Mots pour Mots*.

(1981) '"Biographie de l'écriture': Entretien avec Alain Poirson', *Révolution Magazine*, (31 July): 18–20.

(1982) "Hélène Cixous ou le rêve de l'écriture': Entretien avec François Coupry', *Libération* (22 December): 27.

(1983) 'Hélène Cixous a rencontré la reine des Dacoïts', with Anne Laurent on *La prise de l'école de Madhubaï, Libération* (30 December): 23.

(1984) 'Le Roman d'aujourd'hui: Entretien: Hélène Cixous', with Henri Quéré, *Fabula* 3 (March), Lille: 147–58.

(1986) 'Petit essai sur la dramaturgie de *L'Histoire terrible mais inachevée de Norodom Sihanouk, roi du Cambodge*', based on interview with Gisèle Barret, *Les cahiers de théâtre, Jeu* 39, Montreal: 131–41.

——— '"Une témérité tremblante",: Entretien avec Hélène Cixous par Véronique Hotte', about *L'histoire terrible mais inachevée de Norodom Sihanouk, roi du Cambodge, Théâtre/Public* 68 (March–April): 22–25.

(1988) '"Le tragique de la partition": Entretien avec Hélène Cixous', with Bernard Golfier on *L'Indiade, ou l'Inde de leurs rêves, Théâtre/Public* 82–83 (July–October): 81–4.

——— 'Les Motions contre l'émotion de l'Histoire', with Dominique Lecoq, *Politis* (7 July): 77–80.

——— 'Entretien avec Hélène Cixous', with Pascale Hassoun, Chantal Maillet and Claude Rabant, *Patio* 10 ('L'Autre Sexe'), l'Éclat: 61–76.

(1989) 'Je suis plutôt un être de bord', *La Quinzaine Littéraire* 532 (16–30 May, 'Où va la littérature française?'): 10.

(1990) 'A propos de *Manne*: entretien avec Hélène Cixous', with Françoise Van Rossum-Guyon, in Françoise Van Rossum-Guyon and Myriam Diaz-Diocaretz (eds), *Hélène Cixous, chemins d'une écriture*, PUV/ Rodopi: 213–34.

——— 'L'auteur entre Texte et Théâtre', with Marie-Claire Ropars and Michèle Lagny, 'L'état d'auteur', *Hors Cadre* 8, P.U.V.: 33–65.

(1992) 'Le Lieu de l'autre', with Frédéric Regard, in *Logique des Traverses, de l'Influence*, C.I.E.R.E.C. Travaux LXXVII, Université de Saint-Etienne: 11–26.

(1994) 'Questions à Hélène Cixous', with Christa Stevens, in Susan van Dijk et Christa Stevens (eds), *(en)jeux de la communication romanesque*, Amsterdam: Rodopi B.V.: 321–32.

(1995) 'Derrière le miroir', with Lucien Attoun on *L'histoire (qu'on ne connaîtra jamais)*, (*Mégaphonie*, France Culture, 22 November 1994) *Théâtre/Public* (July–October): 90–1.

(1997) 'Aux commencements, il y eut pluriel . . .', with Mireille Calle-Gruber, *Genesis* (Spring).

Non-French publications

Text in Brazilian

(1991) 'Aproximação de Clarice Lispector', translated by Pina Coco, *Tempo Brasileiro* 104, Rio de Janeiro: 9–24.

Interview in Brazilian

(1982) Interview with Betty Milan, 'Folhetim de Domingo', *Folha di São Paulo* (11 June).

Texts in Danish

(1985) *At komme til Skriften*, translation by Lis Haugaard of *La venue à l'écriture* (1977), Charlottenlund: Rosinante.

(1986) *Den Frygtelige men Ufuldendte Historie om Norodom Sihanouk Konge af Cambodia*, translated by Inger Christensen Copenhagen: Wilhem Hansen. (Unpublished.)

(1988) 'Ekstrem troskab', 'Hélène Cixous Seminarer', 'Tancredi fortsaetter', translated by Marie-Louise Sodemann, *Saa Megen Troksab* 4: 17–81.

Interview in Danish

(1985) 'Samtale med Hélène Cixous (jan. 84)', with Merete Stistrup
Jensen and Lis Haugaard, *Kritik* (Copenhagen)18, 71: 27–41.

Texts in Dutch

(1983) *Portret van Dora*, translation by José Kuijpers, Isolde Landman and
Camille Mortagne of *Portrait de Dora* (1976), Amsterdam: SUA.
(1986) 'De lach van de Medusa', translation by Mary Blaauw and Marcelle
van Proosdij of 'Le Rire de la Méduse' (1975), *Sarafaan* 1, 3: 74–91.
——— Excerpt from *Le Livre de Promethea* (1983), translated by Camille
Mortagne, *Lust & Gratie* 10, Amsterdam.
——— *De verschrikkelijke maar nog Onvoltooide geschiedenis van Norodom
Sihanouk, koning van Cambodja* (two volumes), translated by Pieter
Kottman, Amsterdam: International Theatre Bookshop.
——— *De Verovering van de School van Madhubaï*, translated by Gerard
Kooistra and Camille Mortagne, *Filosofie Feminine*.
——— *De naam van Oidipoes*, Theater *Persona*.
(1991) *Tussen talen onstaan/La Venue à l'écriture*, translated by Camille
Mortagne, Amsterdam: Hölderlin.
(1996) 'Verborgen theater', translation by Marie-Luc Grall and Christa
Stevens of 'Théâtre enfoui' (1989), *Lust & Gratie* 49, Amsterdam:
41–6.

Interview in Dutch

(1982) 'Voor mij gaat het lichaam bevrijden, de geest bevrijden en de taal
bevrijden samen', with Rina van der Haegen, *Tijdschrift voor
vrouwenstudies* 3, Nijmegen: 290–305.

Books in English

(1972) *The Exile of James Joyce*, translation of *L'Exil de James Joyce ou l'art du
remplacement* by Sally A. J. Purcell, New York: David Lewis; London:
John Calder, 1976.
(1977) *Portrait of Dora*, translated by Anita Barrows, *Gambit International
Theatre Review* 8, 30: 27–67; reprinted in, *Benmussa Directs*, Playscript
91, London: John Calder, Dallas: Riverrun 1979: 27–73; translated
by Sarah Burd, *Diacritics* (Spring), 1983: 2–32.

(1979) *To Live the Orange*, translated by Ann Liddle and Sarah Cornell, in *Vivre l'orange* (bilingual), Des femmes.

(1985) *Angst*, translated by Jo Levy, London: John Calder and New York: Riverrun.

(1986) *Inside*, translation by Carol Barko of *Dedans*, New York: Schocken Books.

—— *The Conquest of the School at Madhubaï*, translation by Deborah W. Carpenter of *La prise de l'école de Madhubaï*, *Women and Performance* 3 (Special Feature): 59–95.

—— *The Newly Born Woman*, with Catherine Clément, translation by Betsy Wing of *La jeune née* (1975), Theory and History of Literature, vol. 24, Minneapolis: University of Minnesota Press. 'Sorties: Out and Out: Attacks/Ways Out/Forays', (pp. 63–132) reprinted in Catherine Belse and Jane Moore (eds), *The Feminist Reader: Essays in Gender and the Politics of Literary Criticism*, Houndmills, Basingstoke, Hampshire: Macmillan Education, New York: Blackwell, 1989: 101–16.

(1988) *Neutre*, translated by Lorene M. Birden in 'Making English Clairielle: An Introduction and Translation for Hélène Cixous' "Neutre"', MA Thesis, University of Masachussetts at Amherst.

(1990) *Reading with Clarice Lispector* (seminar 1980–1985), edited and translated by Verena Conley, London: Harvester Wheatsheaf.

(1991) *The Name of Œdipus*, translated by Christiane Makward and Judith Miller, *Out of Bounds: Women's Theater in French*, Ann Arbor: University of Michigan Press.

—— *The Book of Promethea*, translated by Betsy Wing, Lincoln: University of Nebraska Press.

—— *'Coming to Writing' and Other Essays*, edited by Deborah Jenson, translated by Sarah Cornell, Deborah Jenson, Ann Liddle et Susan Sellers, Cambridge: Harvard University Press.

(1992) *Readings, The poetics of Blanchot, Joyce, Kafka, Lispector, Tsvetaeva* (seminar 1982–1984), edited and translated by Verena Conley, London: Harvester Wheatsheaf.

(1993) *Three Steps on the Ladder of Writing*, The Welleck Library Lectures, Irvine (June 1990), translated by Sarah Cornell and Susan Sellers, New York: Columbia University Press.

(1994) *The Terrible but Unfinished Story of Norodom Sihanouk, King of Cambodia*, translated by Juliet Flower MacCannell, Judith Pike and Lollie Groth, Lincoln: University of Nebraska Press.

—— *Manna, for the Mandelstams for the Mandelas*, translated by Catherine A.F. MacGillivray, Minneapolis: University of Minnesota Press.

—— *The Hélène Cixous Reader*, translated and edited by Susan Sellers, London: Routledge.

(1997) *FirstDays of the Year*, translated by Catherine A. F. MacGillivray, Minneapolis: University of Minnesota Press, forthcoming.

Short texts, lectures, articles in English

(1974) 'The Character of "Character"', translated by Keith Cohen, *New Literary History* 5, 2 (Winter): 383–402.

——— 'Political Ignominy: "Ivy Day"', in William M. Chace (ed.), *Joyce: A Collection of Critical Essays*, Twentieth-Century Views, Englewood Cliffs, New Jersey: Prentice-Hall: 11–17 (see *The Exile of James Joyce*, pp. 266–72).

(1975) 'At Circe's, or the Self-Opener', translated by Carol Bové, *Boundary 2* 3, 2 (Winter): 387–97; reprinted in Paul A. Bové (ed.), *Early Postmodernism, Foundational Essays*, Durham: Duke University Press, 1995: 175–187.

(1976) 'Fiction and its Phantoms: Freud's *Das Unheimliche* ('The Uncanny')', translation by R. Dennommé of 'La fiction et ses fantômes' (1972), *New Literary History* 7, 3: 525–548.

——— 'The Laugh of the Medusa', translated by Keith Cohen and Paula Cohen of a revised version of 'Le rire de la Méduse' (1975), *Signs* 1, 4 (Summer): 875–93; reprinted in Elaine Marks and Isabelle de Courtivron (eds), *New French Feminisms: An Anthology*, Amherst: University of Massachusetts Press, 1980 and Brighton, Sussex: Harvester; New York: Schocken, 1981: 245–64; in Elizabeth Abel and Emily K. Abel (eds), *The Signs Reader: Women, Gender, & Scholarship*, Chicago: University of Chicago Press, 1983: 279–97; in Hazard Adams and Leroy Searle (eds), *Critical Theory Since 1965*, Tallahassee: University Presses of Florida/Florida State University Press, 1986: 309–20.

(1977) 'Boxes', translated by Rosette C. Lamont, *Centerpoint* (City University of New York) 2, 3 [7] (Fall): 30–1.

——— '*La Jeune Née*: an Excerpt', translated by Meg Bortin, *Diacritics* 7, 2 (Summer): 64–9.

——— 'From *Partie*', an excerpt translated by K. Cohen, *TriQuarterly* 38, (Winter): 95–100.

(1980) 'Arrive le chapitre-qui-vient (Come the Following Chapter)', translated by Stan Theis, *Enclitic* 4, 2 (Fall): 45–58.

——— 'Sorties', translation by Ann Liddle of an excerpt from *La jeune née*, in Elaine Marks and Isabelle de Courtivron (eds), *New French Feminisms: An Anthology*, Amherst: University of Massachusetts Press, 1980 and Brighton, Sussex: Harvester; New York: Schocken, 1981: 90–8.

——— 'Poetry is/and (the) Political', translation by Ann Liddle of 'Poésie e(s)t Politique' (1979), *Bread and Roses* 2, 1: 16–18.

(1981) 'Castration or Decapitation?' translation by Annette Kuhn of 'Le sexe ou la tête?' (1976), *Signs* 7, 1 (Autumn): 41–55; reprinted in Robert Con Davis and Ronald Schleifer (eds), *Contemporary Literary Criticism: Literary and Cultural Studies*, second edn, New York and London: Longman 1989: 479–91.

(1982) 'Comment on Women's Studies in France', *Signs* 7, 3 (Spring): 721–22.

—— 'Introduction to Lewis Carroll: *Through the Looking Glass* and *The Hunting of the Snark*', translation by Marie Maclean of 'Préface: 'D'une lecture qui joue à travailler" (1971), *New Literary History* 13, 2 (Winter): 231–51.

—— 'The Step', translation by Jill McDonald and Carole Deering Paul of 'La Marche' (*Le Prénom de Dieu*, pp. 33–41), *French-American Review* 6, 1 (Spring) 27–30.

(1984) 'Aller à la mer', translation by Barbara Kerstlake of 'Aller à la mer' (1977), *Modern Drama* 27, 4 (December): 546–48.

—— 'Joyce: the (R)use of Writing', translation by Judith Still of 'Joyce, la ruse de l'écriture' (1970), in Derek Attridge and Daniel Ferrer (eds), *Post-Structuralist Joyce: Essays from the French*, Cambridge and New York: Cambridge University Press: 15–30.

—— '12 août 1980. August 12, 1980', bilingual, translation by Betsy Wing, *Boundary 2* 12, 2 (Winter): 8–39.

—— 'Reading Clarice Lispector's "Sunday before going to sleep"', translation by Betsy Wing, *Boundary 2* 12, 2 (Winter): 41–8.

(1985) 'The Meadow', translation by Penny Hueston and Christina Thompson of an excerpt from *La Bataille d'Arcachon* (1986), *Scripsi* 3, 4 ('Special French Issue'): 101–12.

(1986) 'The Last Word', translation by Ann Liddle and Susan Sellers of an excerpt from *Le Livre de Promethea* (1983), *Woman's Review* 6 (April): 22–4.

—— 'The Language of Reality', in Harold Bloom (ed.), *Twentieth Century British Literature*, Volume 3, 'James Joyce–*Ulysses*', The Chelsea House Library of Literary Criticism, New York: Chelsea House: 1502–5 (see *The Exile of James Joyce*, pp. 673–9, 699–702)

(1987) 'Her Presence Through Writing', translation by Deborah Carpenter of an excerpt from 'La venue à l'écriture' (1977), *The Literary Review* 30, 3 (Spring): 445–53.

—— '*The Book of Promethea*: Five Excerpts', translated by Deborah Carpenter, *Frank* 6–7 (Winter–Spring): 42–4.

—— 'The Parting of the Cake', translation by Franklin Philip of 'La séparation du gâteau' (1986), in Jacques Derrida and Mustapha Tlili (eds), *For Nelson Mandela*, New York: Seaver Books: 201–18.

—— "Life With Him Was Life without Him',' an excerpt from 'The Parting of the Cake' (1987), *New York Times Book Review* 7 (1 November): 35.

—— 'Reaching the Point of Wheat, or A Portrait of the Artist as a Maturing Woman', *New Literary History* 19, 1: 1–21.

(1988) 'Extreme Fidelity', translation by Ann Liddle and Susan Sellers of 'Extrême Fidélité' (1987), in Susan Sellers (ed.), *Writing Differences: Readings of the Seminar of Hélène Cixous*, Milton Keynes: Open University Press and New York: St Martin's Press: 9–36.

—— 'Tancredi Continues', translation by Ann Liddle and Susan Sellers of 'Tancrède continue' (1983), in Susan Sellers (ed.), *Writing Differences: Readings of the Seminar of Hélène Cixous*, Milton Keynes: Open University Press: 37–53; reprinted in *'Coming to Writing' and Other Essays*, 1991; and in *En Travesti*, Columbia University Press, 1995: 152–68.

(1989) 'Foreword', translated by Verena Andermatt Conley, in Clarice Lispector, *The Stream of Life* (translation of *Agua Viva*), Minneapolis: University of Minnesota Press: ix–xxxv.

—— 'Writings on the Theater', translation by Catherine Franke of texts in *L'Indiade ou l'Inde de leurs rêves* (1987), *Qui Parle* (University of California, Berkeley, Department of French) 3, 1 (Spring): 120–35; revised version of 'The Place of Crime, The Place of Forgiveness', in Susan Sellers (ed.), *The Hélène Cixous Reader* (1994): 150–56.

—— 'Dedication to the Ostrich', translation by Catherine Franke of an excerpt from *Manne* (1988), *Qui Parle* (University of California, Berkeley, Department of French) 3, 1 (Spring): 135–52.

—— 'From the Scene of the Unconscious to the Scene of History', translation by Deborah W. Carpenter of 'De la scène de l'Inconscient à la scène de l'Histoire' (1990), in Ralph Cohen (ed.), *The Future of Literary Theory*, New York and London: Routledge: 1–18.

(1990) 'Difficult Joys', in Helen Wilcox, Keith McWatters, Ann Thompson and Linda R. Williams (eds), *The Body and the Text: Hélène Cixous, Reading and Teaching*, Brighton: Harvester Press: 5–30.

—— An excerpt from *Vivre l'Orange*, in *The Virago Book of Poetry*, London: Virago Press: 210–11.

(1991) 'Writing Voices', *Arbeidstotat* 7, Oslo.

(1992) 'The Day of Condemnation', translation by Catherine A.F. MacGillivray of an excerpt from *Manne aux Mandelstams aux Mandelas* (1988), *LIT*, 4, 1: 1–16.

(1993) 'Bethsabea or the Inner Bible', translation by Catherine MacGillivray of 'Bethsabée ou la Bible intérieure' (1993), *New Literary History* 24, 4: 820–37.

—— 'We who are free, are we free?' (Oxford Amnesty Lecture, February 1992), translated by Chris Miller in Barbara Johnson (ed.), *Freedom and Interpretation*, New York: Basic Books: 17–44.

—— 'Without End no State of Drawingness no, rather: The Executioner's Taking Off', translation by Catherine A.F. MacGillivray of 'Sans Arrêt, non, Etat de Dessination, non, plutôt: Le Décollage du Bourreau' (1991), *New Literary History* 24, 1 (Winter): 90–103.

(1994) 'The Coup', and 'It is the Story of a Star', translations by Stéphanie Lhomme and Helen Carr of 'Le Coup' (1985) and 'C'est l'histoire d'une étoile' (1985), *Women: a cultural review* 5, 2: 113–22.

—— 'Preface', translated by Susan Sellers, in Susan Sellers (ed.), *The Hélène Cixous Reader*, London: Routledge: xv–xxiii.

(1995) 'Great Tragic characters . . .', *Times Literary Supplement* 4804 (28 April, 'The State of Theatre'): 15.

(1996) '"Mamãe, disse ele", or Joyce's Second Hand', translated by Eric Prenowitz, in *Poetics Today* 17, 3 (Fall).

—— 'Attacks of the Castle', translated by Eric Prenowitz, in Neil Leach (ed.), *Beyond the Wall: Architecture, Ideology and Culture in Central and Eastern Europe*, London: Routledge.

—— 'An Error of Calculation', translation by Eric Prenowitz of an excerpt from *L'ange au secret* (1991, pp. 251–7), *Yale French Studies* 89: 151–4.

—— 'Writing Blind', translated by Eric Prenowitz, *TriQuarterly* 97 (Fall): 7–20.

—— 'In October 1991 . . .' translation by Catherine McGann of 'En octobre 1991 . . .'(1992), in Mireille Calle-Gruber (ed.), *On the Feminine*, New Jersey: Humanities Press: 77–92.

Interviews in English

(1976) 'Interview', with Christiane Makward, translated by Ann Liddle et Beatrice Cameron, *Sub-Stance* 13: 19–37.

—— 'The Fruits of Femininity', translation of 'Lorsque je n'écris pas, c'est comme si j'étais morte' (*Le Monde*, 9 avril 1976), *Manchester Guardian Weekly* 1140, 20 (16 May): 14.

(1979) 'Rethinking Differences: An Interview', interview from 1976, translated by Isabelle de Courtivron in Elaine Marks and Georges Stambolian (eds), *Homosexualities and French Literature: Cultural Contexts/Critical Texts*, Ithaca: Cornell University Press: 70–86.

(1984) 'An exchange with Hélène Cixous', with Verena Conley (from 1982), in Verena Conley, *Hélène Cixous: Writing the Feminine*, Lincoln and London: University of Nebraska Press: 129–61.

—— 'Voice i . . .: Hélène Cixous and Verena Andermatt Conley', *Boundary 2* 12, 2 (Winter): 51–67.

(1985) 'Interview with Susan Sellers', *The Women's Review* 7 (May) 22–23.

(1987) 'Impassive resistance', with Linda Brandon, *Independent*, 11 November.

(1988) 'Conversations with Hélène Cixous and members of the Centre d'Etudes Féminines', translated by Susan Sellers, in Susan Sellers (ed.), *Writing Differences: Readings from the Seminar of Hélène Cixous*, Gender in Writing, Milton Keynes: Open University Press: 141–54.

—— 'Exploding the Issue: "French" "Women" "Writers" and "The Canon"', with Alice Jardine and Anne M. Menke, translated by Deborah W. Carpenter, *Yale French Studies* 75: 235–6.

(1989) 'Interview with Catherine Franke', *Qui Parle* (University of California, Berkeley, Department of French) 3, 1 (Spring): 152–79.

—— 'The "Double World" of Writing', 'Listening to the Truth', 'A Realm of Characters', 'Writing as a Second Heart', with Susan Sellers, in Susan Sellers (ed.), *Delighting the Heart: A Notebook by Women Writers*, London: Women's Press: 18, 69, 126–8, 198.

(1991) 'Hélène Cixous', in A. Jardine et A. Menke (eds), *Shifting Scenes: Interviews on Women, Writing, and Politics in Post-68 France*, translated by Deborah Jenson and Leyla Rouhi, New York: Columbia University Press: 32–50.

Texts in German

(1971) *Innen*, translation by Gerda Scheffel of *Dedans* (1969), Frankfurt/Main: Suhrkamp.

(1976) 'Die Frau als Herrin?' translation by Erika Höhnisch of 'Échange' with Catherine Clément (*La jeune née*, 1975), *Alternative* 19, 108–109 (June–August), Berlin: 127–33.

—— 'Schreiben, Feminität, Veränderung', translation by Monika Bellan of an excerpt of 'Sorties' (*La Jeune Née*, 1975), *Alternative* 19, 108–109 (June–August), Berlin: 134–47.

—— 'Schreiben und Begehren', translation by Monika Bellan of 'Prédit' (*Prénoms de Personne*, 1975, pp. 5–10), *Alternative* 19, 108–9 (June–August), Berlin: 155–9.

(1980) 'Weiblichkeit in der Schrift', translated by Eva Duffner, Berlin: Merve.

(1986) 'Romeo und Julia', translated by Brigitte Madlo, *Wespennest* 64, Wien.

(1987) 'Die Aufteilung des Kuchens', translation by Helga Finter of 'La Séparation du gâteau' (1986), in Jacques Derrida et al., *Für Nelson Mandela*, Reinbek bei Hamburg: Rowohlt.

—— 'Clarice Lispector, eine feinfühlige Titanin', translation by Michaela Ott of 'Clarice Lispector, titane délicate' (1987), *Konkret* (October): 54–5.

(1988) *Die Schreckliche, aber unvollendete Geschichte von Norodom Sihanouk, König von Kambodscha*, translation by Erika Tophoven-Schöningh of *L'histoire terrible mais inachevée de Norodom Sihanouk, roi du Cambodge* (1985), Cologne: Prometh Verlag.

—— 'Von der Szene des Unbewußten zur Szene der Geschichte, Weg einer Schrift', translation by Karin Rick of 'De la scène de l'Inconscient à la scène de l'Histoire: Chemin d'une écriture' (1990), *Konkursbuch* 20, Tübingen: Claudia Gehrke.

(1990) *Das Buch von Promethea*, translation by Karin Rick of *Le Livre de Promethea* (1983), Wiener Frauenverlag.

(1995) 'Taslima Nasrine', *Zensur* (May): 4–5.

(1996) 'Szenen des Menschlichen', translation by Eberhard Gruber of 'En

octobre 1991' (1992), in Mireille Calle-Gruber (ed.), *Über das Weibliche*, Düsseldorf: Parega: 97–120.

(1997) *Die Meineidige Stadt oder das Erwachen der Erinnyen*, translation by Esther v. d. Osten-Sacken of *La Ville parjure ou le réveil des Erinyes* (1994), forthcoming.

Interviews in German

(1977) 'Die unendliche Zirkulation des Begehrens: Weiblichkeit in der Schrift', translation of interviews by Eva Meyer and Jutta Kranz, Berlin, Merve.

—— 'Trennung', with Maren Sell, *Die Schwarze Botin* 2: 13–23.

(1990) 'Die Seite des Feuers, die Seite des Küchentisches' with Karin Rick and Diana Voigt, *Falter* 13 (30 March–5 April): 11.

—— 'Ich werfe mein Herz aus dem Fenster . . .' *An. Schläge* 4 (April): 37–9.

(1992) '. . . auf der Seite der Schrift', with Jana Ziganke, on *L'Indiade ou l'Inde de leurs rêves* (1987), *Rhein* 31 (16 December).

Texts in Italian

(1977) *Ritratto di Dora*, translation by Luisa Muraro of *Portrait de Dora* (1976), Milan: Feltrinelli Economico.

(1981) 'Celle qui écrit vit', *Nuova Corrente* 28, 84: 159–72.

(1988) 'L'Approccio di Clarice Lispector', translation by Nadia Setti of 'L'approche de Clarice Lispector' (1979), *Donne/Women/Femmes* 7: 35–45.

(1992) *Il teatro del cuore*, edited and translated by Nadia Setti, Parma: Pratiche.

(1996) 'Sangue cattivo', translation by Maria Nadotti of 'Nos mauvais sangs' (1994), *Lapis* 31 (September): 51.

Interview in Italian

(1990) 'Il sapere dell'altro', with Cecilia Gallotti and Roberta Gandolfi, *Lapis* 10 (December), Milan: 29–34.

Texts in Japanese

(1972) 'Henry James: tōshi to shiteno ekurityūru aruiwa risokuno ryōgisei ni tsuite', translation by Shin Wakabayashi of 'L'écriture comme placement' (1978), in *James*, Chikuma Sekai Bungaku Taikei 49 (Library of World Literature 49), Tokyo: Chikuma Shobō: 487–503.

(1975) 'Medyūsa no warai', translation by Yūji Ueda of 'Le Rire de la Méduse' (1975), *Gendaï shisō, revue de la pensée d'aujourd'hui* 3, 12 (December), Tokyo: Seidosha: 98–115.

(1978) *Naibu*, translation by Shin Wakabayashi of *Dedans* (1969), Tokyo: Shinchôsha.

(1989) 'Hikisakareta okashi', translation by Junko Takeda of 'La séparation du gâteau' (1986), in *Kono otoko, kono kuni* (This man, this country), Nagoya Yunite: 95–117.

(1993) *Medyūsa no waraï*, translation by Isako Matsumoto, Sonoko Kokuryo and Keiko Tokura of 'Le Rire de la Méduse', 'Le Sexe ou la tête?', 'La jeune née' and 'La venue à l'écriture', Tokyo: Kinokuniya.

(1995) *Ōkami no ai*, translation by Isako Matsumoto of 'L'amour du loup', 'En octobre 1991 . . .', 'Quelle heure est-il? ou La Porte (celle qu'on ne passe pas)' and 'Contes de la Différence Sexuelle', Tokyo: Kinokuniya.

(1997) Translation by Isako Matsukmoto of an excerpt from *Photos de racines* (1994), Tokyo: Keisō Shobō.

Interviews in Japanese

(1979) 'Kaite inai tokino watasiwa shindamo dôzen desu', translation by Tsutomu Iwasaki of 'Lorsque je n'écris pas, c'est comme si j'étais morte' (1976), in *Sakka no shigotobeya* (Author's rooms), Tokyo: Chûô Kôron: 83–94.

(1985) 'Gaibuwo kiku mômoku no hito Duras', translation by Shinichi Nakazawa of "A propos de Marguerite Duras', par Michel Foucault et Hélène Cixous' (1975), *Yuriika–Eureka* (July, special edition on M. Duras), Tokyo: Seidosha: 208–17.

Texts in Norwegian

(1987) 'A komme til Skriften' translation by Sissel Lie of an excerpt from 'La venue à l'écriture' (1977), Vinduet.

(1991) 'Medusas latter', translation by Sissel Lie of 'Le Rire de la Méduse' (1975), in *Moderne Litteraturteon*, Oslo: Kittang, Tinneberg, Melberg, Skei.

(1996) *Nattspråk*, translation by Sissel Lie of 'La venue à l'écriture' (1977), 'Le Rire de la Méduse' (1975), 'L'auteur en vérité' (1989), an excerpt from *Jours de l'an* (1990), 'Le lieu du Crime, le lieu du Pardon' (1987), 'L'incarnation' (1987), 'Démasqués!' (1995), Oslo: Pax Forlag.

Text in Polish

(1993) 'Smiech Meduzy', translation by Anna Nasilowska of 'Le Rire de la Méduse' (1975), *Teksty Drugie* 4/5/6, Varsovie: 147–66.

Texts in Slovak

(1991) 'Hlavnou postavou tejto knigy je . . .', translation by Katarína Kenízová-Bednárová of an excerpt from *Jours de l'an* (1991), *Slovenské pohl'ady* 11: 150–54.
(1994) 'Niet radosti bez rozdielnosti' translation by Masa Kusa of an excerpt from *Photos de Racines* (1994) *Aspekt* 2: 61–3.
(1995) 'Smích Medúsy', translation by Hana Hajkova of 'Le Rire de la Méduse' (1975), *Aspekt* 2–3: 12–19.

Interview in Slovak

(1991) 'Fenomén Cixous', with Katarína Kenízová-Bednárová, *Slovenské pohl'ady* 10: 142–4.

Texts in Spanish

(1983) 'Poesía como contraveno', translated by Helena Araújo, *Escandalar* (June), New York: 9–14.
(1989) 'La venida a la escritura' (excerpts), translated by Lila Goldsman, *Feminaria* 4 (November), Buenos Aires: 22–8.
(1991) 'Epílogo I: El fuego dest'ella'. Epílogo II: La bella y los héroes, la bella y los eros, la bella y los ceros', translated by Elisabeth Burgos, in *Marina Tsvietaieva*, Madrid: Libros Hyperión: 103–16, 141–57.
(1993) 'Julio Cortázar', *Culimar* 13/14, Río de la Plata: 377–80.
(1994) *La Toma de la Escuela de Madhubai*, translated by Elizabeth Burgos, *Literatura dramática* 33, Madrid.
(1995) 'La Risa de la Medusa', 'La joven nacida', 'Vivir la Naranja', 'A la

luz de una manzana', 'El autor en verdad', translated by Ana María Moix, *Cultura y Diferencia*, Barcelona: Anthropos.

Text in Swedish

(1986) 'Akilles är Pensthesilea är Akilles', translation by Ebba Witt-Brattström of an excerpt from *La jeune née* (1975), *Kinglika Dramastrika Teatern*, Stockholm.

Interview in Swedish

(1986) 'Den Uppslakande Kärlaken', with Ebba Witt-Brattström.

Aftermaths

Eric Prenowitz

In the beginning there is thinking, and unknowing.

> I think that – even if the word 'thought' bothers me – I begin by thinking. [. . .] I do not begin by writing. But when I begin to think it is always applied to [. . .] something that presents itself to me as unknown and as mysterious. [. . .] It is almost the origin of science: I observe a phenomenon.
>
> (p. 42)

There is observation and application, science. A science of meticulous scrutiny, with a rich apparatus of apertures and mirrors, 'Microscopes, telescopes, myopias, magnifying glasses' (p. 4). And yet liberated from the paradigmatic tyranny of an unyielding method. Because for a science to do science, the observer of the unknown should himself be known. Himself or herself. The observing organ must be known, this is the only way of controlling an experiment geared to making the unknown known. The powerful principle of scientific containment. It depends on the demarcation of an unambiguous border between known and unknown domains. Even if one can never know for sure which is the container and which the contained.

However, in Cixous's science I will study a phenomenon I do not know with organs I do not know, though I may have thought I knew them, ignorant of my ignorance too. 'I listen to this phenomenon, I listen to it with my eyes, with organs I do not know, that are in me' (p. 43–4). This is a very knowing ignorance, aware that the unknown is on both sides of the quest to know, which is enough to deconstruct the regressive hierarchy of the traditional science of knowledge and the colonial terror of the sovereign solipsistic subject. There will still be the quest and the questing *I*, but they will

henceforth address the questioning 'inside' along with the questioned 'outside'.

So on one hand there is observation by an observer, even if the observer, and the status of the observer, will be put into question. On the other, there is something to observe, even if it is not what we may commonly think, and even if seeing what we commonly see may blind us to another truth, a 'more true' truth that is none-the-less there, though its mode of being there may not resemble anything like a fixed contemporary presence. In other terms, in another language, this would translate as the minimal hypothesis of a logic of the subconscious, that our psychic symptoms have causes, origins even, that 'the dream does not cheat with metaphor' (p. 27), and so it pays to be meticulous, rigorous. It pays to analyse – on the condition that one be ready to abandon all the techniques with which analysis traditionally identifies itself, a bit like the wolf who is capable of 'unwolfing' himself out of love, but for whom this is the only way of satiating a sublime hunger: 'he feeds on his spiritual brilliance, rather than lamb flesh' (p. 108). So Cixousian analysis may not indulge in desiccating and dissecting its object, cutting it into ever smaller units, it may not design to build an unshakeable edifice of knowledge from the dismembered fragments of a sectioned specimen. But this is not in view of a categorical repudiation of what is indeed an invaluable technique; it is simply a consequence of the fact that when the object of our attentions is 'not stopped-stoppable', when it is 'in the process of seething, of emitting, of transmitting itself' (p. 4), when the thing or phenomenon would be eliminated *a priori* by the method of analysis itself, while these are the most elusive, the most captivating things and phenomena, they will require of us another approach if we ever hope to grasp them, which is to say approach them, if we ever hope to follow along with them as they go.

This Cixousian pursuit is sounded in writing by 'copying reality: living, non-repressed reality' (p. 48); one might call it actuating the anamnesis of reality, fixing the return of its repressed domains, for there is more to reality than meets the eye. It is a sublime technoscience that permits us to 'x-ray-photo-eco-graph a time, an encounter between two people [. . .] and then listen to what is produced in addition to the exchange identifiable in the dialogue', however fantastical it may seem, for 'this is what writing tries to do: to keep the record of these invisible events' (p. 48).

And of the invisible events that writing, that Hélène Cixous's writing chases after, perhaps the most originary of all is sexual difference. Cixous compares the difficulty of defining sexual difference with the difficulty of defining human 'nature', and remarks that although 'one cannot define, finish, close human definition', we none-the-less act as 'the customs officers of communication' (p. 51) and operate the closure. In fact, all that Cixous offers to isolate as a generalizable mark of the human is that 'the factor of uncertainty, [. . .] the *undecidable*, is indissociable from human life' (p. 52), a fact that bewilders any attempt at definitive definition. We do not know for sure what the limits of human nature or life are, though they are not simply without limits, and this is precisely what fills them with opportunity, with promise. It may be an apparent contradiction – we need the word human, but we'll never quite know what it means, at once relative and essential – but it is not incompatible with the heart of human responsibility, since real decisions are taken only where no clear choices are to be had. Now the questioning of our 'exterior edge' (p. 52), of 'the limit of human nature' (p. 53), is part of an effort to be 'better human' or to be human better, that is, 'while being human, not depriving oneself of the rest of the universe' (p. 32), shifting our bounds 'because we can always be stronger than ourselves; we move forward' (p. 71).

A similar question of what or who we are is raised with the enigma of sexual difference, only here it concerns 'the middle'. It is our middle, our medium, our in-between. Yet 'it is not the third term, it is not a block between two blocks: it is exchange itself'. Constantly changing and exchanging, it gives the shake to any stationary theory of itself, whether relativist or essentialist. As well as any normal mode of vision: 'It cannot be seen. [. . .] It is our reading' (p. 53).[2]

And if sexual difference is invisible, this is surely because the subjectivity of our subject is constituted if nothing else by the 'ultimate, voluptuous and cruel point of temptation: if only I could pass to the other side, if only I could [. . .] get to know [. . .] that *jouissance* of yours to which I am and I remain an enchanted and unknowing witness' (p. 53). So sexual difference takes us right up to the interior limits of the science of knowing, where no controlled experiment will ever be possible, and the knowledge that is shared is the knowledge of a noble ignorance. There is untold fluxion, duty-free exchange, ever shifting demarcation, even if the subject of this

frenetic activity, its origin no less than its teleological horizon may be the inaccessible promised land of the other's orgasm. And this is not simply some contingent limit, some physical, technological or biotechnological shortcoming. There is indeed no overcoming it. It is necessary, even for the constitution, for the enjoyment of 'our own' sexual delight. 'Because the secret of *jouissance* is that even while being not-exactly communicable, it is nourished by the unknowable-*jouissance*-of-the-other' (p. 55).

But what is so unique about this one type of sense experience, this one which is one-or-two, when in these terms a person should never be able to experience *any* of another's experiences? Why is sexual difference so different from, so much more different than all the other differences? 1) Sexual pleasure is 'the only pleasure that is structurally indissociable from this dream of sharing' (p. 56). 2) The questions of speciation and taxonomy are never closed, yet if the entire world were drowned in a cataclysmic flood or annihilated by an asteroid, it would take one man and one woman in a boat or a space shuttle for humanity to continue, to avoid extinction, to continue avoiding extinction, in spite of incalculable loss to the genome and the phenome of human culture. And this is true whatever their other differences might be, whether the man and the woman should be near or farsighted, tall or short, lefties or righties, inies or outies . . . So the orgasmic experience, this calamitous climax which is unique and double, uniquely double and doubly unique, is on the one hand the closest to the origin of life, to the origin each time, with each generation, of an endangered species, a species at risk, an organism wanting in orgasm, desiring desire with a desire that is all the more dire in that we will never put our finger on the origin we none-the-less long and lie for, because we can only contemplate the navel of our conception; and on the other, the primordial or paradigmatic experience of the im/possibility of sharing and of sharing experience, *one's* experience, of sharing it with the other, with this irreducible, universal stranger with whom one makes oneself at home, with this other species of one's own, because men and women are two species in one, and the experience of this perceptible, phenomenal but unreachable domain which is the *jouissance* of the other sex is the experience that it takes two to make one, to stave off extinction by engendering and endangering, each one together.

Of course we will never know at what point life begins. We will never know how many a couple is. Nor will we ever have a sextant to take the constant bearings of our sexual orientation. Such are the sources of humanity, 'double and divided', our countless interior exterior couplings, differences, sexual differences that translate as a pair of mates – and a means of transport. Now the first of these, needless to say, is 'our own body' (p. 28). Mobile, 'in metamorphosis', it is itself a place of translation, offering effigies of our ineffable affects. And the question of the body, of one's own body, of the historic and histrionic prop of the body proper as polyglossal theatre of our passions carries in it that of one's relation to the origin, to one's sources, to one's own creation. A question of the relation to memory and the archive, to loss and to the keepsake, to the archaeologist's irresistible obsession, and of course to the apostles of death. It is also a question of sexual difference.

And so it is that Hélène Cixous speaks of her difference, of Jacques Derrida's difference, of their difference, a difference they share between them or between the corpus of their works. 'What Derrida expresses at times is a vital curiosity with respect to those types of primitive scenes that elude us, and that have caused him' (p. 90). Yet what animates Cixous's writing is not so much the impossible reflection of the philosopher 'at the window of himself' (p. 87), not so much this contending with the '"enigma of myself"'; it is rather the thirst for the phenomenon of an instant' (p. 90). Cixous is 'closer to the *theatre*, to the *scene* of the body than Derrida' (p. 89), even if 'He steeps his pen in his own blood' (p. 81), if 'his thought always forms a single *body* with the objects (of thought)' (p. 87). Even if 'he has always written from and *with* his body' (p. 85). And even if Hélène Cixous can also say 'Of course, at times I 'go back' towards the source' (p. 90).

Perhaps we can see in *Rootprints* one of these times, opening a new trail through a remarkable archive of dated phenomena. However the origin is not necessarily a dead and settled past, and so the nostalgia of the (auto)biographic homecoming can also be taken up in a writing of the 'one-step-more' (p. 83). Because a return is always liable to break new ground, something Cixous has a genius for, starting with a fertile displacement at and of her birth: 'I was born so far from my beginnings' (p. 179).

Still, the translator's squeamishness with regard to physical corporeal orgasm, this consummation at the source of an insatiable desire, indeed the translator's unrequited wish, unavowed even as it is acted out, to incorporate the other's orgasm whole, to ingest it undigested into the body of a foreign text, an unabashed alien at home, is thus particularly ironic in that *jouissance*'s only chance, its only window of opportunity gives onto all the ambiguities, all the contradictions, which need not be interdictions, of its sharing, its (re)uniting and its separating, in the intrinsic untranslatable idiomaticity of this one word for two (experiences, sexes, words) that can't even mean the same thing within the confines of a phenomenal French language. For it is a certain experience of translation, of how 'we cannot communicate ourselves mutually in translation' (p. 53), a certain communion at the very point of translation's foundering vanity.

But it may in fact turn out that along the 'double path' (p. 87) of Cixous's writing, as Calle-Gruber puts it, the 'inside' question of sexual difference and the 'outside' question of human nature are the closest of relatives. That they form a shifting nuclear family, conjugated at once in acts of fusion and of fission, kith and kin because 'there is further-than-myself in myself' (p. 56). Such is the point of exquisite extravagance at the heart of the cixouscience of writing, this carefree poetics of caring and freeing, because writing, Cixous's writing especially, exceptionally, might be said to inhabit the pages of a most intimate Mystic Notebook, to be inscribed into a space opened by its very consignment there as an 'interior margin' (p. 130) or a 'prosthesis of the inside'.[3] Which is to say a prosthetic, outer inside, an external substitute or supplement, an addition while also a replacement for the interior, as if it were a stand-in for the unimaginable ablation of the inside; but at the same time a prosthesis *on* the inside, on its side and at its service, a 'domestic outside', accessible through an act of hermeneutic transposition. This is what is suggested in any case by Cixous's account of the physical, of the corporal mechanics of her writing:

it is as if I were writing on the inside of myself. It is as if the page were really inside. The least outside possible. As close as possible to the body. As if my body enveloped my own paper.

(p. 105)

However, such a relationship should not be confused with a simple integration of the paper, with its reduction to an inward pulp, metabolized in a seamless assimilation which would spell its effective elimination as indispensable stranger, as unforgettable foreign body hailing from the outside. Nor is this 'further-than-myself in myself' the indication of some derivative intentionality whispering simultaneous translations of the world into the impassive ear of a hermetically preconceived self-consciousness. It is the most inner trait of who we 'are', precisely in its tempestuous mixing of 'others and myself' (p. 56). It takes precedence as the only hope we can learn, create, change; give too. Get or beget.

The presence of a 'further-than-myself in myself' naturally leads to a reconsideration of the mathematics of intersubjectivity. Because for all its extreme freedom Cixous's writing might be said to obey a uniquely supple rigour, it vows accountability with an arithmetic that promises a reckoning of the incalculable. An imagery of the invisible. This is of course the necessary rigour of liberation rather than one of limitation, but it is a rigour that itself admits more than one logic, more than one approach, more than one writing, and thus more than one inside, or an inside and an outside. The absence of 'normal' character names in Cixous's texts, for example, is a sign that we are inside, 'so deep inside that there had *never been a name*' (p. 18). This inside of Cixous's fictional texts does not correspond to a solipsistic chauvinism; it is simply the most honest, the most humble and ultimately the most powerful or far-reaching approach to the outside, because 'in the school of the other the preschool is oneself'.[4] It is a first lesson in humility. For we are subjects, just as we are inescapably men and women, even if we may never know exactly what this means, and even if our subject may be multiple, divided, polyphonic, often dissonant, syncopated, if there may be intrasubjective intersubjectivity, or rather precisely because of this. The 'inside' is the medium from which to begin, to continue beginning.

And then there can be an extreme limit of the writing of the subject, where the intersubjectivity is so strong that 'the subject is only intersubjectivity' (p. 77). Where the inside is all taken up in the in-between between insides, in the middle of the outside. This is certainly a rare experience, no more than one page in a hundred, in fact it is an experience that cannot properly be called an experience since there is no longer a subjective subject to experience it when it

comes to pass, and thus it can only be related, insofar as it can, from the outside, from the other side of the proper name, at the vanishing-point of a pure variable. The algebraic characters at the end of *Déluge* are of this unusual de-subjected species, and yet, as Calle-Gruber points out, for all their exteriority, indeed thanks to it, they maintain a great 'spectrum of possibilities' (p. 76).[5] It is the type of situation where 'I watch you watching me watch you watching me . . .' (p. 77), except it happens like this:

> A. and Not A. and D. suddenly Not D., no, A. inverted and D. passed and yet still D. but altered altering A., that is A. seen from different Ds, with the feeling of being seen by unknown D., and also A. seen by A. inside, and D. seen by SuperD. [. . .]
>
> (*Déluge*, p. 226)

So even here, in the thirteenth hour of this eleventh chapter called 'Après', even after the impact, as seen from the stars there is inside for these little motes of outside. 'The train A. went off toward the interior. The train D. went off toward the exterior or else vice versa' (*Déluge*, p. 227).

Writing? Love? Writing 'leads to enrichment – not of the narcissistic self but of the self of the person in labour' (p. 112). The writing self is at work, labouring at this prosthetic body proper, but above all *in* labour, parturient, in the process of giving birth and coming into the world, big with what will be the work but still in fusion, molten and so not a self in the staid self-centred sense. The book is not written for the other, but as Cixous puts it with a nod to Stendhal, for 'the skin of our belly' (p. 104), which is to say not for myself either in any simple way, but for a very particular part of myself, or one of myself, at my own middle limit, for the other of myself, because in this writing experience of writing experience 'I is not I, [. . .] it is with the others, coming from the others, putting me in the other's place, giving me the other's eyes' (p. 87).

Writing is not making love but making room, 'making room for the other part of myself who is the other, who can only exist, of course, if I am there to receive' (p. 112). So I have to be there and not be there, the homemaker's predicament. There is no such thing as an inhospitable home, and there is no hospitality without a host, but neither is there any – any true hospitality, any hospitality that is

not already calculating its return – with one. I can only welcome you into a space that is my own, never a neutral or public space, but there cannot be welcoming without a make-yourself-at-home, an abdication of domestic dominion by the landlord or host. It is making room for the guest, this most elusive of beings who is neither me nor you alone, and yet who comes – between us – to be at home. Making room within my rooms, but also making the room of your arrival, raising the walls within which to receive you, building the nuptial chamber of our meeting.

Of course this is true of love too, 'One must open oneself, one must make room for the other' (p. 110). But love is profitable, 'very profitable', and at least to begin with, in love 'we want at any price to devour the other' (p. 111), which gives the loving visitation a rather different seasoning. Because 'in writing, we do not love anyone. Or rather *on aime personne*', Cixous says, which is not exactly the same thing. This is a very strange, unstable expression that might be translated 'we love no-one-in-person'; it is both doubly positive and a virtual negative, inscribing a sort of abstract or phantomatic *person* who is at once present and absent, as if writing were at the limit of loving, not without the other but not with any present lover either. However it is also a *coup d'écriture*, a feat of writing in writing as the object of our love, we love *personne*, this mysterious French word that carefully masks its identity, appearing by turns as an affirmative noun and an indefinite, mostly negative pronoun. Indeed this is a construction that flies in the face of translation and even defies transliteration in the transcript of an oral interview. Because its pronunciation with the elision of an 'n' makes it indistinguishable from the phrase it follows: *On n'aime personne. On aime personne.*

And yet the interview is an edgy form; there is one and there are two, there is speaking and there is writing. And all the while asking and answering. At one point, early on, Mireille Calle-Gruber broaches the question of the 'shock of the other' which can be painful or salutary, and how 'the other can be felt as a breaking, a point of rupture that is more or less painful' (p. 14). To which Cixous responds,

Here is difference between us [. . .]. For you, if I take you literally, there is always breaking and for me, in a certain sense, not. [. . .] Because in breaking I sense: irreparable. But there is *wounding*. The

wound is what I sense. The wound is a strange thing: either I die, or a kind of work takes place, mysterious, that will reassemble the edges of the wound.

(pp. 14-16)

Here are two words, breaking/wounding, that seem to speak of two different events. However, it is always possible, who's to say, that they may in fact be naming one same event as seen from two points of view, from the two edges of an intersubjective divide. Cixous goes on to talk of two different types of misunderstanding in our encounters with each other: on the one hand a negative incomprehension which is a violent close-mindedness and rejection of the other, and on the other a positive incomprehension at work in love or friendship-love: 'The fact that we can say to each other all the time: here, I am not like you' (p. 16).

So in this sequence, in this dialogue, the genre of the interview shows its unmistakable colours, as the question of the interpretation of the encounter with the other is played out between the two discussants in the real time interval of their inter-viewing tryst. Because an interview is supposed to be an encounter between two reflecting subjects, each one the other for the other. And so *Rootprints* keeps the record of such an event, nearly effaced, self-effacing, but altogether real, a breaking or a wounding on the subject of breaking and wounding inscribed into the very body of this faithfully transcribed text.

For Hélène this diminutive rift must be a sort of wound, a minor scratch or a little cut, a fruitful or positive mishap in the community of mutual comprehension. For her the wound has happened, she stresses the *difference*, 'here is difference between us', and the healing too, in a jiffy, practically in a single line. So on one side there *is* a *wound*. But on the other side, for Mireille, there is *not* a *break*, because it is avoided *in extremis* by an absolute agreement: 'Wound and not break: I agree absolutely' (p. 22). This is an eloquent if unimposing example of meeting with the other, in which the healable wound that takes place and the irremediable break that is avoided accord their differences across the interpersonal abyss as joint, tear or seam. Indeed this entire book is the product of a rare encounter, a freindly interlocution between two women, both very much alive. The mutual movement of respect.

And translation? Make believe it's nothing but transcription, a taking down of pre-recorded voices, recopying in a different hand words that shimmer at the surface of another medium. Each new sentence undertaken with a doomed but virgin innocence. Only to be overwhelmed, invariably, by an unbeatable *mal de cœur*, coming on queasy as an excessive, obsessive brand of reading, extremely close, admittedly inimitable, one that will never be subsumed by any other, perhaps, but too fast too close for perspective, and yet halting, interminable, stumbling maladroit over each word, and then going straight for the gist, brutal, sacrificial and superficial, cutting and running, by all accounts a losing proposition. No doubt necessary, but a translation is always most ungainly. Terrible and unfinished, even in the dying turbulence of its own wake.

Notes

1 All page references are to this volume unless stated otherwise.
2 This is consonant with what Derrida says in the first appendix, that 'sexual difference is to be interpreted, to be deciphered, to be decoded, to be read and not to be seen. Readable, thus invisible, the object of testimony and not of proof [. . .] it passes by, it is in passage, it passes from the one to the other, by the one and the other [. . .]' (p. 121), and what he says elsewhere in the same text about the double genitive of the phrase 'readings of sexual difference'. And yet to say about sexual difference that 'it is our reading' is to add still another twist: 1) it is the reading we do, our interpretation or simply our act of reading, as if all our reading brought us back to it, whether we know it or not, 2) it is the reading done of us, perhaps the one done by sexual difference itself, it is what we signify, what any reading of us reveals, but also 3) it is our reading material, the great book laid open before us. So not only is it reading and read, sexual difference is also a read (verbal noun), a good read: 'one can only read it, study it and interpret it' (p. 56), like an ethereal Talmud.
3 Jacques Derrida, *Archive Fever*, Chicago and London: University of Chicago Press, 1996, p. 19.
4 '*Dans l'école de l'autre la maternelle est soi-même*', H. Cixous, personal communication, 1993.

5 This is not true of realist novelistic modes, of realism 'in its banal form' (p. 78), the realism of the fixed and fixing proper name as psychologizing narrative gadget to counterfeit and caricature the character. A realism that effectively eliminates any possibility of the multifarious cixousian subject.